ON CANADIAN WINGS

Peter Pigott

ON CANADIAN WINGS

A CENTURY OF FLIGHT

A HOUNSLOW BOOK
A MEMBER OF THE DUNDURN GROUP
TORONTO

Copyright © Peter Pigott, 2005

All rights reserved. No part of this publication may be reproduced, stored in a retrieval system, or transmitted in any form or by any means, electronic, mechanical, photocopying, recording, or otherwise (except for brief passages for purposes of review) without the prior permission of Dundurn Press. Permission to photocopy should be requested from Access Copyright.

Copy-Editor: Andrea Pruss
Design: Andrew Roberts
Printer: AGMV Marquis

Library and Archives Canada Cataloguing in Publication

Pigott, Peter
 On Canadian wings : a century of flight / Peter Pigott.

ISBN 1-55002-549-X

 1. Airplanes--Canada--History. 2. Aeronautics--Canada--History.
I. Title.

TL523.P522 2005 629.133'34'0971
C2005-900173-9

1 2 3 4 5 09 08 07 06 05

We acknowledge the support of the Canada Council for the Arts and the Ontario Arts Council for our publishing program. We also acknowledge the financial support of the Government of Canada through the Book Publishing Industry Development Program and The Association for the Export of Canadian Books, and the Government of Ontario through the Ontario Book Publishers Tax Credit program, and the Ontario Media Development Corporation's Ontario Book Initiative.

Care has been taken to trace the ownership of copyright material used in this book. The author and the publisher welcome any information enabling them to rectify any references or credit in subsequent editions.

J. Kirk Howard, President

Printed and bound in Canada.
Printed on recycled paper.

www.dundurn.com

Dundurn Press	Gazelle Book Services Limited	Dundurn Press
8 Market Street, Suite 200	White Cross Mills	2250 Military Road
Toronto, Ontario, Canada	Hightown, Lancaster, England	Tonawanda NY
M5E 1M6	LA1 4X5	U.S.A. 14150

For Brian and Marilyn Kenny ... long overdue.

Acknowledgements

I would like to record my thanks to many people for their most generous help in connection with the preparation of this book. Several assisted in a great variety of ways, and the order in which their names appear in no way implies any ranking. Janet Lacroix at the CF Photo Unit, Ottawa, was as patient as ever with my requests. Dr. Cameron Pulsifer of the Canadian War Museum confirmed that the photo I had was of Flight Lieutenant R.V. Manning. As he had previously with the Griffon helicopter, Captain Jonathan Knaul, a test pilot at AETE Cold Lake, demonstrated that he was an authority on the Kiowa. Philippa King of Bombardier Aerospace found for me the photos of the Chipmunk. Kathy Fitton, Manager, Western Development Museum, Moose Jaw, put me in contact with the Vintage Aircraft Restorers. In rebuilding the Cornell, they have preserved part of our aviation heritage and deserve to be listed — Don O'Hearne, Roger Mackin, Frank Brattan, Jim Morrison, Walter Rowan, Jim Mason, Jim Charters, Bill Prowse, Harold Jackson, Jim Gushuiliak, Roy Hiles, and Dale Cline.

My thanks to Jerry Vernon, president of the Vancouver chapter of the Canadian Aviation Historical Society, who located for me the information on the Bell Airacobra test-flown in the RCAF. Kudos to Captain

Gareth "Lester" Carter, Unit Information Officer, CC-NAEWF Geilenkirchen, who wrote of, flew in, and photographed the E-3A. Rachel Julia Andrews of Air Transat sent me the photos of the L-1011 and A-330. A fortunate meeting with Ottawa archivist Rick Wallace gave me the background on William C. Robinson's flight from Montreal to Slattery's Field.

An MG sports car and 1950s bus restorer, Dick Gilbert of Heathfield, East Sussex, is also an agent for charter airlines. Somehow, Dick found time to research for me the fate of the former Air Canada Viscounts. In writing this book, I discovered that the authority on the De Havilland Otter is Irish solicitor Karl Hayes, and he and bush pilot Ken Webster provided the text and photos of the Turbo Otter. The British Antarctic Survey in Cambridge described for me the use of the Turbo Beaver in the polar regions. I harassed Evelyne Bessette of Bombardier PR & Communications for the photos of the Learjet, Challenger, and Global Express. First Air's Tracy Beeman, Director, Marketing Communications, permitted the use of her company's B 727 and HS 128 photos.

Captain J.S. Medves, 1 Wing Headquarters, Kingston, Ontario, (on the Labrador) and Bob Fassold (on the Chipmunk) gave so willingly of their time, talent, and expertise that I wish that space limitations would have allowed their complete texts to be published. For all who contributed to this book, truly, aviation is not a passion but a disease from which there is no reprieve.

Table of Contents

Introduction	13
Bleriot Monoplane	17
Vought/Lillie	21
Burgess-Dunne	27
Bleriot Experimental 2	31
De Havilland 4	35
Bristol F2B	39
Nieuport 17	41
Felixstowe F-3/F-5	45
HS-2L Flying Boat	49
Vickers Viking	53
Fairchild Super 71P	57
Fairchild 82	59

De Havilland 90 Dragonfly	63
Bellanca Aircruiser	67
Barkley-Grow T8P-1	69
Lockheed 12A Electra	73
Fairey Swordfish	77
Douglas Digby	81
Bell P-39 Airacobra	85
Fleet Fort	89
Vickers Wellington	93
Bristol Blenheim	97
Fairchild Cornell	101
Bristol Beaufort	105
Curtiss Helldiver	109

Fairey Firefly	113
Hawker Sea Fury	117
De Havilland 83 Fox Moth	119
Avro Lincoln	123
Vickers Viscount	125
De Havilland Chipmunk	131
Bristol Britannia	137
De Havilland Canada Otter	141
Boeing 707/AWACS E-3A	145
De Havilland Canada Turbo Beaver	151
Cessna L-19 Bird Dog	153
CH-113 Labrador/CH-113A Voyageur	157
Boeing 727	163

Canadair Argus CP-107	167
Avro 748	171
Bell CH-136 Kiowa	173
Beech Musketeer CT-134	177
Lockheed L-1011 Tristar	179
Bombardier Learjet	181
Airbus 319/320/321	185
Bombardier Challenger	189
Raytheon CT-156 Harvard II	193
Bombardier Global Express	195
Canadair Regional Jet	199
Airbus 330	203

Introduction

The use of air power can be traced back to the Battle of Fleurus in June 1794, when, in the Duke of Wellington's words, balloons were used to "see around the other side of the hill." From this humble beginning, air power (or air supremacy) has come to dominate modern warfare. Today, little of the actual fighting or support to the front line can take place without the air component. As Viscount Montgomery of Alamein observed, "If we lose the war in the air, we lose the war and we lose it very quickly."

This book, the last of the trilogy that began with *Wings Across Canada: An Illustrated History of Canadian Aviation* and continued with *Taming the Skies: A Celebration of Canadian Flight*, arrives just after the country celebrated the eightieth anniversary of the birth of its air power element, and indeed, the Burgess-Dunne, its first military "platform," is part of it. There had been attempts to create a national air force before 1924, including the Canadian Aircraft Corps (CAC), the Royal Canadian Naval Air Service (RCNAS), and the Canadian Air Force (CAF). What gave the Dominion of Canada a permanent air arm were three factors: the return of former Royal Flying Corps (RFC) personnel, the Imperial Gift of aircraft, and, most critical of all, the necessity for some sort of government air organization that could defend the Empire when called upon and serve civil functions like

forestry protection when not. After the First World War, several countries had become fired with the idea of aerial warfare — reconnaissance sorties, air policing, and transport. The creation of the Royal Air Force on April 1, 1918, as a distinct branch of the military was followed by a slew of others, and when on August 13, 1921, His Majesty bestowed the prefix "Royal" on the Australian Air Force, it gave encouragement to those in the CAF who sought the same. On January 5, 1923, an application was made to the Governor General through the Department of External Affairs. His Majesty approved it, and to keep with the Royal Air Force tradition, the light blue

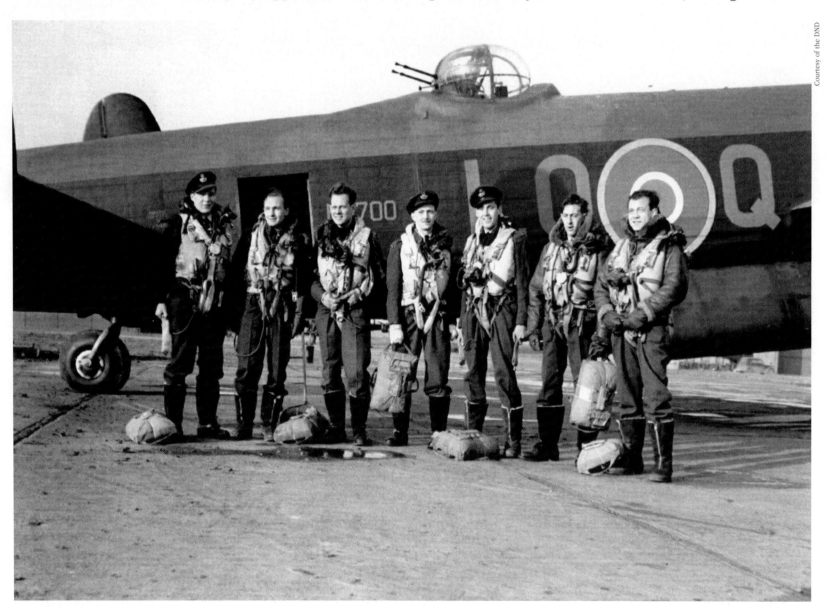

Introduction

uniform and motto "*Per ardua ad astra*" ("Through adversity to the stars") were also adopted. The official birth date of the Royal Canadian Air Force (RCAF) is the day that the regulations were announced: April 1, 1924.

It was while researching *Wings Across Canada* that I came across this photograph. There was no identification as to who the RCAF bomber crew were or where and when the photo was taken. I have often wondered about their fate: did they return home, do they lie in a European cemetery, or have they no known grave? All I can be certain of is that at the precise moment the camera clicked, those young men, the human face of air power, were someone's sons, brothers, husbands, and sweethearts.

Each year, as the Second World War slips deeper into a sepia-tinted past, those who fought or endured it are carried off by dementia or death. More and more, what occurred on the world stage between 1939 and 1945 is left for professional historians to interpret. This is as it should be, but something will forever be lost, as the personal experiences, conversations, and thoughts of those who witnessed the conflict will soon be no more, leaving many stories untold.

It was very different when I was a child. Although I grew up in post-war Bombay, India, far away from the battlefields, almost every adult I knew had been personally touched by the war. My father had fought in Burma with the Chindits, his brothers had been with the Royal Electrical & Mechanical Engineers in North Africa, two of my aunts wore the uniform of the Women's Auxiliary Corps — and my mother outranked them all as an officer in the Women's Royal Naval Service. If this was the first war to be extensively documented for the newsreels, it was also the first for the personal camera. What was pasted into our family photograph albums might not have competed with Alfred Eisenstaedt, but here was my parent's war: young men and women in khaki, "civvies," or bathing suits, sporting trim figures and full heads of hair, self-consciously posing beside Austin Tens or the pyramids, smoking cigarettes in manning depots or crowded onto blankets at picnics. As a child, I thought that the whole war had taken place in black and white and bright sunshine with everyone grinning to the camera.

The talk at our family gatherings was never about the great battles, heroism, or grand military strategy but of the minutiae of war — life on board the crowded troopships, the inevitable lining up for everything, the pleasures to be had in Port Said, in ENSA, and watching Vera Lynn. Indeed, much of my female relatives' war seemed to consist of being squired around by young men with lots of back pay who were far from dreary, blacked-out England. What struck me later was that there was no talk of blood, drama, or triumph — at least not in my hearing. Perhaps because they had a "good" war, the adults in my family remembered it with affection.

In university, during the anti-Vietnam war years, I came to despise everything that my parents' generation held about war, and those stirring movies and waving of flags all seemed like so much jingoism. In hindsight, perhaps I was not a little envious of the emotions that they had experienced. What occurred between 1939 and 1945 had given them a permanent "high" and an endless source of stories for any occasion. Perhaps it was because I was now conscious of its terrible carnage (the cemeteries, atrocities, camps, and casualty lists) and of the fact that my parents' war had never really ended, that we were still living in its shadow through Korea, the Sinai, Vietnam, Beirut, and Baghdad.

Historians write that the Second World War was the fulcrum of our time and that the men and women who lived through the conflict helped shape the post-war world of my generation. If many of those who volunteered did so because it was a job that offered an escape or excitement, it was also because they sincerely held that they were fighting to make a better world. It was the last, clear-cut, black and white crusade, and as the obituary columns attest, those that fought it will soon be no more. It is far easier to see them as the nameless bomber crew in the photo.

When posted to the embassy in The Hague I visited the Canadian War Cemetery at Groesbeek. On the memorial were inscribed the following words: "*Pro amicis mortui amicis vivimus*" ("We live in the hearts of friends for whom we died").

Perhaps it's as simple as that.

Bleriot Monoplane

Daily, contrails fill the sky over Montreal and Toronto as airliners climb out or descend. How many Canadians know that the first aircraft to overfly both cities was French and that its pilot was a dashing French nobleman?

His family manufactured automobile headlights, a growth industry in 1909, which allowed Louis Bleriot the luxury of experimenting with flying machines. While his contemporaries built pusher biplanes, he opted for the unusual — a tractor monoplane in the now familiar crucifix layout. He used Alessandro Anzani's engine to power it — an air-cooled three-cylinder device that sustained about 22 horsepower at a maximum 1,400 rotations per minute. If it was prone to overheat in sustained use (his Channel flight of thirty-seven minutes was the longest that the Anzani had ever been run), it was also the best available. Halfway across the Channel it did overheat, and what saved Bleriot from an ignominious ditching was an opportune rain shower that cooled the Anzani.

After the Channel flight, Bleriots were turned out by the hundreds, and some were exported to Canada. In 1910, Edward C. Peterson of Fort William, Ontario, and Achille Hanssen of Montreal, Quebec, built copies.

Because it was so simple to operate, early in the First World War the Royal Flying Corps, the Royal Naval Air Service (RNAS), and all the French flying schools adopted the Bleriot as a tethered trainer (called a "clipped-winged penguin").

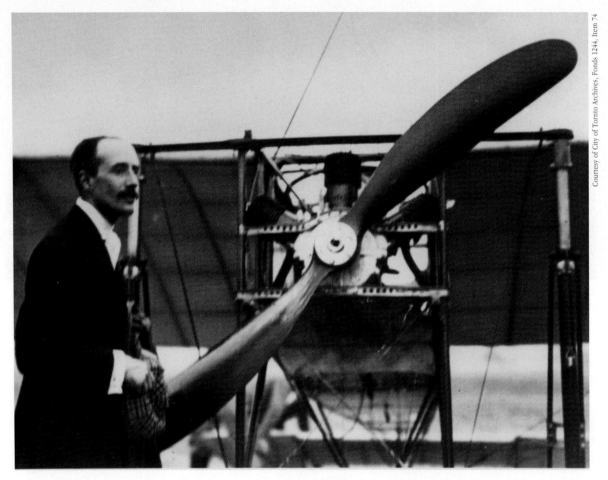

Jacques de Lesseps with his Bleriot at Weston.

The second person to successfully fly the English Channel is less well known. The son of the celebrated engineer that built both the Suez and Panama Canals, Count Jacques de Lesseps learned to fly at Bleriot's school and received French Pilot's Licence No. 27. Not relying on provident rain showers, for his Channel flight in March 1910 he used a 50-horsepower Gnome motor instead of the Anzani to power his Bleriot XI. Five weeks later, he arrived in Canada to take part in the first Canadian aviation meet and brought with him the same aircraft, now christened *Le Scarabée*, but with both the Gnome and Anzani engines.

Sponsored by the Automobile & Aero Club, the meet took place from June 25 to July 4 on the cleared, levelled fields at Lakeside (now Pointe Claire) in Montreal's West Island. Even then, the meet was understood to be a watershed battle between various modes of air transport. Every Edwardian aviator and balloonist, it seemed, competed. There were balloons, dirigibles, Wright biplanes, and Bleriot monoplanes. A local summer resident, nine-year-old Gordon McGregor, the future president of Air Canada, recalled that the whole experience was rich in aviation: there were tents and crowds, daily parachute descents, and even a runaway

Bleriot Monoplane

balloon. No one had seen so many diverse aircraft in one place — and in the air — all at the same time. Canada's own J.A.D. McCurdy failed to get his Baddeck No. 2 biplane airborne and met with disaster. American aviator Walter Brookins, flying a Wright biplane, was only a little more successful. Without doubt, victory belonged to Jacques de Lesseps. There were two other Bleriots on the field, but his *Le Scarabée* was easily the winner. Not satisfied with just circling the field, on July 2 he flew on a forty-nine-minute circuit from Lakeside to the centre of Montreal, making it the first Canadian city to be flown over.

Then the competitors packed up and moved to Toronto. Hosted by the Ontario Motor League, the Toronto meet was held at the Trethewey farm, Weston, near Black Creek. A runway was levelled (near present-day Hearst Circle), and a grandstand was built for spectators. Once more de Lesseps prevailed over McCurdy — and everyone else. On July 13, he flew to Humber Bay and circled the CNE grounds before returning to the Trethewey field (which can lay claim to being Toronto's first airport). The flight of twenty miles was made in twenty-eight minutes, the monoplane at a height of between 1,500 and 2,000 feet at 70 miles per hour. Although not the first to fly in Toronto, de Lesseps had accomplished the first long-distance flight in the city.

The twenty-seven-year-old Frenchman was the toast of the city that summer, the local media making much of the blossoming romance between the aviator and Grace Mackenzie, the daughter of Sir William

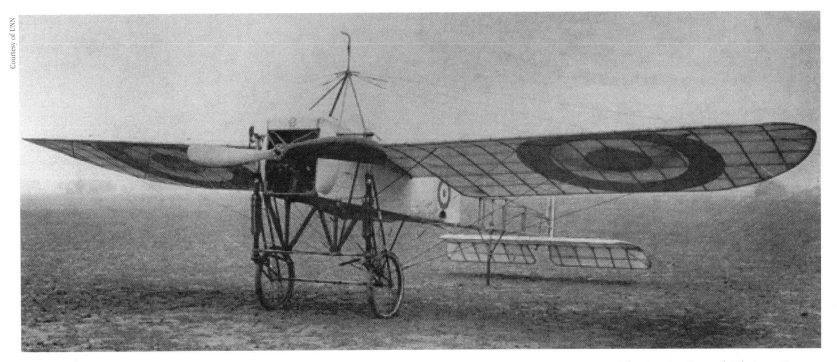

Bleriot in Royal Flying Corps.

Mackenzie, who owned the city's streetcar company. The couple were married and moved into the family mansion, Benevenuto, on Avenue Road. No slouch herself, Grace became one of the first Canadian women to fly when that summer she accompanied her husband to the air meet at New York's Belmont Park and took the faithful *Le Scarabée* on a couple of circuits herself. The Bleriot was later sold to H.A. Somerville of Montreal and disappeared from public attention.

De Lesseps returned to France during the First World War, joining the French Air Force and defending Paris against Zeppelins, completing a total of ninety-five bombing raids before the war ended. He came home decorated with le Croix de Guerre and the Legion of Honour; after the war he lived in Rosedale with his wife and four children, but he kept in touch with his air force colleagues and dabbled in flying.

In 1926, the aviator was hired by la Compagnie aérienne franco-canadienne to photograph the Gaspé region for cartography purposes, and sadly, on October 18, 1927, he and his co-pilot disappeared in bad weather over the St. Lawrence. De Lesseps's body eventually washed up on the Newfoundland coast, and he was buried in the Gaspé cemetery on December 14, 1927. The gallant Frenchman who captured the hearts of Canadians in 1910 is commemorated in this city, in a wonderfully evocative monument sculpted by Henri Hebert.

Vought/Lillie

In the summer of 1913, Montreal was in the midst of a newspaper war. The upstart *Montreal Daily Mail* was fighting the established *Montreal Star* for readers. In an effort to increase circulation, the *Mail* ran photo spreads of royal weddings, got humorist Stephen Leacock to write letters praising it, and even serialized a romantic novel for women. Then the *Mail*'s editor hit on a publicity stunt — why not have the morning edition delivered by air directly to the country's leaders in Ottawa: the prime minister, the Right Honourable R.L. Borden, and the leader of the Opposition, the Right Honourable Sir Wilfrid Laurier? Montrealers were familiar with exhibition flights, some having seen Count de Lesseps's Bleriot at the aerial meet two years before, but this was different. It would be using aviation, the paper said, for "Canadian enterprise."

Max Lillie ran a flying school/clubhouse at Chicago's Cicero Field, where exhibition aviators like Lincoln Beachey, Glenn Martin, and William C. Robinson met. Dissatisfied with the frail Wright pushers available, one of his students, Chance Vought, designed a tractor biplane with a staggered wing. Its French 50-horsepower engine had been built by the Société Des Moteurs Gnôme and featured a stationary crankshaft, around which the cylinders rotated when running. Air-cooled and lubricated with castor oil, the Gnome was high-torqued,

noisy, and temperamental. The Vought/Lillie airplane was test-flown by Robinson at Cicero Field, and when he was contacted by the *Mail*, he brought it to Montreal by train.

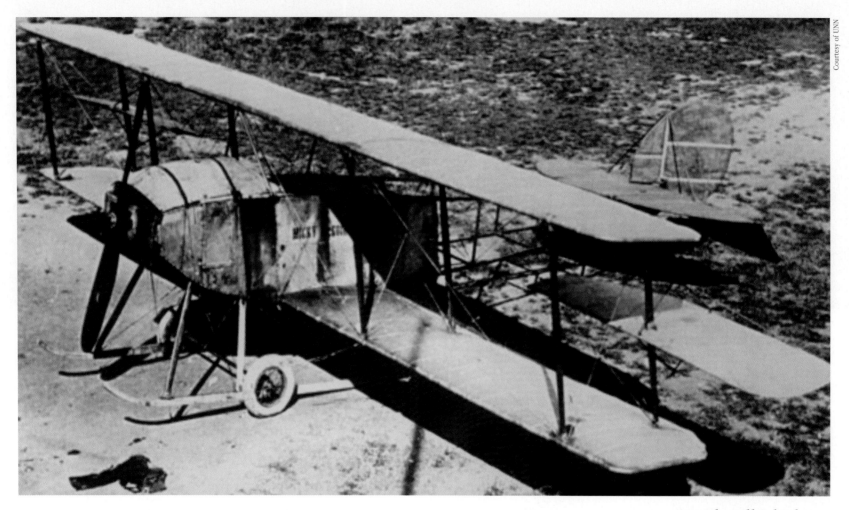

Vought/Lillie biplane.

The paper planned the intercity flight with care. Publicized as the "*Mail*'s own birdman," Robinson was to fly copies of the newspaper on October 8, 1913, from Snowdon Junction in Montreal West to Lansdowne Park at the Ottawa exhibition grounds. Much of his account would also be ghostwritten, the *Mail*'s editor not wanting truth to get in the way of a good story. On takeoff from Snowdon Junction, the aviator would overfly Fletcher's Field in downtown Montreal, where the *Mail* ensured that crowds would be gathered, and then head west for Ottawa. The Vought/Lillie had the endurance to make Ottawa in four stages, so it would refuel en route in the villages of St. Anne de Bellevue, Choisy, Caledonia Springs, and Leonard Station. Gasoline and castor oil were sent ahead to be stored at these landing fields, which would also be marked with

large white cotton crosses twenty yards in length. Circulars were distributed warning farmers along the route that a "real aeroplane" would be coming down in those fields and to keep their animals out. Robinson was to navigate by the "iron compass" — i.e. he would follow the Canadian Pacific Railway tracks to Ottawa and then look for the exhibition grounds.

On the great day, Robinson and his mechanic, Frank Burns, were still working on the Vought/Lillie at Snowdon Junction when Montreal Mayor Louis A. Lavellee arrived at 8:00 a.m. by automobile. Like most of the audience, he had never seen an aircraft actually take off before and said that he was very excited. Standing before the grey biplane, the mayor made a speech wishing the *Daily Mail* a long life. Then, "donning oil-skins and a leather cap," Robinson got into the aircraft. Copies of the newspaper were handed to him by the editor. As the engine was started, the *Mail*'s reporter wrote:

> Willing men rushed up and shoved the huge biplane forward. The revolutions grew faster and faster, causing the spectators to be enveloped in a cloud of dust ... the aviator turned and shouted one last word to his mechanic as the aeroplane lurched forward ... it looked as though the aviator was going to be dashed against a fence but it left the ground and gracefully shot into the air ... higher and higher he rose.

Robinson lifted off at 9:50 a.m. and made for the Lake of Two Mountains. Walking to his car, the mayor prophesied, "The flight is a good augury of the success of the *Daily Mail*." Perhaps nervous about the Gnome engine or about wasting time, Robinson decided not to circle the city (as the *Mail* had promised he would) but to make directly for Ottawa.

But hardly had the editor gotten to his office when he received the news that the aircraft had landed just outside the city, in the suburb of Lachine. Its gasoline pipe had developed a leak, and Robinson had put down at the Belanger Farm, east of the CPR bridge at Highlands Station. Fortunately, the faithful Burns had been following by car and actually saw the aircraft, as he told the newspaper, "volplanning." The leak was fixed, and Robinson was in the air once more, getting to a height he estimated at fifteen hundred feet. He landed at St. Anne de Bellevue shortly after noon and, while refuelling, asked a woman to get him a sandwich. Then it was off Montreal Island to Choisy (a passenger train had passed him at St. Anne, but he caught up with it at Choisy) and across the Ontario border to Caledonia Springs. Landing there at 2:45 p.m. Robinson left the aircraft as it was being refuelled and went to the CPR hotel, where he drank the mineral water for which the

town was renowned. He arrived at the last stop, Leonard Station, at 4:10 p.m. and was met by aviation enthusiast George Conway, who had driven from Montreal to help with the refuelling.

At 4:30 p.m. the biplane was once more in the air, bearing for Ottawa. Low cloud had enveloped Robinson most of the way, sometimes making it difficult to see the railway lines, but it cleared up from Leonard Station onward. "The first knowledge I had of the capital was the big bend in the river and the Parliament buildings," Robinson would tell the *Mail*. "Then I discerned the Chateau Laurier. The exhibition grounds I located by the half mile track." In 1913, the area of Ottawa between the Rideau Canal and the Rideau River was still rural; the most prominent landmark would have been the Scholasticate, a complex of buildings belonging to a religious order, and Robinson would have used them to find Lansdowne Park on the other side of the canal. He flew over both the river and the canal and prepared to land. But the closer he came to the exhibition grounds the more people he saw spread out over the field. "I thought it not very safe so I wheeled around and went back across the canal." He made instead for farmer Bernard Slattery's field on the other side of the canal. Then disaster almost struck. "Just as I was landing ... there was a horse in the field and as I came down the animal came in front of me. I had to raise one wing and make a very sharp turn to miss striking it."

By coincidence, Slattery's fields had been used as a runway before. In 1911, because the exhibition grounds at Lansdowne were too crowded, aviators Lee Hammond, flying Thomas S. Baldwin's Red-Devil biplane, and Georges Mestach, flying a Borel Morane monoplane, had both brought their aircraft to it.

When he landed on the farmer's field, Robinson calculated that he had covered the 115 miles from Montreal to Ottawa in 2 hours, 55 minutes flying time. He was driven to the Chateau Laurier while copies of the newspaper were delivered to Laurier and Borden. When asked about the flight, in an exclusive interview Robinson told the *Ottawa Mail* correspondent, "The ride was pleasant ... it is like riding on a big locomotive in a way for you feel the throbbing of the engine as you float through the air so smoothly that the sensation is a soothing one."

A week later, Robinson flew over the Experimental Farm and the Parliament buildings before returning to Slattery's field. This time he was not as fortunate, and an unrecorded mishap occurred that resulted in Robinson and the aircraft being sent back to Montreal by train.

The *Mail* milked the whole experience for as much as it could, even getting Laurier to endorse the event. But it was soon yesterday's news. Having carried out the first commercial intercity and interprovincial flight in Canadian history, Robinson and the aircraft would disappear into the exhibition circuit. Within a year, with the start of the Great War, both the *Montreal Daily Mail* and the *Montreal Star* would have more than enough

Vought/Lillie

to fill their pages. The flight itself would later be commemorated in a painting by former Canada Aviation Museum Director R.W. Bradford.

But the biplane was to be only the first of Chance Vought's innovative designs, and from his company would emerge aircraft such as the F4U gull-winged Corsair and the B-2 bomber. Slattery's fields remained rural until the 1950s, when Ontario Hydro built a substation on the spot where the first flights took place. A plaque on the wall of the substation, erected by the Canadian Aviation Historical Society, commemorates the flights with these words:

> In this area, once a cow pasture, the first aeroplane flights occurred in the Ottawa Region. Between September 11th and 14th, 1911, Lee Hammond, flying a biplane, performed before crowds attending the Central Canada Exhibition. On October 8th 1913, William C. Robinson landed at Slattery's Field after flying from Montreal. The first flight between two Canadian cites. Both pilots had to contend with cows & horse which shared this crude airfield.

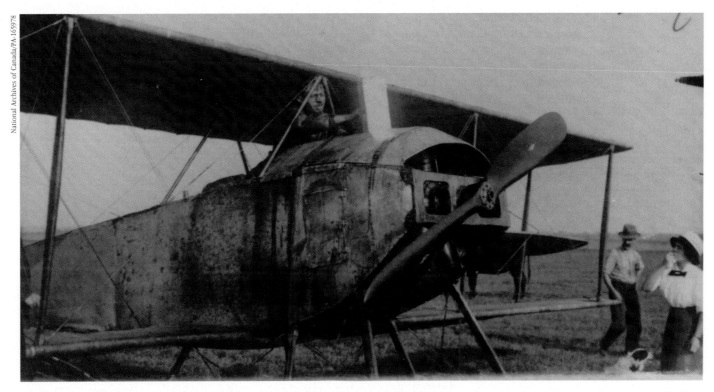

William C. Robinson, pilot, in the cockpit of his Vought/Lillie biplane during his Montreal–Ottawa flight.

On Canadian Wings | A Century of Flight

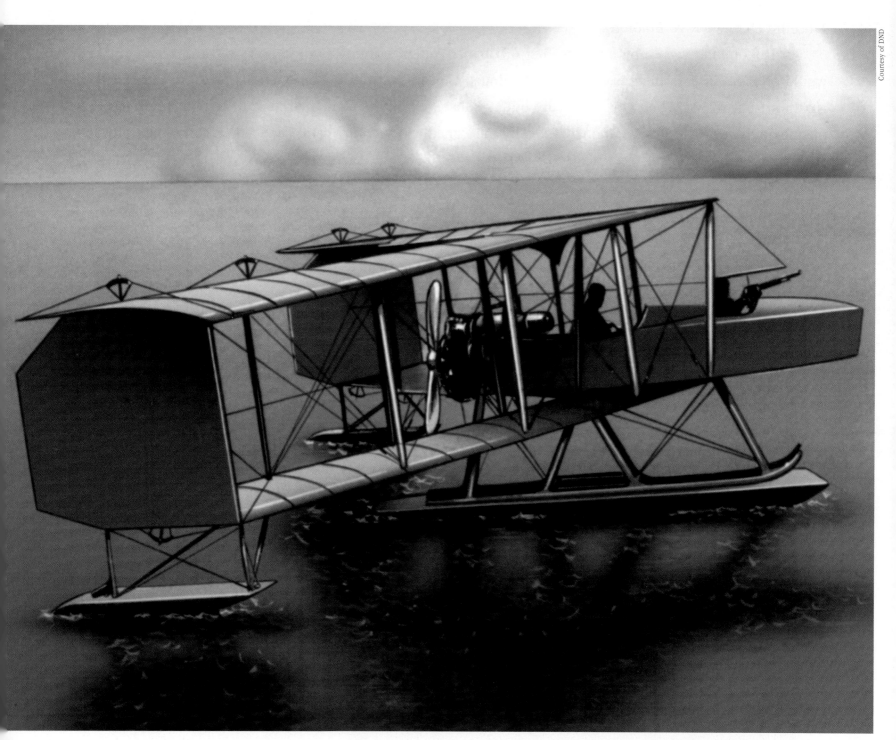

Artist's depiction of Burgess-Dunne, Canada's first military aircraft.

Burgess-Dunne

Invalided home from the Boer War, Lieutenant John Dunne spent his time writing fanciful books on flight and designing "heavier than air" machines. In 1905, the Royal Balloon Factory at Farnborough contracted him to build kites that could lift a man into the air, an idea that the military thought could be useful for battlefield observation. The resourceful Dunne took the idea a step further with a hang-glider. Sporting swept-back wings, it was aerodynamically far ahead of its time but completely unstable and prone to crash landings. Dunne added a 25-horsepower engine, enough to drive two pusher propellers, and a four-wheel landing gear. Even with this, the strange aircraft made no more than a few hops into the air, and the government soon lost interest in it. But aviation has never lacked for investors willing to throw good money after bad, and the Short Brothers took up the contraption, allowing Dunne to pursue his experiments at their workshop on the Isle of Sheppey. By 1910, he had graduated to his fifth model — now with accommodation for a pilot and observer, a 60-horsepower engine, vertical fins on the wing tips, and ailerons for better control. Dunne demonstrated this at Farnborough in March 1914, but by then there were

so many conventional aircraft available that no one wanted a weird, tailless biplane that needed constant adjustments to the rigging.

His aircraft might have vanished into obscurity had not the Burgess Company of Marblehead, Massachusetts, an American boat builder, taken it up. Guessing that those crashes were because the aircraft was susceptible to crosswinds on landing, they remade it as a seaplane, replacing the wheels with a single float and installing a powerful Curtiss OXX-2 engine. Now called the Burgess-Dunne, it was a one-off aircraft, and the company looked for customers.

Once more the oddity might have vanished into history except for Toronto aircraft enthusiast Ernest Lloyd Janney. It was September 1914, and the Great War was in its enthusiastic phase with the first contingent of the Canadian Expeditionary Force (CEF) hurriedly assembling at Valcartier, Quebec, to go overseas before it could end. Even before the hostilities, many air enthusiasts had unsuccessfully attempted to convince the Canadian government to form an air corps. Somehow Janney talked the Department of Militia and Defence, and especially its controversial minister, Sam Hughes, into doing just that — naturally with himself as its commander. Hughes granted commissions in the Canadian Aircraft Corps to Janney and to W. Sharpe, a native of Prescott, Ontario, who had learned to fly the year before at the Curtiss School in Texas. The minister also authorized a sizeable expenditure of $5,000 for the purchase of an aircraft. Janney wanted to be on the first CEF convoy to Britain, rightly suspecting that the erratic Hughes could change his mind about the CAC at anytime. He had heard of the Burgess-Dunne and rushed to Massachusetts with cheque in hand, arriving at the Marblehead workshop on September 12. When the aircraft was demonstrated on September 17 he bought it, despite warnings from the manufacturer that the engine needed to be overhauled. Then he made for Quebec City.

No one had then flown across country at such length, but Janney insisted that he fly to Valcartier immediately to catch the convoy. The Burgess Company disassembled the plane at its own expense and shipped it by rail across the border to Lake Champlain. From there, on September 21, with Janney as a passenger, company pilot Clifford Webster flew it to Sorel, Quebec. Following the St. Lawrence River, they made it as far as Champlain, Quebec, before the engine died of exhaustion. The aircraft was then transported the remainder of the way to Valcartier by road.

The Burgess-Dunne was loaded onto the SS *Athenia* and, presumably because there was no time to take it apart, lashed on deck. Predictably, when it arrived in England, it was battered out of shape from the rough seas. In whatever form, it was shipped to the Central Flying School at Uphavon for trials, but there it rotted

Burgess-Dunne

away, never to be flown. The CAC disappeared too, as neither the British nor the Canadian governments wanted anything to do with it (or Janney). Sharpe transferred to the Royal Flying Corps and died in a crash in February 1915.

But that was not the end of the irrepressible Janney. He returned to Canada in January 1915 and opened a private flying school at Lawrence Park, Toronto. How that fared is not known, but when the Royal Canadian Naval Air Service was begun in September 1918, he was one of its first cadets. The Burgess-Dunne, Ottawa's first aircraft purchase, like Janney, played an important, if confused, part in Canadian history.

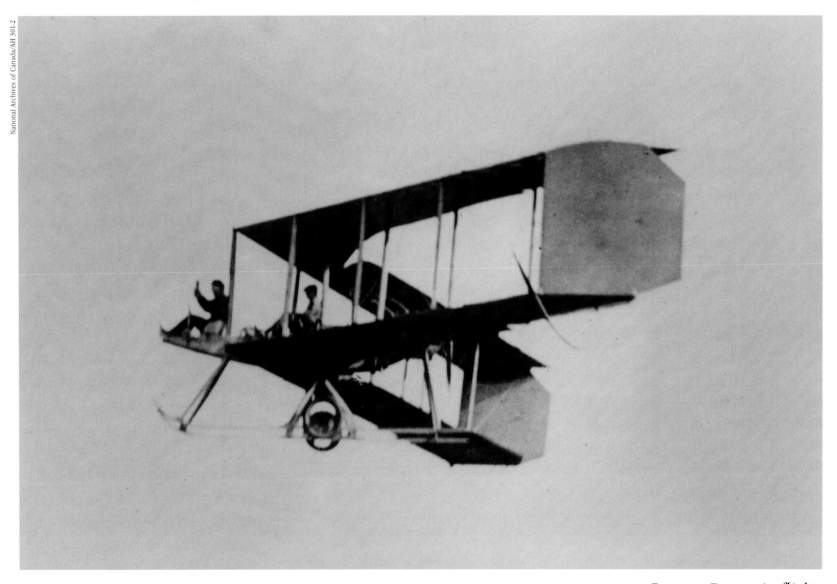

Burgess-Dunne in flight.

ON CANADIAN WINGS | A CENTURY OF FLIGHT

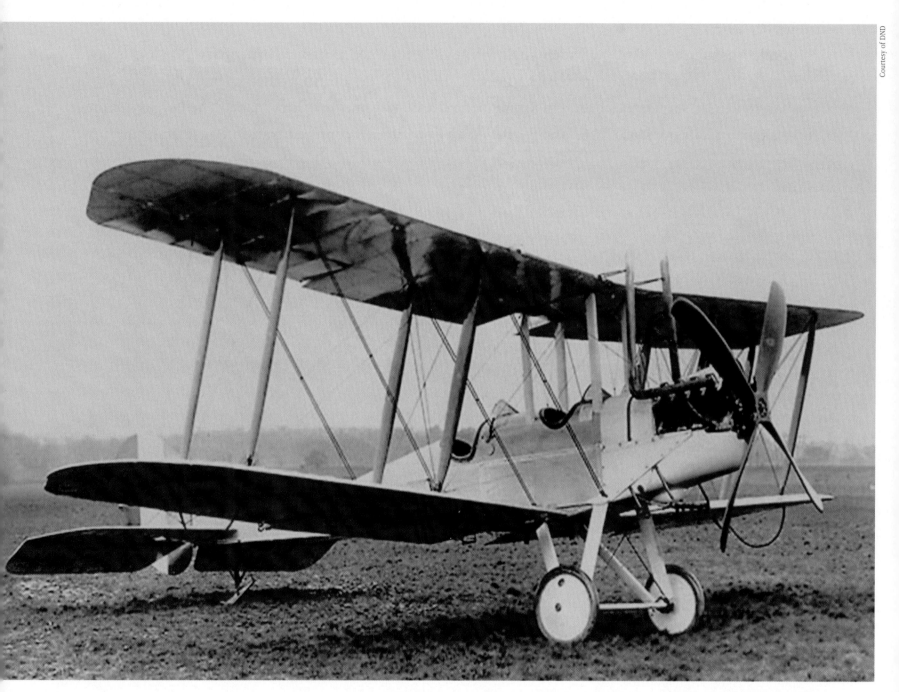

Bleriot Experimental 2.

Bleriot Experimental 2

In June 1914 the entire Royal Flying Corps — all seven hundred men and thirty aircraft — assembled at Netheravon on the Salisbury Plain. They were to be the British Army's aerial scouts and artillery spotters, a definite improvement over the observation balloons then used. The highlight of the camp was the arrival of the latest version of the Bleriot Experimental 2. Major Sefton Brancker flew one over from the factory at Farnborough and, on landing, told the assembly that he had taken off, climbed to two thousand feet, and then so stable was it that he had occupied himself with writing a reconnaissance report until Salisbury Plain appeared below his wings. Brancker (destined to be a major-general and the director of civil aviation) paid a tribute to the BE2's reliability for allowing him to do this. News that an Austro-Hungarian archduke had been assassinated somewhere on the continent caused the exercise to break up, no one guessing that the first war for air superiority was about to begin.

The Bleriot Experimental 2 had been shown to the public in August 1912 in the first Military Aeroplane Contest held at Larkhill on Salisbury Plain, England. Flown by its designer, the young Geoffrey de Havilland, and carrying a passenger, it climbed to 10,560 feet with a load of 450 pounds, beating out all competitors. The

aircraft's Renault 70-horsepower engine gave it a maximum speed of 80 miles per hour, and control was by wingwarping. But later models — the A, B, and C — would have staggered wings, ailerons on both the upper and lower, and built-up cockpit coamings. They were the ultimate in reconnaissance soundness — and as a result would suffer terribly when air fighting began in 1915.

That it was a Bleriot-inspired design was not surprising, for at the time the French led in all things aeronautical. The French themselves considered the Bleriot outdated, and the new escadrilles of the French Army were flying Nieuports instead. But the British government was sufficiently impressed in 1912 to order that the BE2 be built at the Royal Aircraft Factory. Official acceptance came when they were flown in the great naval review at Spithead. They so impressed King George V that through his influence and that of Winston Churchill, the young first Lord of the Admiralty, all "naval minded" aviators in the RFC were permitted to form the Royal Naval Air Service with the BE2 as the main aircraft. In April 1914, when the king went to France, the royal yacht *Albert and Victoria* was escorted by BE2s of the RNAS. The RNAS was not constrained, as the RFC was, to buying only aircraft built at the Royal Aircraft Factory; they purchased their BE2s from private firms, in this case Hewlett and Blondeau. When Britain entered the war, the BE2 was the RFC's mainstay, and on August 11, 1914, the first Royal Flying Corps aircraft to land on French soil was a BE2a flown by Lieutenant H.D. Harvey-Kelly.

In 1915, aerial warfare changed rapidly over the front when the Germans introduced the Fokker E-111, or Eindekker. With its fixed synchronized machine gun, it could attack Allied aircraft from any angle, and RFC losses escalated, with a corresponding drop in morale by the soldiers in the trenches. By now reconnaissance aircraft had become prize targets for the German Fokkers, and the RFC devised forward-firing mountings for a Lewis gun on the BE2s. There were several Canadians in the RFC flying BE2s, attempting to cope with the Fokkers any way they could. Alan Duncan Bell-Irving, later to become Canada's first air ace, was then flying a BE2c in 7 Squadron, and on September 20 he had a narrow escape. The most famous Canadian air ace of them all, W.A. "Billy" Bishop, trained on BE2s before he came to the front to fly Nieuports. As RFC squadrons received more lethal machines, their BE2s were handed down to training schools or the colonial air forces on other fronts. In 1916, 17 Squadron's BE2s were sent to the Middle East to equip the first Australian Flying Corps squadron.

On December 11, 1916, Captain Loudon Pierce Watkins of 95 Breadalbane Street, Toronto, reported to the Home Defence Squadron at Goldhanger, Essex. The aircraft he was assigned was #6610, a BE12 with a Daimler engine — a more powerful version of the BE2. On the morning of June 17, 1917, Watkins and his

Bleriot Experimental 2

observer, Lieutenant C.W. Wridgeway, were patrolling over Harwich when he sighted a Zeppelin. It was L48, part of a flight of two Zeppelins from Nordholz heading for London. Harried by fighters, L42 dropped its bombs over Ramsgate and made for home, and the crew of L48 must have wished the same. Watkins was at eleven thousand feet when he spotted the shape far above him. He pulled back the stick, and the BE12 climbed slowly to 11,500 feet, at which point he fired off a drum of incendiary bullets, but to no effect. He climbed higher still, firing down to his last drum. There were now two other machines with him. There was an explosion, and L48 sank stern first, covered in flames. It crashed near Holly Tree Farm, Thebreton, Suffolk, and incredibly, three of its crew survived to be taken prisoner. Awarded the Military Cross, Watkins was posted to France with 148 Squadron, then flying FE2bs. On Dominion Day 1918, on a night bombing raid, he and his observer (the same Wridgeway) crashed on takeoff, and Watkins was killed.

As for the BE2, once the pride of the RFC, it was last used in combat over the Dardenelles — an old warhorse that belonged to the days when gentlemen aviators did not fire at each other and war was still chivalrous.

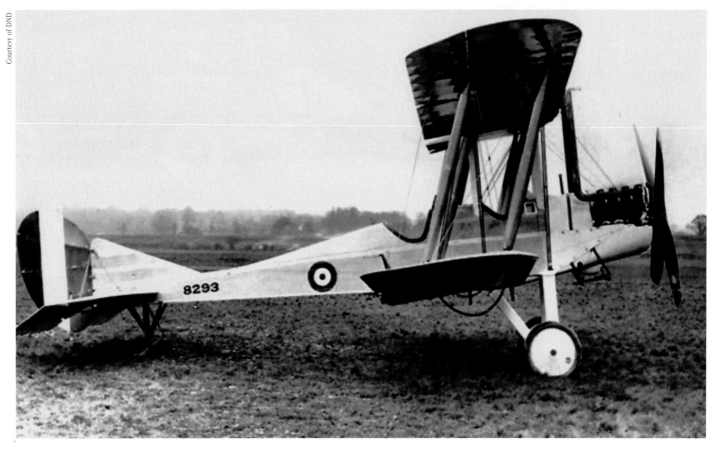

Bleriot Experimental 2.

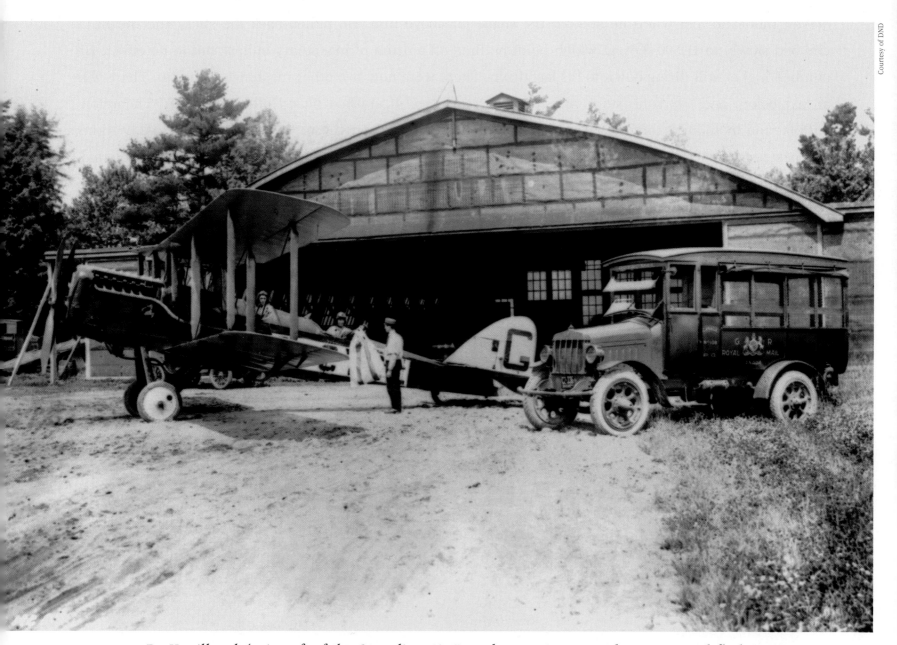

De Havilland 4 aircraft of the Canadian Air Board preparing to make an airmail flight to Toronto.

De Havilland 4

The DH 4 had many firsts: it began the long line of De Havilland tractor aircraft; it was the only British aircraft to be built in large numbers in the United States; and post-war, many of them would become the basis of the United States Army Air Corps (USAAC) and would be used in shaping the U.S. airmail service. In Canada, the DH 4 also equipped the embryonic Canadian Air Force, as it would the Belgian, Greek, Japanese, and Spanish air arms.

The fourth aircraft built by Geoffrey de Havilland (and the last at his old employer, Airco) had its origins in 1916 when the Royal Flying Corps wanted a dependable day bomber. The value of tactical bombing was just being appreciated, and this was to be the first British aircraft designed specifically for that purpose. Its distinctive "automobile radiator" 160-horsepower BHP engine was the creation of three men: Sir William Beardmore, Frank Halford, and T.C. Pulinger. When serious production problems developed, a variety of other engines, from the Fiat to the Sunbeam to the American Liberty, were substituted, but none was better than the superb 250-horsepower Rolls Royce Eagle engine, soon to power Alcock and Brown's Vickers Vimy across the Atlantic Ocean.

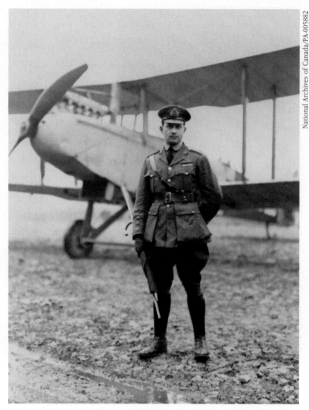

Major D.R. MacLaren with DH 9 aircraft Leicester.

Whatever the power plant, the Airco DH 4 is acknowledged as the best bomber in the First World War. It was pleasant to fly, light on the controls, and its tailplane could be adjusted by a hand wheel so that the pilot could trim the aircraft in flight. Lateral control was by a stick, which had the trigger mechanism for the guns. It differed from the older aircraft in that the fuselage was covered with plywood from the nose to behind the observer's cockpit, which dispensed with the internal bracing that fabric needed. The two cockpits were far apart to give the pilot a good downward and forward view for bomb aiming and the gunner/observer a good field of fire for his Lewis guns. The aircraft was used extensively for strafing the trenches (the word *strafe* derived from the German expression "*Gott strafe England*," or "May God punish England"). Its under-fuselage and under-wing bomb racks had a capacity for 460 pounds of bombs, allowing the RFC to use the DH 4 in such operations as the Raid on Zeebrugge and the sinking of U-boats. The bombing raids at the front were usually about fifteen to twenty miles behind the enemy lines and consisted of high explosives or incendiaries that the pilot released by a toggle and cable mechanism outside his cockpit. Pinpricks when compared with the damage that bombers inflicted in the next war, these were more for morale purposes and usually preceded a "push."

The observer played a big part in the operation of the DH 4. He was trained to be a substitute pilot, and stowed in his cockpit was a control column with dual rudder bars. Most DH 4 pilots taught their observers to fly as soon as possible in case they were hit, and there were several instances of observers bringing the aircraft back. The distance between the two cockpits was a fundamental weakness in communication — at least before the use of the Gosport tube — that made the aircraft vulnerable to air attack. To overcome this, many DH 4 pilots equipped their aircraft with an automobile-type rear-view mirror to keep an eye on their observers, with whom they communicated through sign language.

Many Canadians flew the DH 4 during the First World War, the most famous flight occurring on August 5, 1919, when the young Captain Robert Leckie, flying as an observer with Major Egbert Cadbury, shot down the pride of the German Naval Airship Services, the Zeppelin L70.

De Havilland 4

Post-war, the fortunes of the DH 4s were more mundane. In 1918, the Canadian government accepted from King George V a gift of ten DH 4s to begin a national air force. Anxious to demonstrate the variety of roles that aircraft could perform, the government dispersed the planes across the country on forestry, fishery, and photographic survey missions. Some of the DH 4s were based at Morley, Alberta, to patrol over the Rocky Mountain Forest Reserve; it was in one of these, G-CYBV, that ex-RFC pilot Lieutenant William Shields met his death. When taking off for a forestry patrol on August 1, 1921, he began a climbing turn before he had attained sufficient airspeed and slipped sideways to the ground.

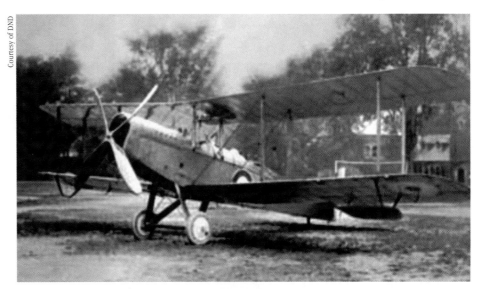

Airco De Havilland 4.

In the United States, the Dayton-Wright Airplane Company and the Fisher Body Corporation made 3,227 DH 4s powered with Liberty engines. By 1918, these equipped thirteen American squadrons. They became the mainstay of the post-war United States Army Air Corps and starred in several long-distance flights. On August 29, 1919, Major J.W. Simons of the U.S. Air Corps flew one from Toronto to New York City in three hours, forty-four minutes. On April 15, 1920, Lieutenant-Colonel H.E. Hartney and Captain H.T. Douglas connected the two capitals by air, landing their DH 4 at Bowesville airfield (now Uplands) in Ontario. That same summer, four Air Corps DH 4s, as part of the first Alaska Air Expedition, flew from New York to Nome, Alaska. They arrived at McClelland Field in Saskatoon on July 25 and at Edmonton's McCall Field on July 27. Landing at Jasper, Alberta, Prince George and Hazelton, British Columbia, and Dawson City, Yukon, on the way home, the DH 4s would give many Canadians their first view of an aircraft.

The DH 4 was a hard act to follow. It was so good that when its successor, the De Havilland 9, was built critics thought it a failure. The DH 9's dimensions were similar, and the pilot and gunner were closer, but it had none of the speed, ceiling, or stability of its predecessor. It complemented but never fully replaced the DH 4. As part of the Imperial Gift, twelve DH 9As were given to Canada. Three of them would be involved in the first trans-Canada flight, and one, G-CYBF, would be used in the final leg and land in Vancouver. The DH 9As would remain in RCAF service until 1927.

ON CANADIAN WINGS | A CENTURY OF FLIGHT

One of the two "Brisfits" that came to Canada.

Bristol F2B

Many Canadians flew the "Brisfit" in the Royal Flying Corps, but first among them was Second Lieutenant Andrew Edward McKeever from Listowel, Ontario. McKeever joined the RFC in 1916, and within a year, he and his observer, Second Lieutenant Leslie Archibald Powell, flying a Bristol Fighter, had accounted for twenty-eight enemy aircraft.

Frank Barnwell, Bristol's chief designer, was a captain in the British army; fortunately, in August 1915 he was sent home to design aircraft. The result was one of the outstanding military planes of the day: the Bristol Fighter. It was large, heavy, and sluggish on the ailerons, but it was the first two-seat fighter that the Royal Flying Corps used.

The Brisfit made its debut during "Bloody April" 1917, the period when the RFC's single-seat fighters were being severely mauled by the latest German Albatross D-IIIs. Compared with single-seat fighters like the Camel and Pup, the Brisfit was huge — it had a wingspan of thirty-nine feet and a loaded weight of twenty-eight hundred pounds. The most noticeable difference between the it and conventional two-seaters was that now the pilot and observer/gunner were seated back to back, giving the latter a good field of vision — except for directly astern or below the aircraft.

Heavily armed, it was to be a flying gun turret, with a .303 Vickers forward firing through the propeller and twin Lewis .303 guns mounted on a Scarff ring on the rear cockpit. With such armament, RFC pilots were confused: should the pilot fly to give his observer the best opportunities or should he fly it as a conventional fighter and use the observer to protect his rear? What gave the aircraft its power was the 275-horsepower Rolls Royce Falcon III. An in-line, water-cooled engine, it was gratefully received by RFC pilots who had suffered years of rotary engines. A top speed of 125 miles per hour made it a formidable opponent, and because of its weight it could dive faster than any other aircraft. As a result, pilots chose to fly their machines as single-engined fighters, a tactic that served to kill many of their observers, who had to stand up and bring their gun to bear on pursuing enemy fighters without an engine to protect them. Escaping a pursuer was a problem, for although the Brisfit was fast, it was heavy at the ailerons and couldn't twist and turn quickly. It also took a lot of muscular energy to move — one could always tell a Brisfit pilot by his bulging biceps.

While the Brisfit remained in production until 1926 and in RAF service until 1932, only two came to Canada as part of the Imperial Gift. After the Armistice, Brisfit ace Andrew McKeever, appointed commanding officer of No.1 Squadron of the Canadian Air Force, adopted one of the two Bristol Fighters as his personal aircraft. When demobilized he somehow managed to keep it, and the old warhorse appeared in the civil register as G-CYBC. Unhappily, McKeever was killed in a car crash on December 26, 1919.

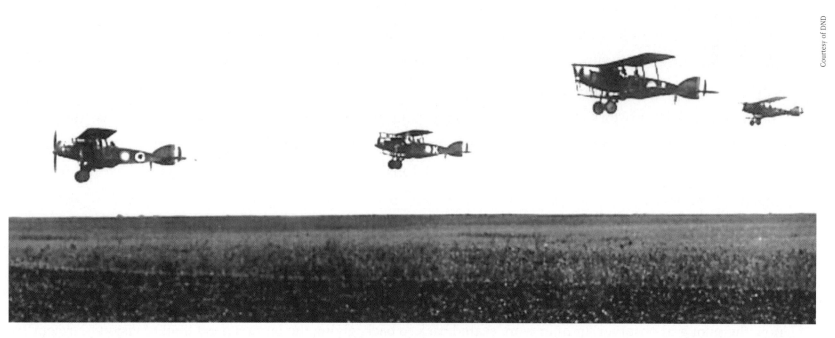

Bristol F2Bs in flight.

Nieuport 17

In 1982, the documentary *The Kid Who Couldn't Miss* provoked more controversy than any other that the National Film Board had ever done. It implied that William Avery Bishop had fabricated his military exploits, in particular the dawn airfield raid for which he had been awarded the Victoria Cross. Inextricably linked with this was Bishop's aircraft, the Nieuport 17.

Gustav Delage designed his first Nieuport in 1914, modelled after a pre-war Gordon Bennett racer. With a single Lewis firing over the top of the wing, the Nieuport 11 was so small that the French press called it the *Bébé*. Delage then began a series of Nieuports, with the sporty looks, the sesquiplane layout, and the V struts becoming his trademarks. The Nieuport 17 reached the front on May 2, 1916, and initially was sent only to the French escadrilles. But as the Royal Flying Corps and the Royal Naval Air Service were short of armed scouts, both placed large orders for the plane.

The early Nieuports had a Lewis gun mounted on the over-wing rail, but later machines also featured a synchronized Vickers in the nose. Neither weapon was sufficient for "balloon-busting," and by 1917, Le Prieur electrically fired rockets were fitted to the struts. With these and other modifications, Delage's racing design was

called on to do more than it was capable of. As a result, by the summer of 1917, many Nieuports were coming apart in mid-air with their lower wings separating from the struts, and in Bishop's squadron alone there were six such fatal accidents.

Like British air ace Albert Ball, Bishop had a great kinship with the little fighter, writing home, "being a French model, the Nieuport Scout is a beautiful creature." His first fight (and first victory) took place in one on March 25, 1917, when he shot down an Albatross, putting the Nieuport into a near vertical dive to get at it. In doing so he oiled up the plugs on the Nieuport's rotary engine, and it cut out. Unable to restart it, Bishop managed to glide 150 yards behind British lines. On landing, he dragged the aircraft out of artillery range, cleaned the plugs with a toothbrush, took off, and returned to his airfield. His pragmatism — particularly the use of the toothbrush — was the stuff of heroes, and the Canadian public lapped it up. As millions pitted themselves against each other in trench warfare, here was a lad from Owen Sound, Ontario, a knight of the air in his modern-day charger — the Nieuport 17.

Always a crack marksman, Bishop went on to bring down twenty more German aircraft in April and May 1917, but it was what took place in the dawn of June 2 that made him and his Nieuport immortal — and controversial. Ever the loner, Bishop took off before first light, found a German airfield, shot it up, and then did the same to another, causing havoc among the lines of German fighters starting up. He then outflew and shot down the Albatross D-IIIs sent up to get him. When he returned to his base at 60 Squadron, the bullet-scarred Nieuport and his word were all that his commanding officer needed to recommend him for the Victoria Cross.

The film implied that Bishop could not have done any of this because the Nieuport did not have the endurance to do so. Worse, it implied that the bullet holes on his fighter must have been self-inflicted — that he had landed, shot up his aircraft himself (the Lewis gun was missing from the wing rail after the raid), and then flown home with the preposterous story. It was even more damning that neither the Germans nor Allies had witnessed any of the events and that there were no enemy squadrons in the area he had been in.

Disregarding that lack of corroborative evidence, from the aeronautical point of view was it all possible? The mission required the Nieuport to fly for one hour, forty-three minutes, which was just within its level of endurance of two and a half hours. In later years, an author claimed that Bishop had admitted to him he had become so disoriented after the raid that he had landed at a farmhouse to ask directions. But putting a Nieuport down away from an airfield was a rash idea: the aircraft had no wheel brakes or self-starter. The obliging farmer would have had to have been prepared to run out to meet Bishop, halt the aircraft, and then get it going again by swinging the propeller, skills that were hardly widespread among the rural community

Nieuport 17

in 1917. But Bishop didn't need a helpful farmer at all. He had done this before — on his first kill when he had landed, cleaned the plugs with his toothbrush, and taken off again, once more without witnesses. As for shooting it up himself, the Nieuport was a fragile aircraft at best, and intentionally riddling it with bullets was self-destructive. The aircraft's structural problems did not need a fusillade of bullets to make themselves known. Military authors also note that a Nieuport 17 could never have outrun an Albatross D-III. Finally, what had happened to Bishop's Lewis gun? Had he left it at the farmhouse? Bishop's son Arthur Bishop wrote that his father had thrown it overboard because it had jammed and become a dead weight.

Whatever took place that early morning, whatever controversy surrounds Billy Bishop, at least the Nieuport 17's qualities are unquestionable. Descended from Gustav Delage's *Bébé*, it was a nimble little fighter that almost ninety decades later still speaks of speed and manoeuvrability.

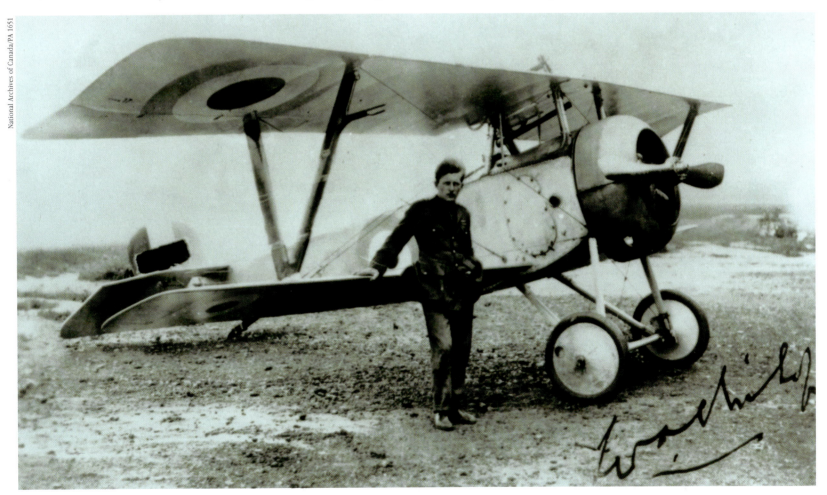

Captain William A. Bishop, V.C., Royal Flying Corps.

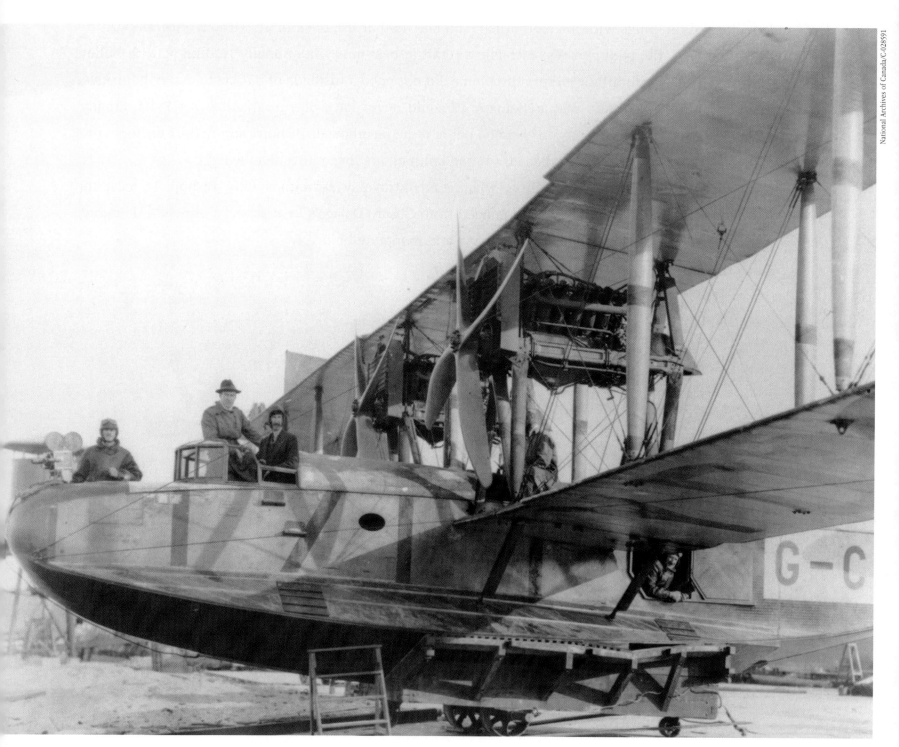
Felixstowe F-3 flying boat G-CYDI of the Air Board, Jericho Beach, British Columbia, circa 1921.

Felixstowe F-3/F-5

The F-3 was made in Britain but was flown extensively in Canada. The F-5 was made in Canada but was never flown by Canadians. Versions of the famous Felixstowe flying boat, both models played their part in the development of Canada and both originated from a competition held in 1913 to fly the Atlantic Ocean. Man had not been flying for even a decade when American aircraft manufacturer Glenn Curtiss and former Royal Navy officer John Cyril Porte planned to cross the Atlantic. British newspaper owner Lord Northcliffe had offered a prize of $50,000 for the first team to do so, and the unlikely pair came together to build a large, twin-engined flying boat.

Christened *America*, it was being tested for its transatlantic flight through the summer of 1914 when the First World War broke out. With the United States neutral, the U.S. Navy had little interest in it. But the British did, and Curtiss was fortunate that Porte was made squadron commander of the naval air station at Felixstowe on the North Sea. His enthusiasm, combined with the growing German submarine and Zeppelin threat, convinced the Royal Navy to buy sixty Curtiss flying boats for coastal patrol. Porte adapted the *America*'s design to British standards, renaming it the F-1 Felixstowe after his base and following with the F-2, F-3, and F-4 models.

By the time the F-5 was launched in 1917 with its superb Rolls Royce Eagle engines and strengthened hull to deal with the North Sea, the British series had far outpaced the original Curtiss flying boats.

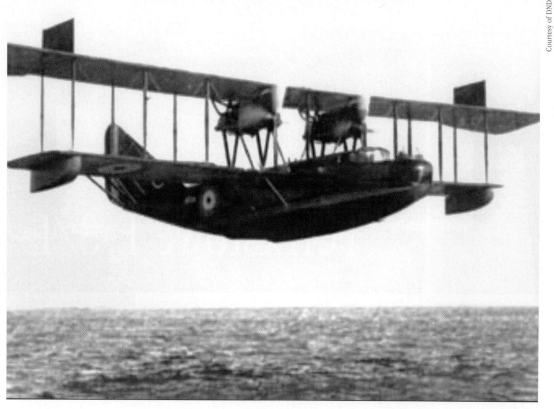

Felixstowe F-3 in flight.

The United States entered the war that year, and to protect American convoys leaving from the east coast, the U.S. Navy found itself urgently in need of flying boats. It attempted to build as many Felixstowes as it could, as soon as possible. The Naval Aircraft Factory in Philadelphia was contracted for 137 F-5s with American modifications, substituting Liberty engines for the Eagles and adding larger, strengthened tails and elevators. With what must have seemed to him supreme irony, Curtiss was also contracted to build sixty Felixstowes, and because of its experience with the Curtiss Canada series, Canadian Aeroplanes Limited of Toronto was asked to build thirty F-5s as well.

The Canadian company's experience in aircraft extended to building JN-4 trainers, and an aircraft as big and sophisticated as the F-5 was an ambitious undertaking. The Liberty engines and wireless equipment were shipped to Toronto for installation, but the sheer dimension and complexity of the craft must have been almost beyond the scope of the company. Yet so efficient was the operation that by August 1918, the first Canadian-built F-5 was delivered to Philadelphia. When production ended in January 1919, the final Canadian F-5 would be the last large aircraft built in Toronto until the Second World War.

Post-war, part of the Imperial Gift to Canada were eleven Felixstowe F-3 flying boats. They were sent out to air stations in British Columbia (Jericho Beach, Vancouver) and Manitoba (Victoria Beach Air Station, Winnipeg). Rarely flown, as they were too large for bush flying, the F-3s were too complicated to maintain

in such surroundings. However, a single aircraft did have its moment of glory when it was used in the first trans-Canada flight. To publicize the feasibility of transcontinental airmail, the Canadian Air Force and the Air Board planned to fly a token bag of mail from Halifax to Vancouver in relays, using different aircraft and pilots. Seaplanes would be used on the Halifax-Winnipeg leg and landplanes on the Winnipeg-Vancouver part. The flight began on October 7, 1920, with a Fairey III seaplane from Halifax to Rivière du Loup, then an HS-2L to Ottawa. From there an F-3 was to fly the better part of the route. It would carry the bag from Ottawa to Pembroke to Mattawa to North Bay to Sault Ste. Marie, across Lake Superior to Port Arthur, and finally to Kenora. Its crew were the director of flying operations for the Air Board, Wing Commander Robert Leckie, and his co-pilot, Basil Hobbes; they took off from Ottawa in the F-3 on October 8. They passed the mail on at Selkirk, Manitoba, on October 10 (by road) to Captain C.W. Cudamore, who was waiting in a DH 9A. The F-3 had flown the 4,124 miles at an average speed of 59 miles per hour without serious incident. The historic first flight across Canada was completed on October 17 at Lulu Island, Vancouver.

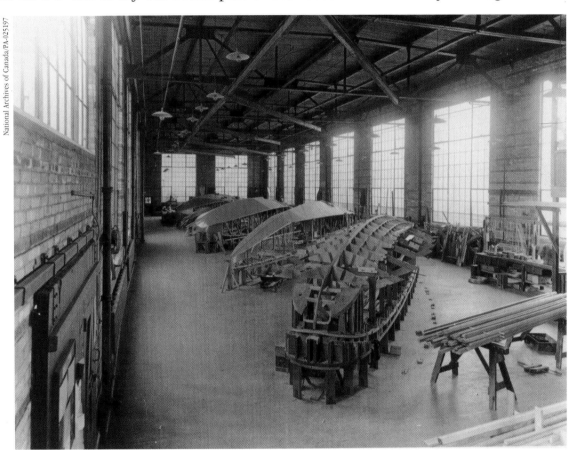

F-5 flying boat hulls under construction. Canadian Aeroplanes Limited, Toronto, Ontario, 1918.

The F-3 Felixstowes remained in use with the CAF until replaced by Canadian-built Vickers aircraft. The Canadian-built F-5s served in the U.S. Navy on both coasts and in Hawaii until 1926.

ON CANADIAN WINGS | A CENTURY OF FLIGHT

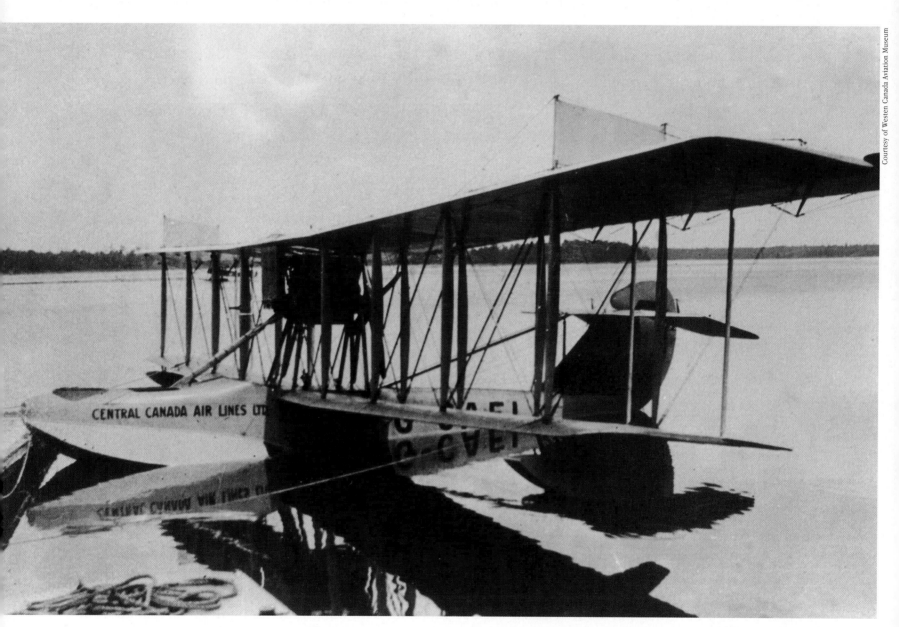

This Curtiss HS-2L was the first Western Canada Airways aircraft.

HS-2L Flying Boat

Golden wings forged in need
In trying times, lands uncharted
A brave band as with a steed
Guided you through and so parted
The very North.*

The modes of transportation that changed Canada were the birch bark canoe, the steam engine, and, improbably, an American flying boat built to hunt for German submarines. That its cumbersome wingspan and nautically shaped bow earned the Curtiss HS-2L the nickname "Pregnant Pelican" was no surprise. Easily waterlogged, requiring a mile to take off, unable to be fitted with skis or wheels, and with a wingspan of seventy-four feet — the HS-2L's defects made it completely unsuited to be a bush plane. Yet at a time when there were no airports or aircraft designed specifically for bush operations, this former submarine hunter was Canada's very first aircraft of the bush.

* W. Gourlay. "Your Forests," Ministry of Natural Resources, Toronto, 1974.

For such a historic aircraft, the HS-2L's appearance in Canada was anti-climactic. On August 17, 1918, the first arrived in a crate at Halifax to be shipped across the harbour to the United States Naval Air Station at Baker's Point. From there, the first HS-2L would take off on August 25 to protect the troop convoys bound for Europe; this date is taken as the birth of maritime aviation in Canada. When the war ended that November, the U.S. Navy returned home, leaving their HS-2L flying boats behind. For Canada, it was an American version of the Imperial Gift. And none too soon.

In 1919, the Air Board loaned two of the former American naval HS-2Ls to a group of Quebec pulp and paper companies in the St. Maurice River Valley to patrol their forest reserves. A former Royal Naval Air Service pilot, Stuart Graham, was hired to get them to the intended base at Lac-à-la-Tortue. Graham tested the boats on June 2, and three days later, with his wife as navigator and Bill Kahre as air engineer, he took off from Halifax in G-CAAC. Their flight of 645 miles took ten hours flying time over three days. But in doing so, Graham introduced bush flying to Canada — indeed, to the world. The aircraft must have been put to use immediately, for on July 7, Graham reported a forest fire, the first time one had ever been detected from the air.

The province of Quebec wasn't alone in the use of HS-2L flying boats for forest fire detection. In Ontario, forest firefighting was also in its infancy, for the only means to find and suppress one was by canoe. In 1922, one memorable fire destroyed 2,120,148 acres of forest at Haileybury, Ontario, before it could be brought under control. In a province dotted with lakes, the use of seaplanes to detect and fight fires was logical, and in 1924, the Ontario provincial government allocated funds to start an Air Service. Roy Maxwell was lured away from Laurentide Air Services to become the first director of the Ontario Provincial Air Services (OPAS), and three HS-2Ls were leased to operate from a central base at Sault Ste. Marie.

The H-boats, as they were called, were said by their crews to be "the cussedest contraption of wire and canvas that ever defied gravity. It was cranky to fly and brutal to service." Yet they were very delicate, and one sank in Toronto harbour, holed by a floating whisky bottle. In his book *The Firebirds*, Bruce West observed, "Officially, the H-boats were listed as having a top speed of 91 miles an hour … But many H-boat pilots swore they had but one speed — 60 miles an hour. They maintained that they took off at 60 miles an hour, cruised at 60 miles an hour, and landed at 60 miles an hour." In that first year, they flew 167,000 miles and completed 866 patrols. They also had thirty-three forced landings, but in 1925, thirteen more of the planes were purchased by the OPAS. As late as 1932, four of those would remain in service.

The men who flew and observed from the H-boats were equally offbeat. "They were a colourful group both in wardrobe and behaviour, although none could match the director [Roy Maxwell] himself with his shiny leather

HS-2L Flying Boat

jackets, pressed breeches, gleaming boots, 16 cylinder Cadillac and grand plans," West wrote. Once a fire was discovered, the news had to be communicated to the ground, and at first Maxwell toyed with the idea of the pilots using carrier pigeons for this purpose. But because so many of the crew had served in the Army Signals Corps, they were familiar with radio, and in 1924 the first successful air-to-ground radio report of a fire took place. Doc Oakes, Romeo Vachon, Pat Reid, George Phillips, Frank MacDougall, and Fred Stevenson were some of the OPAS pilots to be awarded the McKee Trophy. Duke Schiller, Al Cheeseman, Tommy Siers, and Terry Tully found fame in other sectors of aviation, and C.M. "Black Mike" McEwen, who had been an ace fighter pilot, would later command 6 Group in the RCAF. Bruce West thought that the reason for the high incidence of former OPAS men in Canadian aviation history was "the simple fact that the pilots and engineers were a mighty tough, ingenious and wilderness-hardened lot, who had won their hawk's spurs on the eccentric H-boats."

The HS-2Ls were the workhorses of the Air Board and Canadian Air Force in the early 1920s. The five based at Jericho Beach Station in Vancouver had been bought from United States naval stocks. With all the wood planking and struts used, the crew called them "flying cigar boxes" or "flying forests." Yet they were effective in combatting narcotic smuggling by intercepting packages dropped from liners to waiting speedboats in the Juan De Fuca Strait. Using the new Fairchild and Eastman aerial cameras, the HS-2L crews photographed Vancouver harbour in mosaic. The HS-2Ls were also used on fisheries patrols on the British Columbia coast. They could cruise at six thousand feet and swoop down and catch the owners of seine net boats that ignored the "No Fishing" signs.

In 1923, the Canadian Air Force chose the locally made Vickers Viking IV to replace its HS-2Ls. Not only was it sturdier, the Viking had an additional camera position in the nose for aerial photography. Four years later, the OPAS replaced their HS-2Ls with de Havilland 60X Moths that could be fitted with pontoons, skis, and wheels.

Inevitably, the ex-naval/firefighting HS-2Ls found their way into the commercial market. In 1925, former Royal Flying Corps ace Donald MacLaren, now owner of Pacific Airways Ltd., bought one in Baltimore that had been in storage for years. The Air Board and Canadian Air Force were withdrawing from fishery patrols, and MacLaren got the contract. He had the HS-2L assembled at Jericho Beach and continued with the patrols. Another ex-RFC pilot, Jack Clarke, began Central Canada Airlines with an HS-2L to ferry supplies and men from Minaki Lake, Ontario, to the gold mines at Red Lake. It was Clarke's flying boat that vacationing grain millionaire James Richardson saw and bought on August 27, 1926. That HS-2L began Richardson's own Western Canada Airways, and thus all the airlines that followed from it: Canadian Airways, Canadian Pacific Airlines, and finally Canadian Airlines.

On April 5, 1974, fifty years after the first HS-2L had patrolled Ontario's forests, a cairn was dedicated at Sault Ste. Marie on the site of the former OPAS Central Base. It said, "These airplanes and adventurous band of pilots, air engineers and observers who flew them on fire patrols, photography, mapping and on mercy flights, played a vital role in Canada's colorful bushflying era."

Through the efforts of R.W. Bradford, the former director and curator, the HS-2L that Stuart Graham flew as the world's first bush plane can be admired today, albeit in reconstructed form, at the National Aviation Museum in Ottawa. In 1994, the Royal Canadian Mint also commemorated the flying boat and pilot when it created a coin depicting an HS-2L and a cameo in gold of Stuart Graham. Norsemen, Beavers, and Otters may have been more suited to the bush, but none would attain the special niche in Canadian history that this former submarine patrol aircraft had.

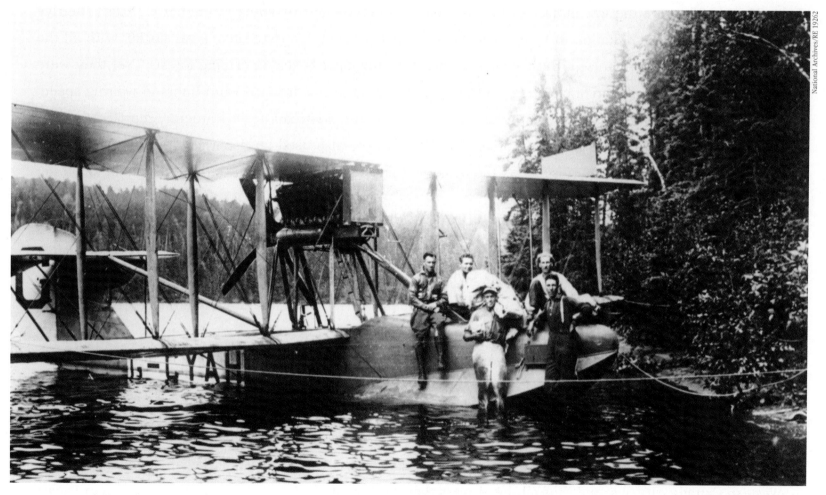

Ontario Provincial Air Service Curtiss HS-2L with Forestry crew.

Vickers Viking

In 1922, the Canadian Air Force and the Air Board were looking to purchase aircraft. By now, overused and unsuited to the Canadian climate, the Imperial Gift Felixstowes were decomposing. Although there were no aircraft manufacturing facilities in Canada, the federal government stressed that any aircraft purchased would have to be made locally, "as wood used by British manufacturers was unsuitable." There was also some urgency to the acquisition, as the flying boats would soon be needed for summer forestry patrols.

With the CAF's strong British ties, the choice fell to two British aircraft: the Supermarine Amphibian and the Vickers Viking IV. Neither was satisfactory: Supermarine would build its aircraft only in Britain, and the Vickers Viking had an unsavoury reputation. On December 18, 1919, Sir John Alcock, who that summer had conquered the Atlantic, was killed flying a Vickers Viking at the Paris Air Show. But if chosen, Vickers promised to use its Montreal shipbuilding facility to build the aircraft, and on the basis of this, the RCAF awarded it the contract for eight Vikings. But typically, there was a proviso. Wanting to appear parsimonious, Ottawa stipulated that instead of the 450-horsepower Napier Lion engine that the Viking was designed for, Vickers had to make use of all the Rolls Royce Eagle engines that Canada had. Part of the Imperial Gift, the

Eagles were smaller than the Napier Lions and, at 360 horsepower, less powerful — but they were free. The choice would hamper the Viking throughout its operational life.

Canadian-built Vickers Viking IV.

The Viking IV was all wood: American elm was used in the main longitudinal parts of the hull, the transverse frames were spruce, and the planking was two-ply mahogany. The wing and tail surfaces were wood, and while the engine was supported by tubular steel, the interplane struts were wood. The first two Vikings were built in Britain and were shipped to Canada to have their Eagle engines installed. The aircraft also came with detachable amphibian gear: two giant wheels and a steerable tail wheel strut that allowed it to be used on land. Never used, as there were no airports, it was handy to beach the Vikings with after every flight. Skis were built for the aircraft but were also never used. On July 25, 1923, Mrs. G.J. Desbarats, wife of the Minister of National Defence, launched the first Canadian-built Viking, G-CYEU. As soon as they were ready the Vikings were sent off to RCAF bases in Manitoba for survey roles.

Resplendent in its polished mahogany planking and gleaming rivets, the Viking resembled a cigar box with wings. Because of the wood, it had to be beached after every flight and polished with cedar oil. The pilot had to choose where he landed with care, for with the underpowered Eagle, taking off required a run too long for most lakes. The three-seater housed its crew in open cockpits with a camera position in the nose. The whole exercise of taking off was laborious and dangerous, as one of the crew had to climb out from the back, clamber to the front, and stand with the photographer in the nose to change the centre of gravity and get the aircraft up on the step. Because of the camera's weight, it took an hour to get to five thousand feet. The Viking was also nose-heavy, and taxiing in rough water was difficult enough without worrying about the cockpit filling up

Vickers Viking

with water. To improve performance, early in 1925, a Viking was brought to Ottawa and its Eagle replaced with a Liberty engine. When it crashed on August 2, 1925, the experiment was never repeated.

With the Viking, the departments of National Defence and the Interior began an extensive program of aerial photography. The land mass of Canada had never been fully mapped, and with the Viking and the new aerial cameras this was now feasible. In the summer of 1924, a Viking was used on an extensive mapping flight in the Reindeer Lake–Churchill River district. The crew (pilot Squadron Leader Hobbs, camera operator Flight Officer D.J.R. Cairns, and engineer Corporal J.A. Milne) never got above four thousand feet because the heavily laden Viking could climb no higher. Hobbs removed the wheels and tail skid to increase his height, to no avail. But despite engines failures and poor weather, they took seventeen thousand photos in a month.

The next summer, the RCAF personnel at Norway House, Manitoba, operated a Viking for a variety of duties: spotting forest fires, making flights for the Department of Agriculture, flying Indian Affairs agents to distribute treaty money, and conducting emergency medical flights and survey missions.

Given the aged Eagle engines, the wooden cigar box structure, and the heavy use, the casualty rate of Vikings was high, and by 1932, none were in use. The single Vickers Viking in existence today is at the Alberta Aviation Museum in Edmonton. On long-term loan from the Lancaster Museum at Nanton, it is a seven-eighths replica with a Napier Lion engine and was used in the 1991 movie *Map of the Human Heart*.

Crew of Vickers Viking IV flying boat G-CYET of the RCAF.

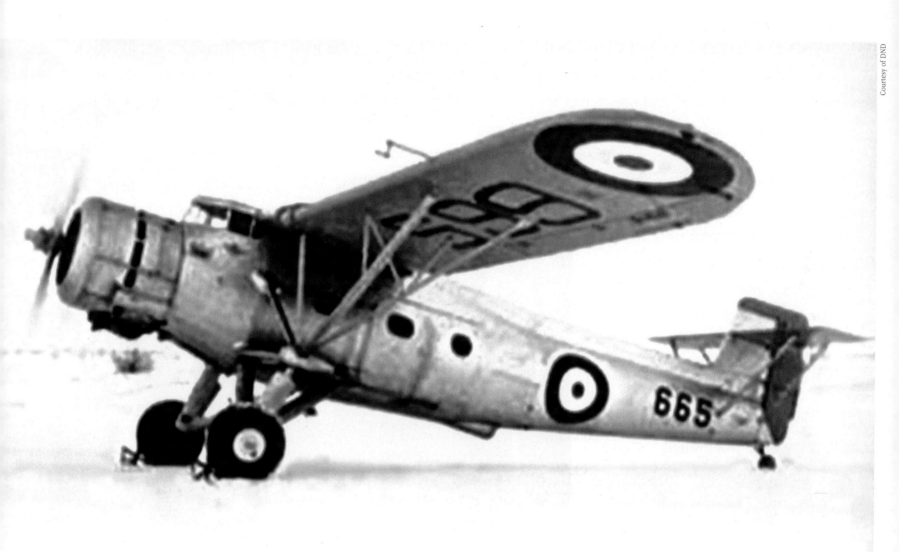

Fairchild Super 71P bought by RCAF for photographic survey.

Fairchild Super 71P

Sherman Fairchild's aircraft did well in Canada. Although designed for the American market, his Fairchild Commercial, or FC-2, the seven-seat FC-2W2, and the Model 71 had all sold well, popular with the bush companies and the RCAF alike. Encouraged by this, the company brought out a Super 71 — an aircraft configured specifically for Canadian conditions. But it was 1933, and this time, fate conspired against the manufacturer.

The first impression of the Super 71 was that of a shiny metal tube. The second was how suitable it would be for bush flying. The monocoque fuselage was duralumin — the first to be so constructed in Canada. The large door on the left side opened to a cabin thirteen feet in length and five feet wide, and the tail was set high to clear the spray in takeoff from water. But the most unique feature was the location of its open cockpit, which was set far behind the wings to the rear of the aircraft. The prototype made its first flight on October 31, 1934, and was taken over by Canadian Airways on a lease-purchase basis for use at its base in Oskelaneo, Quebec. Romeo Vachon, the district manager for Canadian Airways, and pilot James Harold Lymburner pronounced the 71 a good freighter — it even carried two live oxen on one flight. Lymburner said that having

the cockpit so far in the rear did not bother him. He must have been the exception. Other pilots did not agree, and bush company operators were apprehensive about repairing the duralumin skin in the woods. As a result, no one placed orders, and a single Super 71 was built.

But this did not stop the RCAF from ordering two examples of the Super 71P in 1935. Considering that the air force, like the whole federal government, was in an impecunious state, this is surprising. Historians reason that (not for the last time) Ottawa wanted to keep a local aircraft manufacturer in business, regardless of the viability of the product. The Super 71P was also of duralumin but now in a more conventional design: the cockpit was enclosed and in front of the wing, and the wings themselves faired in a hump on top of the fuselage.

The RCAF bought two examples, #665 CF-AUJ and #666 CF-AUT, for use in photographic survey. As a result, installations for cameras and radios increased the weight of an already heavy aircraft. Both 71Ps were tested on floats and delivered to the RCAF in August and November 1936. But whether on floats, wheels, or in the air, they were disliked by pilots. When on August 6, 1937, CF-AUT crashed at Morrison Lake, Manitoba, it was thought that moving the cockpit forward and fairing in the wing had caused an airflow and elevator problem at high angles of attack. After this, Fairchild returned to making a more traditional bush plane, the 82.

The remaining 71P, CF-AUJ, was assigned to "hack" duties at Camp Borden and later Trenton, where it was to be an air ambulance. Rarely flown at either location, it was struck off strength in August 1940.

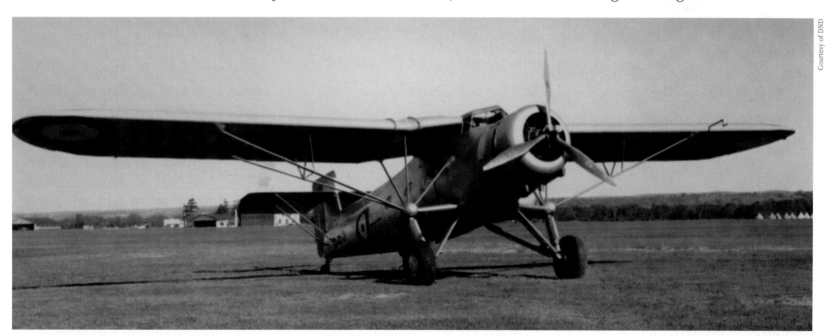

Fairchild Super 71P.

Fairchild 82

I'm an ordinary pilot, of
A Fairchild Eighty-Two,
But there are no limits to the things that I can do.

A Pilot's Soliloquy, Charles R. Robinson.

With the Fairchild Super 71 a commercial failure, the company returned to what it knew best — building conventional aircraft for the bush flying market. The Depression had forced the cancellation of airmail contracts and the reduction of the RCAF, but there was always freight to be flown, especially to and from the mining communities. The price of precious metal had caused the Golden Age of air freighting in the bush; during the 1930s more freight was moved by air in Canada than in the rest of the world combined.

Fairchild was fortunate that in February 1931, Francis Percival Beadle had joined as chief engineer. He was able to adapt quickly to the current market and build a utilitarian, affordable bush plane that allowed Fairchild to survive the Depression until it received the Bristol Bolingbroke contract from Ottawa in 1939.

After Beadle left to join National Steel Car Corp., Fairchild was never to be so successful with bush planes again, and after the failure of its Husky F-11 in 1946, it went out of business.

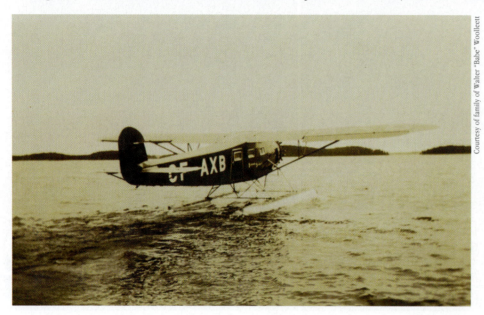
Woollett's Fairchild 82 CF-AXB.

Beadle took the wings from the 71C model and attached them to a swollen, roomy fuselage. The resulting aircraft, called the Model 82, could now be loaded with freight or up to nine passengers, all on detachable bench seats along the sides of the cabin. Wide doors allowed for the loading of bulky items. The 82 was designed to be used by a number of power plants in both A and B models, the B having an enlarged fin and rudder. With a cruising speed of 128 miles per hour and a range of 657 miles, the 82 was a "flying truck" that presaged the Noorduyn Norseman. The prototype CF-AXA was put on floats and flown by Alexander S. Schneider on July 6, 1935, and four years later, twenty-four aircraft had been built at Longueuil. The 82 was affordable and popular with small Canadian bush companies like Wings Ltd., Dominion Airways, Starratt Airways, and Arrow Airways; when all were taken over by Canadian Pacific Air Lines (CPAL), there were seven 82s in service. Although exported to Mexico, Venezuela, and Argentina, the aircraft was never ordered by the armed forces of either the United States or Canada.

Dominion Skyways owed its start in 1931 to the construction king of Canada,

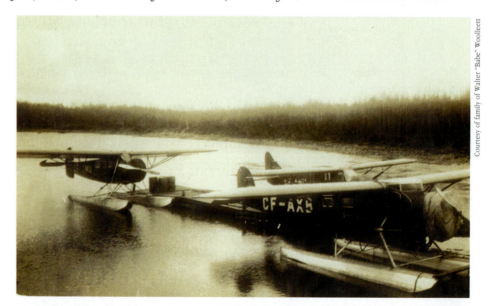
Dominion Skyway's Fairchild 82 CF-AXB at Senneterre, Quebec.

Fairchild 82

Harry F. McLean. Known to be unorthodox — he is remembered by the management of the Ritz Carlton hotel in Montreal for throwing thousands of dollar bills out his window, causing a riot on Sherbrooke Street — McLean sold his private aircraft for one dollar to his pilot, Peter Troup. Troup rented or bought more aircraft and, from a base at Lake Osisko, Ontario, serviced the mines at Val d'Or and Timmins. In 1934, he hired bush pilot/author Walter "Babe" Wollett to set up at Senneterre, Quebec, where Canadian Airways had the monopoly supplying local mining towns. Woollett flew the Fairchild 82 CF-AXB, "shuttling back and forth," in his words, "with equipment, food supplies, booze and people of every description, including members of the oldest profession."

Of the many hair-raising escapades that Woollett had in the 82, the most memorable was the day he had CF-AXB (with the wings folded) towed by horses down Senneterre's main street. Called to pick up a critically ill person, he discovered that the lake ice hadn't yet formed sufficiently to take his ski-equipped Fairchild. Once on the town's Rue Principale he had the street cleared of traffic, the wings locked into flying position, and then took off. The story might have gone down as one of Woollett's tall tales had not a reporter from the *Montreal Gazette* been staying at the Mont Laurier Hotel on main street and witnessed CF-AXB roaring past. He watched it gain height and miss the CNR station by inches. He wrote, "Some air show! The pilot Babe Woollett and plucky air engineer Joe Lucas were responding to an SOS ... the ice was not strong enough to put their plane on the river they normally operated from so as is the way of most bush pilots, Woollett and Lucas just improvised a bit and used the main road." The injured man was picked up in time and flown to hospital, but the article came to the attention of the unimaginative bureaucrats at the Department of Transport. With the press interest, they didn't dare revoke Babe's licence for dangerous flying, but when the investigation uncovered the fact that his medical examination was two weeks overdue, they were able to suspend him for that.

Soon after, Woollett succeeded in "pranging" (his word) CF-AXB into the ice, but the Fairchild was repaired and remained in use with Canadian Pacific Air Lines into the war years. Woollett was also destined for greater things, as he went on to organize much of the British Commonwealth Air Training Plan (BCATP) during the Second World War, for which he was awarded the Order of the British Empire.

Another Fairchild 82, CF-AXL, was bought by Starratt Airways in March 1937 and also came to Canadian Pacific Air Lines. As late as 1965, it was still being flown by Alberta Fish Products of Edmonton. The employees of Canadian Pacific Air Lines, many of whom had trained on aircraft like it, purchased the 82 and reconditioned it at the CPAL Vancouver base. When it was donated to the National Aviation Museum in Ottawa, one of CPAL's veteran bush pilots, Bob Randall, offered to fly it across the country.

Wiser heads prevailed, and CF-AXL was put on a railcar and freighted to the museum, where it now resides. On November 26, 2003, "Babe" was inducted into the Quebec Air and Space Hall of Fame for his contribution to the development of aviation in that province. At the ceremony, was there the ghost of a Fairchild 82 roaring by with Woollett waving from its cockpit? The poet was right: there really were no limits to what that man and machine could do.

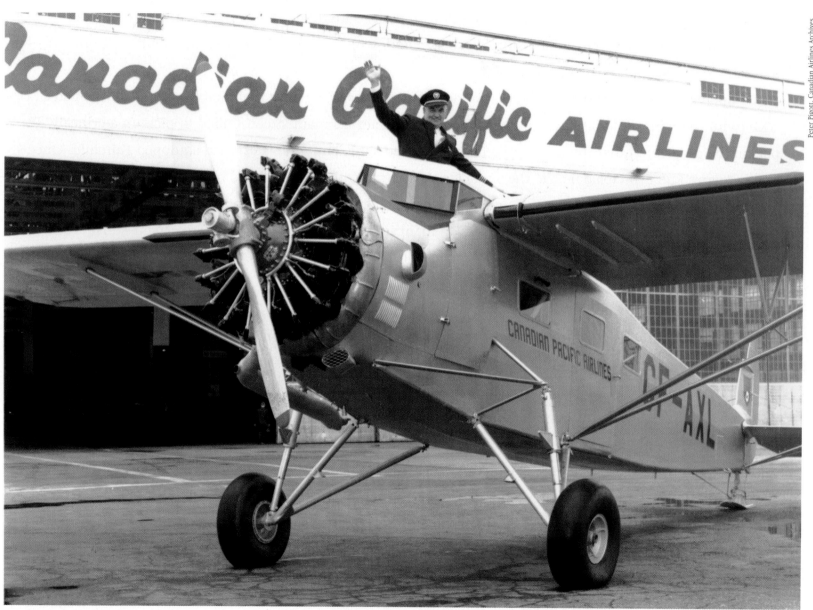

The surviving Fairchild 82 at Vancouver with veteran Bob Randall. Flown by Canadian Airway Ltd. Wings and Starratt Airways, it is now in the National Aviation Museum, Ottawa.

De Havilland 90 Dragonfly

The year 1935 saw the launch in Britain of two fast executive transports. Despite the Depression, both Bristol and De Havilland brought out aircraft that only the very rich could afford. But while Bristol's Type 142 became the Blenheim bomber, Geoffrey de Havilland's Dragonfly had limited appeal and fared better in Canada.

The Dragonfly might have resembled its predecessor, the DH 89 Rapide airliner, but actually owed its distinctive shape to the aircraft before. In 1934, De Havilland's Comet won the England to Australia race, and its shape (which foreshadowed the Mosquito six years later), elicited much attention in the media. Like the Comet, the Dragonfly had a smooth monocoque plywood fuselage that made the fabric-covered Rapide look outdated. The Dragonfly's stubby struts and wings and streamlined nacelles gave it a sporty look. Expensive to own, radio-equipped, with a landing light in its nose and a well-furnished cabin for four passengers, it was the Learjet of its day and affordable only by the very wealthy — and by the Royal Canadian Mounted Police.

De Havilland had long considered assembling their aircraft in Canada, especially their popular Gipsy Moths. In 1928, the company purchased Trethewey Farm, Weston, outside Toronto, the site of the first

aerial meet held in Ontario. Fred Trethewey's old vegetable warehouse was used to assemble the first Gipsy Moths. It was unsuitable, but it did have double doors and its own railway siding. This last was important, as the crates of unassembled Moths could be shipped from Britain and taken directly by train to the warehouse. In 1929, De Havilland bought enough local lumber to build its own fifty-by-fifty-foot hangar (later taken to Downsview). In it they assembled such historic aircraft as the DH 61 Giant Moth, the DH 84 Dragon, the DH 89A Dragon Rapide, and the DH 90 Dragonfly.

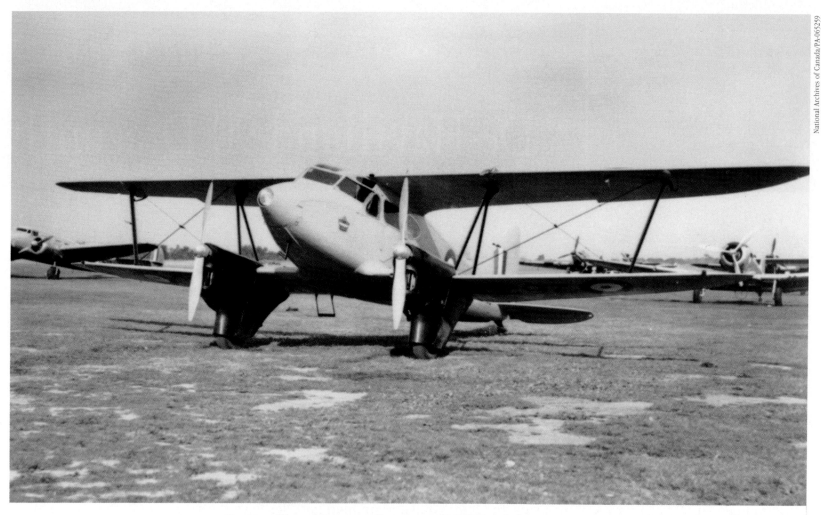

De Havilland Dragonfly aircraft 7623 of the RCA., Trenton, Ontario, October, 1940.

If there were no individual Canadians wealthy enough to afford the Dragonfly, its modernity and speed attracted an organization that needed both. Because of Prohibition in the United States, rum-running in the Maritime provinces had become a growth industry. In British Columbia the problem was drug smuggling.

De Havilland 90 Dragonfly

At first the RCAF had intercepted the speedboats used by smugglers. But when the air force withdrew from these duties, the Royal Canadian Mounted Police (RCMP) took them over. The RCMP was fortunate that its commissioner then was the aviation-minded Major General Sir James MacBrien. A former general manager for Canadian Airways and president of the Canadian Flying Clubs association and the Aviation League, MacBrien flew about extensively in his own DH 60 Moth. If the anti-smuggling patrols went unnoticed by the public, the manhunt in 1932 for the "Mad Trapper of Rat River" did not; it dramatically emphasized the Mounties' need for their own air arm. In 1937, MacBrien ordered four Dragonflies for the first RCMP air division. The first, CF-MPA, was delivered May 5, followed by MPB on May 29, MPC on July 15, and MPD on June 26. Each was named after a flower taken from the last letter in its registration — Anemone, Buttercup, Crocus, and Dandelion.

Royal Canadian Mounted Police aviation section with De Havilland 90 aircraft (CF-MPA, CF-MPB, CF-MPC, CF-MPD).

Eventually, a total of eight Dragonflies were assembled by De Havilland at Downsview; when war came, the RCAF took over six of them for pilot training. Canadian Pacific Airlines inherited two from its bush airline purchases and bought one from the RCAF in 1943. By 1949, Dragonflies were no longer is commercial or military use anywhere in Canada.

De Havilland 90 in military garb.

ON CANADIAN WINGS | A Century of Flight

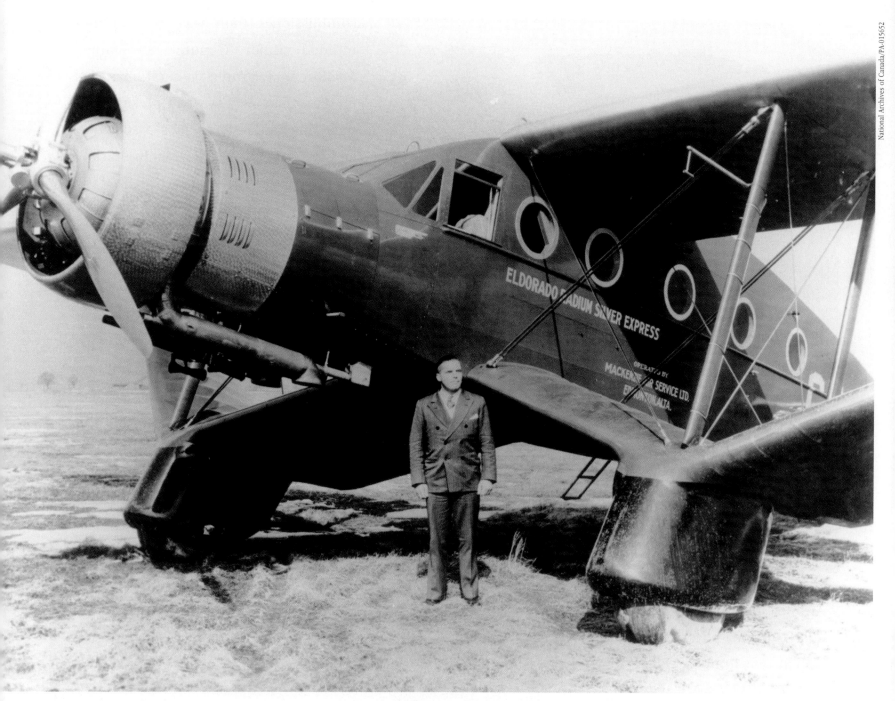

Leigh Brintnell, President, with Bellanca 66-70 Aircruiser CF-AWR of Mackenzie Air Service Ltd., Edmonton, Alberta, 1935.

Bellanca Aircruiser

The "Flying W," the "Airbus," and the "Big Bellanca" — whatever the name, it deserved better from fate. Designed as a high-density commuter aircraft to operate between urban centres, the Bellanca Aircruiser was treated unkindly by history and, condemned, lived out its days as a pickup truck in the Canadian bush.

Giuseppe Mario Bellanca arrived in the United States at the turn of the century with a degree in engineering and a desire to build airplanes. He flew his first creation in Brooklyn in 1911 and through the decades built a variety of commercial and military aircraft, racers, and seaplanes. But unlike the Lockheed brothers or Donald Douglas, Bellanca never made it into the major leagues. In 1924, Bellanca merged with another fading aviation star, the Wright Aeronautical Company, to form Columbia Aircraft. The company missed out on fame and fortune when the then unknown Charles Lindbergh chose a Bellanca Columbia for his historic flight but they refused to meet his price, causing him to go to Ryan instead. Erroll Boyd, the first Canadian to fly the Atlantic, would use a Bellanca to do so. In 1929, Bellanca Aircraft of Canada opened to make aircraft for the bush, but with the Depression the factory was never built. The RCAF did

buy American-built Bellanca CH-300 Pacemakers, and later Canadian Vickers in Montreal was contracted to build six more under licence.

Giuseppe Bellanca began work on the Aircruiser in 1934. It was a large, single-engined aircraft that could carry up to fifteen passengers. Historians have puzzled over why he chose this design, as the year before, after the death of football coach Knute Rockne in an air crash, Washington had forbidden airlines in the United States to operate single-engined aircraft. A unique design, the Aircruiser was a sesquiplane in which the aerofoil-shaped stubby wings and outer struts gave an additional 30 percent lift. This, with a powerful Wright Cyclone engine, allowed it to lift into the air more than its own weight. Bellanca numbered his aircraft by their specifications — the first number was wing area and the second was the horsepower. The Aircruiser was the 66-70, 66-76, or 66-85 depending on its Wright Cyclone engine of 715 horsepower, 760 horsepower, or 850 horsepower. The Aircruiser was certified on March 16, 1935, but strangely shaped and single-engined, it was unrecognized by the American public. However, it found its niche in Canada, where a mining boom was taking place and its lifting capacity and short takeoff ability made it much in demand.

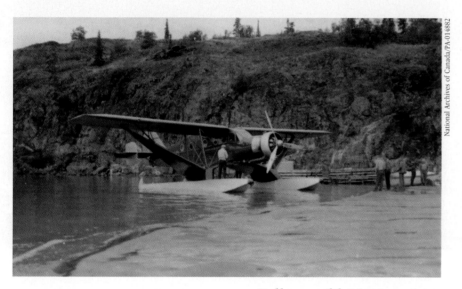

Bellanca 66-70 Aircruiser.

The most famous of all the Bellancas flown in Canada was CF-AWR. When W. Leigh Brintnell left Canadian Airways in 1931 to form his own air company, MacKenzie Air Services, he also acquired the manufacturing rights to build Bellancas. Brintnell bought two Aircruisers, CF-AWR and CF-BTW, to carry uranium concentrate from the Eldorado Mine at Port Radium, Northwest Territories, to Edmonton, Alberta, and dubbed them the "Eldorado Radium Express." After the Canadian Airways Junkers CF-ARM, they were the largest aircraft in Canada and were nicknamed the "Big Bellancas." In 1947, CF-BTW was sold to Central Northern Airways and disappeared from view. CF-AWR crashed in northern Ontario that same year and was abandoned until 1974, when the Western Canada Aviation Museum in Winnipeg recovered it.

Barkley-Grow T8P-1

"I froze my toes in Barkley-Grows ..." went the old bush pilot poem, an unfair criticism of a good aircraft. Although only eleven were built before the company went out of business, the significance of the Barkley-Grow in Canadian aviation is irrefutable. It was the transitional aircraft that took the bush airlines from floats in the summer and skis in the winter to wheels throughout the year.

Archibald Barkley came from an old North Carolina family and used to help the Wright brothers with their gliders at Kittyhawk, North Carolina. In 1931, he patented his own unique multi-spar, stressed skin, ribless wing design and built his first aircraft. It was destroyed by fire on the first flight, but four years later, when he and Harold B. Grow set out to manufacture airliners in Detroit, Barkley made his wing a feature of the aircraft. The Barkley-Grow T8P-1 was a muscular eight-passenger airliner powered by two 450-horsepower Pratt &Whitney Wasp Junior engines. When it flew in April 1937, observers compared it favourably with the Lockheed 12 or Beech 18, except that it had a triple tail and a fixed undercarriage, which, although elegantly spatted, made it something of an anomaly even then.

Building a good aircraft like the T8P-1 was one thing, but marketing it was another, and in the United States, without a distribution network, the company faced stiff opposition from Boeing, Douglas, and Lockheed. To what must have been their great relief, Montreal railway builders Canadian Car & Foundry asked them for worldwide distribution rights (with the exception of the United States) for the aircraft. Having made a fortune on rolling stock, Canadian Car wanted to break into aviation, either by selling other companies' planes or by building its own aircraft. Its directors knew that the recently elected Mackenzie King government was about to acquire fleets of aircraft for Trans Canada Airlines (TCA), the Department of Transport, and possibly the RCAF. There were also rumours that the Canadian Pacific Railway was considering entering aviation as well. In May 1937, the Barkley-Grow prototype X18388 was sent to Montreal, registered as CF-BVE, and demonstrated to the RCAF and the Department of Transport. The RCAF bought one, but TCA and the DOT did not, preferring the Lockheed models. At CDN$75,000 each, the T8P-1 was more expensive than the Lockheed, and its non-retractable landing gear was a hindrance to sales. Soon Canadian Car found itself with three Barkley-Grows that no one wanted on either side of the border.

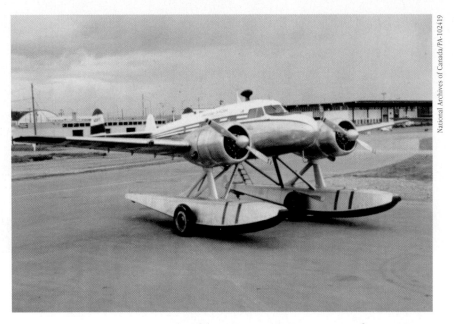

Barkley-Grow T8P-1 aircraft CF-BQM.

That was when the company's directors got a call from Grant McConachie. Although his United Air Transport (UAT) was flying on a combination of gas fumes and sheer audacity, the ever-optimistic McConachie reckoned that the Barkley-Grow was just the aircraft he needed. He wanted to move his bush air company into the world of all-metal, comfortable aircraft equipped with radio compasses. The radio-equipped, enclosed Barkley-Grows would allow his pilots to wear uniforms and operate on scheduled routes. When he expressed an interest in the aircraft, the directors at Canadian Car were so eager for a sale that they sent him at their own expense to Detroit to test-fly one. When he arrived at the Montreal head office, McConachie was full of praise for the aircraft and told the directors how appropriate it would be for his mail contracts. Its non-retractable landing gear was actually an asset, for there were few airports in British Columbia or the Yukon then, and the

Barkley-Grow T8P-1

little airliner could be fitted with wheels, floats, or skis. Knowing that a sale would publicize the aircraft, the directors lowered the price to $10,000 each. A born wheeler-dealer, McConachie knew that the railway coach builders were in a bind: no one wanted the aircraft. He would take them off their hands, he told the board, at a dollar each, and when the mail contracts came in, he would pay $1,000 monthly on each plane. It was better, he pointed out, than having the three aircraft sit idle in Montreal. The Canadian Car directors knew that they had no choice, and the Barkley-Grows were his. Years later, the UAT accountant recalled that Canadian Car never pressed for payment and completely forgot about the aircraft.

The three Barkley-Grows, CF-BLV, CF-BMG, and CF-BMW, served McConachie well. At a time when only Trans Canada Airlines operated twin-engined, all-metal airliners in Canada, he was able to move up the corporate ladder. He was awarded mail contracts, his crews wore uniforms, and the radio and direction-finding equipment allowed for safer flying. By 1939, passengers were served a box lunch and there were scheduled flights from Vancouver and Edmonton into the Yukon. By the time the war began, UAT was an "all wheels" airline, and its name was changed to Yukon Southern Air Transport (YSAT). All three aircraft survived the war years with CF-BLV scrapped at Peace River, Alberta, in 1960.

As for the prototype, CF-BVE, it was bought by Prairie Airways. The eleventh and final Barkley-Grow, CF-BTX, went to Mackenzie Air Services. When Canadian Pacific Airlines took over all of the bush companies in 1942-3, it took on six Barkley-Grows, some of which would be fitted with EDO floats and fly for Russ Baker well into the 1950s.

The aircraft did outlast its manufacturer, as Barkley-Grow was sold to Stinson in 1939, which itself was absorbed by Aviation Manufacturing Corp and Vultee the following year.

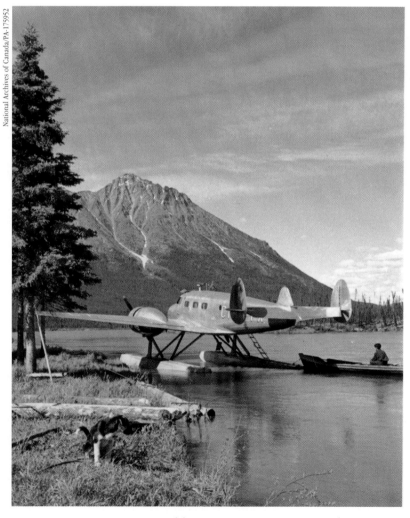

Barkley-Grow T8P-1 aircraft CF-BTX.

71

ON CANADIAN WINGS | A CENTURY OF FLIGHT

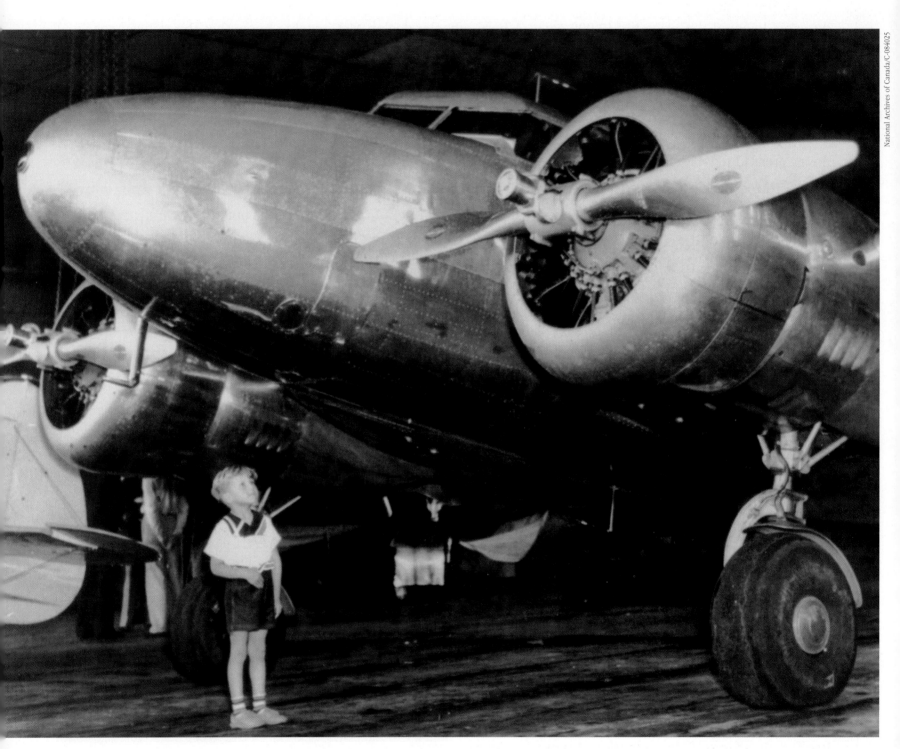

Boy viewing Lockheed 12 aircraft of the Department of Transport, circa 1937.

Lockheed 12A Electra

First flights across one's country are iconic, linked as they are with national identity. The "Dawn to Dusk" flight across Canada in 1937 is no exception. Until then, all airmail and passengers between Montreal and Vancouver went south of the border via the American air networks. Canada had been crossed by air before, but for the first time, to assert national sovereignty and fend off encroaching American interests, three middle-aged men in suits (not leather-coated, goggled, and gloved aviators) would travel in a Lockheed 12A from Montreal to Vancouver within the span of a single day.

Fifty-two years before, the Canadian Pacific Railway had brought the concept of Canada as a nation into reality. Now the Trans Canada Airway, a chain of airfields, radio, and navigation aids between Halifax and Vancouver, was about to reinforce this. In December 1936, the new Minister of Transport, C.D. Howe, had rashly promised that the Airway would be ready for commercial use by the next Dominion Day, July 1, 1937. When it wasn't — as many of the radio beacons were not calibrated — Howe demonstrated that he had the utmost confidence in the Airway by announcing that Canada could now be crossed by air between dawn and dusk, and that on July 30, he was going to prove it. It was pure grandstanding, but the challenge captured the attention of the country.

The year before, the United States Bureau of Air Commerce had had aircraft manufacturers submit designs for a small airliner that could feed passengers into the major airports. In response, Lockheed brought out the Model 12A Electra Junior, a six-passenger version of its Model 10 Lodestar. The Electra Junior was four feet, three inches smaller than the 10 but had the same shape — low set wings and a double fin. The prototype, registered as NX16052, flew on June 27, 1936, and its sales proved a disappointment. Too small for the airlines and too large for the corporate market, the 12 attracted only the foreign military, and its first customers were the Argentine Army and the Netherlands East Indies Air Force, both of which configured the aircraft as a bomber. The British government also bought three 12As, disguising them in British Airways livery and then secretly photographing Nazi Germany's military installations.

Easily the most famous Lockheed 12A of them all would be the one in the 1942 Warner Brothers movie *Casablanca*, before which the characters played by Humphrey Bogart and Ingrid Bergman say their goodbyes. Warner Brothers had borrowed an Electra from Lockheed for what would become the only outdoor shot in the movie — when Nazi Major Strasser lands at Casablanca (actually Van Nuys Airport, California). Because of the subsequent Japanese attack on Pearl Harbor, all later outdoor filming was cancelled, and the immortal farewell scene was thus shot on Stage 1 at the Warner Brothers studios, where mock-ups of the Air France 12A (made of plywood and balsa) were used with liberal amounts of fog. The original aircraft from the first scene is now part of the *Casablanca* set on the MGM tour at Walt Disney World in Orlando, Florida.

Clarence Decatur Howe was just starting his sensational career. A wealthy engineer and an inveterate air traveller, at the height of his power Howe used to say that all he really wanted to do was run a national airline. But in 1937, there were no suitably equipped aircraft to use for the flight. Born on April 10 of that year, his Trans Canada Airlines would not get its first aircraft until August. That left only the brand new CF-CCT, the Department of Transport's first aircraft, a Lockheed 12A Electra Junior. Howe proposed to fly from Montreal's St. Hubert Airport to Vancouver's Sea Island Airport, directly along the Airway, just as Trans Canada Airlines would soon do. For the flight, he personally chose his fellow passengers. They were Herbert Symington, KC, a barrister who was on the board of railway and power companies, and the DOT's Chief of Air Services, Lieutenant Commander C.P. Edwards. The crew was also hand-picked. They were Squadron Leader John Henry "Tuddy" Tudhope, co-pilot Jack Hunter, and engineer Lou Parmenter. A former Royal Flying Corps air ace, Tudhope had made the first air survey of the Rockies.

The whole experience was not without some drama. On July 30, weather reports showed that a band of thunderstorms extended over Quebec and Ontario. To see how high and far they extended, before Howe

arrived, Tudhope took the Electra up. Visibility to the west was so poor that he decided to cancel the flight and put the aircraft away. When Howe arrived at St. Hubert he told Tudhope to disregard the weather and to get the plane back out on the tarmac. Whatever the weather, he had too much riding on this trip and was going to go ahead with the flight. They took off into a thunderstorm and refuelled first at Gillies, Ontario, an emergency strip near North Bay. But because the Airway radio beacons had not been calibrated, they missed the next stop, Kapuskasing. Unable to fly "the beam," Tudhope kept trying to figure out on the map where they were while Edwards (who had trained in radio with Guglielmo Marconi himself) tried to reach the stations ahead to get a weather report. Through it all, legend has it that Howe sat placidly, reading his papers and enjoying the flight.

It was dead reckoning and sheer luck that got them through. The aircraft was almost out of fuel when they broke through the clouds and found themselves above Sioux Lookout, quite by chance. They refuelled, and then it was on to Winnipeg, where they met Philip Johnson, the American whom Howe had hired to set up TCA. Johnson was appalled that the three men most important to the future of aviation in Canada would risk their lives in such a venture. The next stops were Regina and Lethbridge, after which the little aircraft climbed over the Rockies at twelve thousand feet. CF-CCT landed at Sea Island Airport seventeen hours after leaving St. Hubert, in an actual flying time of fourteen hours and thirty minutes. Photographs show Howe disembarking from the Electra to greet the media, none the worse for wear.

Pilots in cockpit of the Lockheed 12 aircraft CF-CCT during the "dawn to dusk" transcontinental flight on July 30, 1937.

ON CANADIAN WINGS | A CENTURY OF FLIGHT

With the flight, he had dramatically proved that the Trans Canada Airway was functioning (more or less) and that with it a commercial airliner could now cross the country by day or night and within twenty-four hours. Perhaps as a reward for accompanying him on the flight, Howe appointed Edwards the Deputy Minister of Transport and Symington the second president of TCA. As for CF-CCT, it would serve the Department of Transport faithfully until 1963, when it was retired and presented to the National Aviation Museum in Ottawa.

Members of C.D. Howe's party and the Airway officials who saw them off, St. Hubert airport, Montreal, Friday, July 30, 1937. From left to right: D.W. Saunders; L. Parmenter, engineer; F.I. Banghart, airport manager; W.H. Hobbs, secretary, TCA and CNR; H.J. Symington, member of the board of directors, TCA and CNR; C.D. Howe; Squadron Leader J.H. Tudhope, chief pilot; Commander C.P. Edwards, chief of air service, Department of Transport; J.D. Hunter, co-pilot; J.A. Wilson, controller of civil aviation; George Wakeman, divisional inspector of air services; and D.R. MacLaren, TCA.

Fairey Swordfish

To the envy of the Germans and the Americans, the British possess a talent for "muddling through," for improvising in times of crisis. In the First World War, double-decker buses were plucked off the London streets to rush troops to the front, and in the Second World War, excursion steamers evacuated part of the British Expeditionary Force from Dunkirk. So it was with the Swordfish aircraft. Whether it was guts or stupidity, this time the British faced Axis battleships with an aircraft that resembled more a four-poster bed than a weapons delivery system.

The Swordfish's flaws were obvious: obsolescent design, open cockpits for the pilot and observer/telegrapher/gunner, and a lack of power — all deficiencies that would have rendered it a museum exhibit in other navies. Yet it sank more enemy tonnage than any other Allied aircraft in the Second World War and more than once changed the course of the war. Even its nickname was quaintly British: "Stringbag." It was explained to foreigners that this was what British housewives packed the groceries in. With the United States Navy then operating Grumman Avengers, no wonder the Americans were befuddled.

It didn't have speed, armament, or complexity of design, for the Swordfish was born in another time. In 1935, the Royal Navy put out specifications for a carrier-based "fleet spotter/torpedo bomber." To run

effectively, a torpedo had to be dropped at precisely sixty feet above the waves, and the Swordfish entered a steep dive to do so, hence the strong wings to support it. Its undercarriage had to be robust enough for it to land on a pitching carrier deck. The chances of a Swordfish encountering enemy fighters so far from land were minimal, so the single fixed Lewis gun of First World War vintage was enough. Torpedoes, bombs, mines, depth charges, or rockets, it had be able to carry everything — hence the name Stringbag. Finally, it should be as uncomplicated as an aircraft from the previous world war: its inertia starter, for example, was cranked manually, and its wings had to fold back easily (two simple latches secured them in place). In this way the aircraft could be depended upon, whatever the conditions.

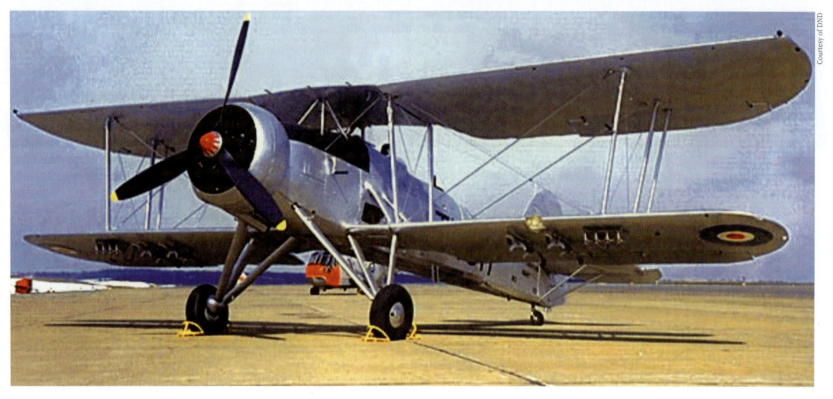

Fairey Swordfish.

When Britain entered the war, the Swordfish's peculiar assets made themselves known. In the Norwegian campaign, it was so slow that by hugging the sides of fjords, it escaped from the faster German fighters. When it went up against battleships, enemy gunners couldn't depress low enough to get at it, so it flew under their shells. The joke among Fleet Air Arm pilots was that the reason the enemy couldn't hit a Swordfish was because the speed settings on their gun sights were not low enough. Swordfish did so well on November 11, 1940, at Taranto, putting the Italian fleet out of the war, that the Japanese naval officers who inspected the docks after

the raid used the Swordfish tactics as a template for Pearl Harbor. Spotting for the navy at Trondheim, crippling the German battleship *Bismarck*, sinking (from Malta) four hundred thousand tons of supplies meant for the Afrika Korps, escorting Arctic convoys, flying off MACs (merchant ships that had been converted into aircraft carriers) to bridge the "Atlantic Gap" … the Swordfish earned its battle honours without fuss.

The first Swordfish came to Canada in 1941 to be put on board the MAC carriers then being built in American shipyards. They were shipped to Dartmouth from Britain, assembled, test-flown, and boarded onto the waiting MAC carrier at Halifax. In 1942, the Fleet Air Arm set up a school at Yarmouth to train aircrew to fly torpedo aircraft and took over some of the Swordfish. Because of the Canadian climate, some of them were modified with enclosed cockpits. As Canada had no aircraft carriers, Canadians joined the Fleet Air Arm after their training.

In 1945, when Canada did embark on creating its own naval aviation squadrons, the Royal Navy gave it the remaining Swordfish aircraft at Dartmouth. The following year the Swordfish were withdrawn from active service and sent to naval reserve divisions across the country. All were disposed of in 1947 to be sold off by Crown Assets Disposal, and while most were scrapped, seven were bought by a Tillsonburg, Ontario, farmer. These deteriorated in his fields until 1965, when the Canada War Museum bought enough of what remained and, with the advice of Fairey Aviation, built out of them a single Swordfish — now on static display at the National Aviation Museum in Ottawa. There is one Stringbag kept in flying condition at the Royal Naval Aviation Museum in Yeovilton, Britain.

It lacked sophistication and looked like a joke taking to the air. But it followed in the British tradition of old-fashioned improvisation. Rugged dependability was the Swordfish trademark — and that is why it worked.

ON CANADIAN WINGS | A CENTURY OF FLIGHT

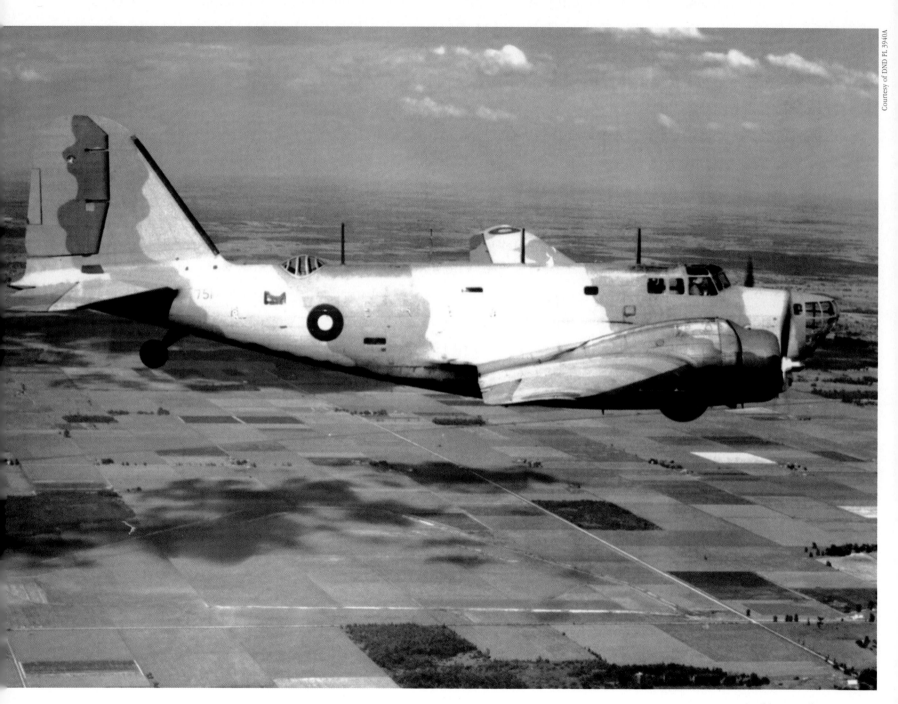

Douglas Digby.

Douglas Digby

Even before Douglas built the famous DC-3, it had surprised the aviation world with a superlative bomber. In 1931, the Douglas B-7, an all-metal, streamlined monoplane with retractable landing gear, delighted the United States Army Air Corps. It was ideal when the army was given the airmail routes to fly, and B-7s linked Wyoming with the West Coast. Thus encouraged, Douglas entered the 1934 bomber competition.

This time its DC-2 transport was available for adaptation, and the company took from it the tail, fuselage, and engine. The body was made deeper, dorsal and nose turrets were installed, and the DC-2's wing was increased by a four-foot span and was mounted on the fuselage in a mid-wing position. Competing against the Boeing Model 299 (later to become the B-17 Flying Fortress), the DB-1 (for Douglas bomber) stood little chance, and Douglas later responded with the four-engined XB-19A. But the USAAC also needed a medium bomber, and in two contracts an order for 350 DB-1s was placed. Called "Bolo," it was powered by two Wright R-1820-53 Cyclones that gave it a service ceiling of 23,900 feet, a range of 1,200 miles, and a cruising speed of 167 miles per hour. Armament was three 0.3-inch machine guns in nose, dorsal, and ventral positions, the last accessed via a tunnel in the under-fuselage area. Many USAAC squadrons were equipped with Bolos for

bombing and anti-submarine duties in the Caribbean, Panama, and the Pacific; in the Japanese attack on Pearl Harbor, most of those based in Hawaii would be destroyed.

The United States' neutrality in 1939 presented the British and Canadians with considerable problems. Not only were they dependant on buying American aircraft by the thousands, especially for the BCATP, but the need for anti-submarine patrols off the east coast was even more urgent. The security of the east coast of Canada was precarious — particularly as the German pocket battleship *Deutschland* was rumoured to be south of Greenland, and departing Allied convoys had to have air cover.

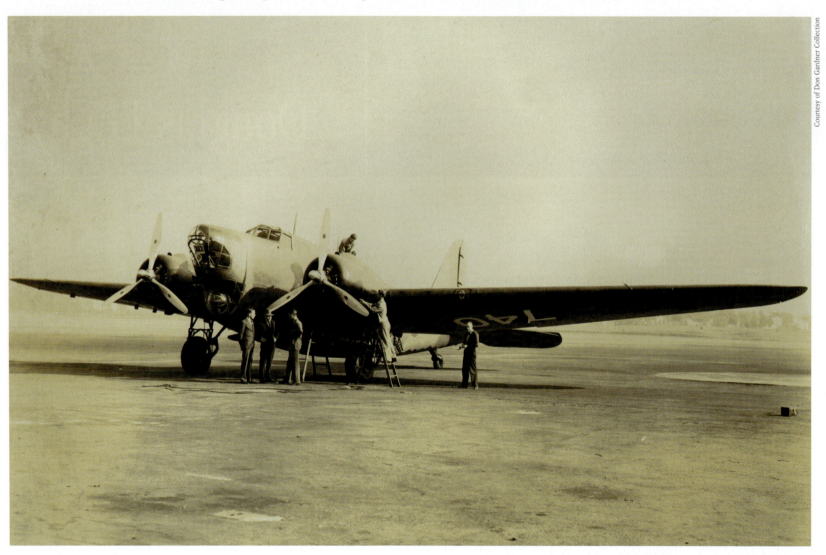

Douglas Digby: A DC-2 in wolf's clothing, already obsolete when the war began, used for anti-submarine patrols in the North Atlantic and Caribbean.

Douglas Digby

This led to the DB-1 Mark I Bolos being literally dragged across the Canadian border. Because of the neutrality laws imposed by the United States, American aircraft were not permitted to be sold to Canada. Thus clandestine arrangements were made to get the Bolos across. In December 1939, American crews flew the first two to the airfield at Sweet Grass, Montana, and taxied them up to the barbed wire fence that marked the border between it and Coutts, Alberta. The Americans got out, shook hands with the waiting Canadians, cut the wire, and threw a rope across the border. It was tied to the tail wheel of the first aircraft, and a team of horses dragged the aircraft over. The only problem encountered was physical rather than legal: the ground sloped on the Canadian side, and the Bolo unexpectedly rolled with gathering speed toward the bystanders. Someone jumped in and put on the brake. Eighteen others were brought across in this way at Emerson, Manitoba. They replaced the ludicrous Wapiti biplanes flown by No. 10 (BR) Squadron, which could now become operational at Dartmouth, Nova Scotia, and then at Gander, Newfoundland, in June 1940.

Called Digbys, after the Nova Scotia city, they joined with Lockheed Hudsons, another maritime patrol aircraft that had started life as an airliner, to provide the east coast's first credible defence. In the fall of 1941, with a patrol range of over 350 miles and a 12-hour endurance (compared with the Hudson's seven hours) the Digby performed heroically through the battles in the waters off Newfoundland. Unsung and unknown in the annals of anti-submarine warfare, the Digbys of 10 Squadron patrolled to the extreme limits of their endurance, fighting headwinds and low visibility. In August 1942, when three U-boats penetrated as far the Strait of Belle Isle, 10 Squadron's Digbys extended coverage to the St. Lawrence, providing escorts for convoys bound for the construction of the airport at Goose Bay.

By late 1942, the Digbys were replaced by aircraft more appropriate to maritime patrol — 10 Squadron received Liberators, and United States used Navy B-17s to take over the harbour patrol duties in the Caribbean. Some Digbys were converted to transports designated as C-58s and others became trainers.

ON CANADIAN WINGS | A CENTURY OF FLIGHT

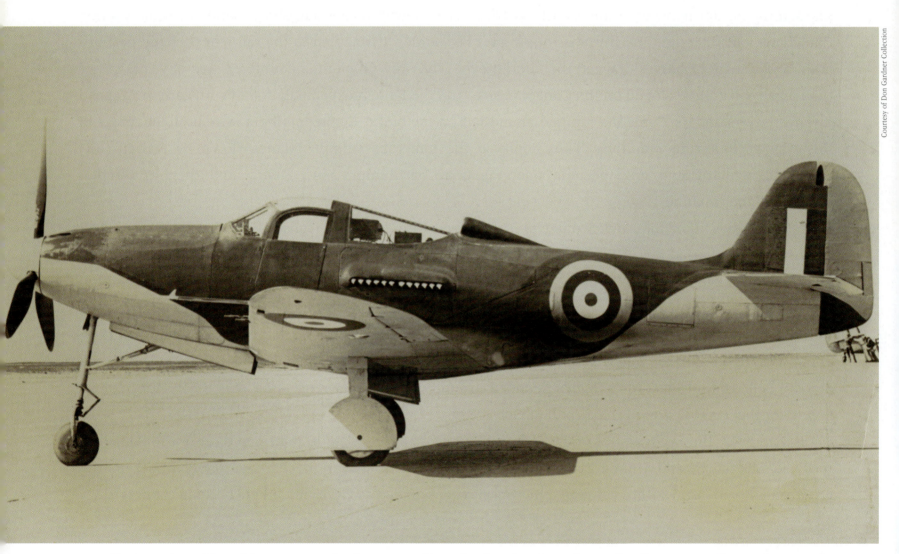

Bell Airacobra: The ultimate gun platform, excellent for low-level work, and a fine ground attack aircraft.

Bell P-39 Airacobra

The Bell Airacobra might have become Canada's Home Defence aircraft during the Second World War, except that wiser minds prevailed and the Curtiss P-40 Kittyhawk was chosen for that role. An aeronautical oddity, the Airacobra deserves to be remembered for that reason alone.

Laurence Bell left Consolidated Aircraft in 1935, when it moved to San Diego, and began his own aircraft company. One of his first designs was the Airacobra, and in 1939, the United States Army Air Corps ordered eighty of the fighters, designating them P-39s. Along with the Kittyhawk, immediately after Pearl Harbor the P-39 became the first line of defence for the United States.

The fighter was planned around a 37-mm cannon that fit into its propeller shaft. The appeal was obvious and logical: if it could fire directly through its nose, the whole aircraft became a gun. To accomplish this, Bell performed some extraordinary engineering feats. As the breech mechanism of the cannon took up all of the front, the engine was in the rear, behind the pilot. This meant that the driveshaft ran between his legs. It also meant that the front of the aircraft had to be supported by a tricycle undercarriage, the first time this was ever used on a mass-produced fighter. Desperate for fighters in 1939, the

French and British purchasing commissions placed large orders for the Airacobra, and when France fell, the RAF took over the French aircraft. The RAF would eventually buy 675 Airacobras, but only 80 were actually accepted into squadron service. The remainder were repossessed by the USAAF, where they were re-designated as the P-400. The only RAF squadron to fly the Airacobra in Britain was 601 Squadron based at Duxford. The aircraft's deficiencies were so obvious in a raid on the French coast on October 9, 1941, that the squadron was hurriedly converted to Spitfires soon after.

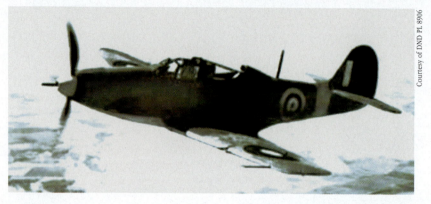
Bell Airacobra.

If ground crew disliked the Airacobra because the engine's location made it difficult to service, pilots thought it quite special. With a tricycle undercarriage, taxiing visibility was excellent, the cockpit windows could be wound down like a car's, and when the 37-mm cannon was fired, the satisfying smell of gunpowder filled the air. It was a good aircraft up to fifteen thousand feet, after which it became an easy target for Bf-109s. Pushing the huge 37-mm before it, the poor Allison 170 engine could barely make the service ceiling of thirty-five thousand feet. As a result, by 1941, the P-39 in all models was delivered to squadrons far from the European theatre. These were places where any aircraft was welcome — the Australians in New Guinea, the Russians through Lend-Lease, and various South American air forces. The Airacobras that Canadians saw were those being ferried through Canada and Alaska to the Soviet Union; of the 9,560 built, 5,000 would be supplied to the Soviets this way or through Iran.

The RCAF was originally to receive 144 Airacobras for the war effort at home, and the initial plan was to manufacture P-39s in Canada. "At one point, Larry Dunlap [later Chief of Air Staff] of the RCAF considered the Airacobra to be superior to the Kittyhawk, which he described as 'obsolescent,'" notes Jerry Vernon, president of the Vancouver chapter of the Canadian Aviation Historical Society. He went on:

> After a lot of back and forth, the final deal was for the RCAF to receive 72 Kittyhawks from the large RAF order. Typically, there had been a lot of fuss in Canada over which would be the best fighter, just as the RAF had turned down the Airacobra as being unsuitable. In due course, more Kittyhawks, of later models, trickled into service, until the final total was 143 P-40s of various models. All that explains why

Bell P-39 Airacobra

the RCAF never got Airacobras for general service. The RCAF never used them in squadron service, but more than likely some individual RCAF pilots may have flown then with non-RCAF units here and there.

Why the RCAF only received 143 Kittyhawks and not 144 is explained by an RCAF Accident Card, which shows that the first Airacobra was sent to Rockcliffe, Ontario, for evaluation. The Test and Development Establishment was among 12 Communications Squadron's wartime roles at the base, and on November 26, 1941, at 11:00 a.m., Airacobra s/n AH621 was written off by one Flight Lieutenant R.B. Middleton. A forced landing with the undercarriage up took place in a field two and a half miles northwest of Rockcliffe, and Middleton was slightly injured. It was later discovered that the Airacobra's engine had failed because of a fuel stoppage. The aircraft was a complete write-off, and the crash sealed the type's fate in the RCAF. An experienced pilot, having flown with Imperial Airways and Trans Canada Airlines, Robert Bruce Middleton was recommended for the Air Force Cross. He received it on January 9, 1943, with the citation, "This officer is the outstanding test pilot in the Test and Development Establishment at RCAF Station Rockcliffe. He has always displayed exceptional devotion to duty and has always taken the initiative in the testing of new types of aircraft." In light of what had occurred, it is fortunate that the Airacobra did not get into operational service with the RCAF.

As for Laurence Bell, he would continue to design and build innovative aircraft. The Bell P-59 Airacomet, the first jet aircraft for the United States Air Force, followed, along with the famous X-1 series. Bell's company then entered the field of helicopters, where they had more success — especially with the UH-1 Huey, which did serve in the Canadian Armed Forces.

Designed around a 37-millimetre cannon that fired directly through the propeller shaft, the aircraft was hard to service because of the engine location.

Fleet Fort. The only wartime aircraft completely designed and built in Canada, its low elliptical wing, raised rear cockpit, and fixed undercarriage made it unique — and obsolete.

Fleet Fort

"An humdrum aircraft ... completely uninspiring," were the comments of some of those who knew the Fort. But as with buildings and fashions thought hideous in their day, with time, the Fort gained respect and — as it was the only wartime aircraft completely designed and built in Canada — even patriotic pride.

In 1938, with a war in Europe imminent, Jack Sanderson, president and general manager of Fleet Aircraft of Fort Erie, Ontario, did not want his company caught short. Without a firm order from either the RAF or RCAF, Sanderson and his aeronautical engineer, R.E. (Dick) Young, set out to design a trainer as good as the Harvard. Fleet was busy building its Finch and Fawn basic trainers, and Sanderson reasoned that what was going to be in short supply was an intermediate trainer — an aircraft between the Finch and the Harvard. The RCAF concurred and planned to introduce Yales between the Tiger Moth and the Harvard. Fleet's Model 60, built in Canada, would be a locally made substitute.

Powered by a 330-horsepower Jacobs radial engine, the monoplane had a fixed undercarriage with semi-retractable spats around the wheels. The idea was that students could practice raising and lowering the

undercarriage without the complexity or danger of working an actual one. But the Model 60's most prominent feature was the bubble of the instructor's cockpit. Located behind the student's it was also raised above it, giving the instructor a good view. Another unusual feature was the semi-elliptical shape of the trailing edge of the wing with the ailerons extending out to the wing tip.

The Model 60's first flight took place on March 22, 1940, and in May the prototype, CF-BQP, was sent to the Central Flying School in Trenton, Ontario, for evaluation. It scored highly with the pilots, who compared it with the Harvard. The British Commonwealth Air Training Plan was about to be set up, and there was a

A pair of Fleet Forts used for training wireless operators.

Fleet Fort

fear that Canada could be cut off from Britain, its traditional supplier of training aircraft. It made sense to have a locally made trainer, and the RCAF placed an order for two hundred Model 60s, now called the Fort, after its birthplace. By May 1941, the first production Fort was flying — and ground looping. The brakes kept locking. Because the ailerons extended to the wing tips, the Fort was prone to stalling, something that student pilots might not be able to get out of. The prototype was well built, but the production aircraft weren't. There were complaints about their poor workmanship and lack of spares, and the air force had to make over one hundred changes to the original design.

Fleet Fort with raised instructor's bubble cockpit.

Worse was to come. The BCATP discovered that an intermediate trainer was unnecessary, as students not only had no problems graduating from the Tiger Moth to the Harvard but also were confused by the Fort. The intermediate trainer phase was abandoned, and the order for two hundred Forts was halved. Renamed Fort IIs, they were designated wireless operator trainers instead. The poor DH 82C Menasco Tiger Moths had been doing stalwart service as BCATP wireless operator trainers, lugging heavy T-1083 transmitters and R-1082 receivers around between the cockpits. In the hot prairie summers, they were barely able to get off the ground. The wireless operator training schools in Winnipeg and Calgary began receiving their Forts in January 1942. A radio receiver and transmitter were substituted for the instructor's panel in the rear cockpit, and a radio direction finding loop and radio antenna were installed. In this role, too, the Fort was found unsuitable. It still ground looped, and now the Jacobs engines gave problems. The Fort's high-wing loading hindered the tuning and keying of the radio sets in bad weather.

But by the end of 1942, all one hundred Forts had been delivered from Fleet, and like it or not the aircraft became the standard wireless trainer until replaced by Harvards in July 1944. The only Fort in flying condition today is operated by the Canadian Warplane Heritage Museum in Hamilton, Ontario.

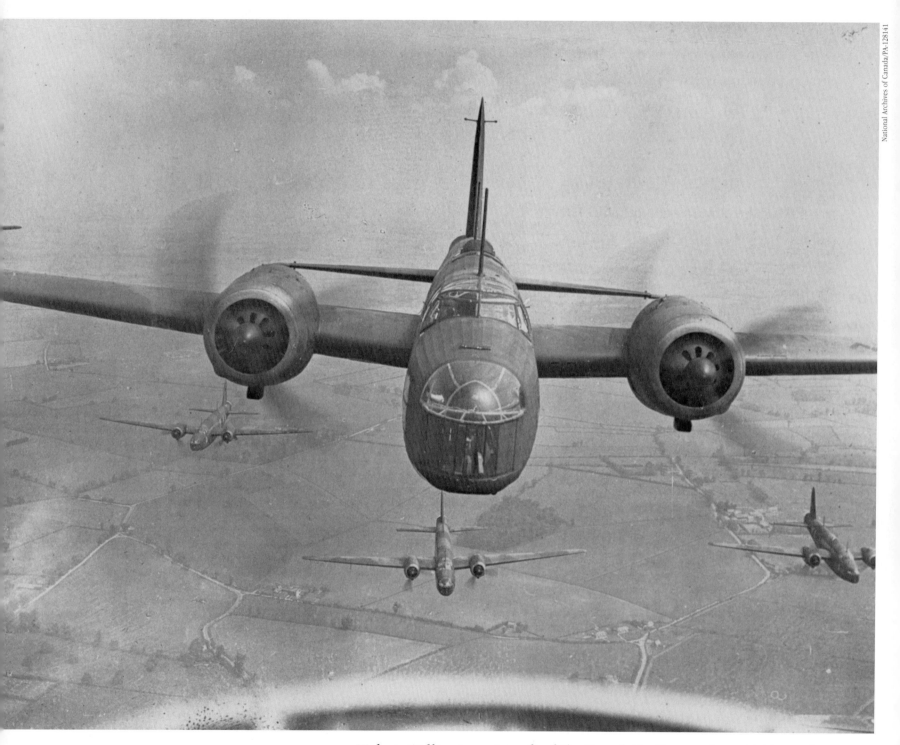
Vickers Wellington aircraft of the Royal Air Force, circa 1938–1940.

Vickers Wellington

On March 30, 2003, a black granite monument fitted with three bronze maple leaves was unveiled in the tiny Dutch village of Wilnis, southwest of Amsterdam. It honoured the RCAF aircrew whose Wellington bomber HE727 NA-K had been shot down on May 5, 1943, returning from a raid over Dortmund. Two of the crew had parachuted to safety, but three had not. Sixty years later, the Royal Netherlands Air Force Salvage Team and a local citizens group had salvaged the remains of the bomber from a bog and retrieved the bodies of Flight Sergeant Joseph White, twenty, and Flight Sergeant Adrien Thibaudeau, twenty-one. The plane's pilot, Warrant Officer R.B. Moulton, twenty-two, had been killed in the crash and was buried in the Wilnis General Cemetery. At the ceremony, hundreds of Dutch came to honour the young Canadians who had fought and died so that Europe might be free. Fittingly, below the maple leaves and inscribed words "For Peace and Freedom" are preserved the salvaged parts of the Wellington bomber.

Named after Arthur Wellesley, the first Duke of Wellington, who had saved Europe from another dictator, the bomber suffered the indignity of becoming better known during the war as the "Wimpy," after the hamburger-gorging friend of Popeye. Its other nickname, "Flying Cigar," might have better described the

bomber's fuselage, but it was never as popular as "Wimpy", evidence of a much-loved aircraft. Designed by Vickers in 1935 (the same year as the B-17) to meet an Air Ministry specification, by the war the Wellington was obsolete. Its Bristol Hercules engines were too slow and gave it a very limited ceiling of eighteen thousand feet. Its twin .303-inch guns in the nose and tail turrets were inadequate to keep the fighters off, and its forty-five-hundred-pound bomb load was too light for the heavy bombing that the war entailed. Wellingtons were taken off daylight raids in 1941 and put on night bombing, minelaying, pathfinder target indicating, and anti-submarine duties. Yet it was kept in production, going through several Marks — improving its cruising speed, ceiling, and power — until by the time the Wellington X came out, it was everything that

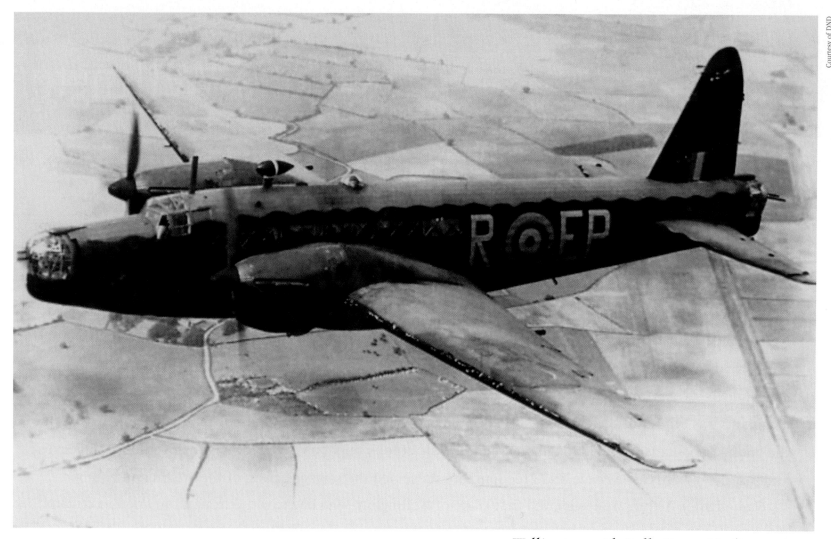

Wellington with Rolls Royce Merlin engines.

the namesake of the old Iron Duke should be. For like a faithful old dog, the Wimpy could be counted on to bring its crews home. The geodetic "basket weave" fuselage construction under its fabric covering (designed by the Vickers team, led by Barnes Wallis) made it extremely rugged and difficult to shoot down. Again and again, Wimpies limped home missing whole chunks out of their fuselages, which would have demolished other aircraft.

The Wellington was constantly upgraded, some re-engined with more powerful Rolls Royce Merlins and others with Leigh Lights for hunting U-boats. Although never officially taken on charge by the RCAF, Wellingtons equipped eleven RCAF squadrons in bombing and maritime roles. Typical were the experiences of two such squadrons. Formed at Dishforth, Yorkshire, in October 1942, RCAF 426 "Thunderbird" Squadron flew their first raid with Wellingtons on January 14, 1943, bombing the U-boat pens at Lorient. Canadian aircrew thought the Wellington a death trap — the unofficial hope in one was, "It won't happen to me." They feared that until sufficient numbers of the Canadian-built Lancasters arrived, the British would continue to allocate these superannuated bombers to their 6 Group rather than to the RAF squadrons. Validating their fears, the loss rate for Wellingtons in north-central Germany remained very high — sometimes at 6.6 percent of a mission. On the Nuremberg raid of August 28, 1943, for instance, 34 percent of the Wellingtons sent up did not return.

Based at Chivenor, Devonshire, RCAF 407 "Coastal Strike" Squadron flew Wellingtons in an anti-shipping role over the Bay of Biscay in April 1943. By now, locating and destroying U-boats was almost impossible with their use of *schnorkels* (breathing apparatus that could be fitted to U-boats so that they would no longer need to surface in order to recharge their batteries). Yet in the early hours of December 30, Squadron Leader C.J.W. Taylor made radar contact with one in the English Channel and, switching on the Wellington's Leigh Light, straddled its schnorkel with six depth charges. He had sunk U-772 and was awarded the Distinguished Flying Cross. It may have had its day, but the Vickers Wellington was still a potent weapon.

Its bombing roles apart, the Wellington was also assigned to training units, leaflet raids (which were unpopular with the crews as they did not count toward completing a tour), and radio countermeasures. The last Wellingtons to be flown operationally were with the very courageous Polish squadrons. In tribute to the aircraft's solid construction, the unofficial motto of a Wellington squadron was said to be "Press on, regardless." Its namesake, the Iron Duke, would have liked that.

On Canadian Wings | A Century of Flight

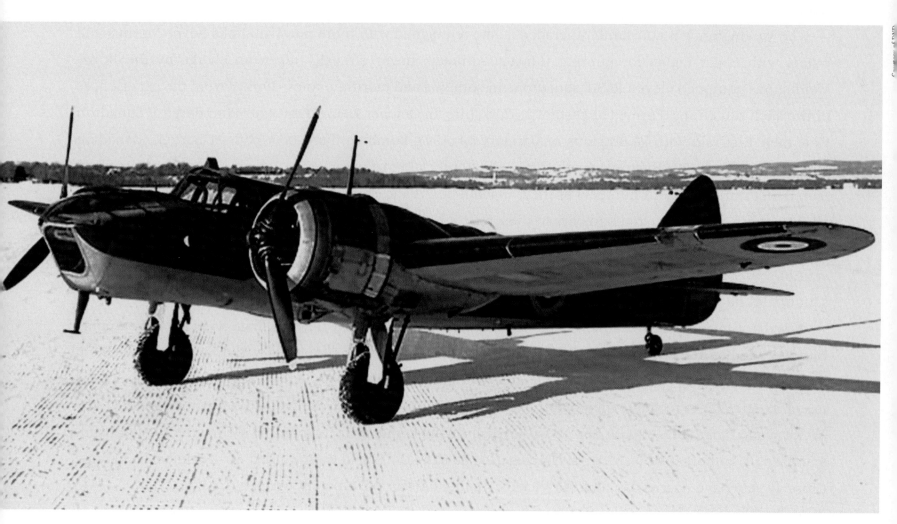

Blenheim at RCAF Rockcliffe.

Bristol Blenheim

The Blenheim bomber began as the Learjet of the 1930s. When the owner of the *Daily Mail* newspaper, Lord Rothermere, wanted the fastest British-made aircraft as an executive aircraft, the Bristol Aeroplane company built him the Type 142: a sleek, all-metal, snub-nosed racer sandwiched between two huge supercharged engines. At a time when aircraft were fixed-wheel, fabric-covered, wire and strut biplanes, the Type 142 with its Alclad aluminum skin, clean monoplane design, and retractable undercarriage was a phenomenon.

Dubbing it *Britain First*, Rothermere bought the Type 142 and gave it so much publicity that it got the Air Ministry's attention, which is what he had intended. When the Air Ministry wanted to evaluate it, Rothermere loaned them his machine. They discovered that it was faster than any of the RAF's front-line fighters, and 70 miles per hour faster than the Gloster Gauntlet. The timing was perfect — Britain was about to re-arm, and in May 1936, the Air Ministry placed an order for the Type 142 as a bomber, calling it the Blenheim or, more popularly, "The Wonder Bomber." A total of 1,242 Blenheim Mark Is would be built, all going initially to RAF home squadrons. Bristol also built the Bolingbroke, a reconnaissance version, but when

the RAF asked that the company concentrate on the Blenheim, the RCAF took an interest it. When it flew on September 24, 1937, the Bolingbroke prototype was shipped to Canada, and Fairchild Aircraft Ltd. at Longueil, Quebec, was initially contracted to build eighteen. On September 14, 1939, the first Canadian Bolingbroke flew. It still had British instrumentation by 1943, but later models were so Canadianized that only the basic airframe was still British. The RCAF also wanted to develop the Bolingbroke as a seaplane for coastal reconnaissance, and MacDonald Brothers of Winnipeg was contracted to provide it with Edo floats. But on August 28, 1940, when the prototype was tested, the result proved so disappointing that the single Bolingbroke float plane was then sent to No. 5 (BR) Squadron at Dartmouth.

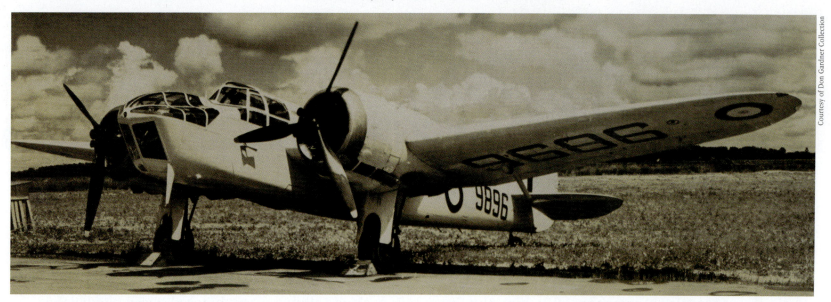

Although a total of 6,260 Blenheims/Bolingbrokes were built in Britain and Canada between 1935 and 1944, few survive in Canadian, British, Belgian, and Finnish air museums.

Whatever the name, Bolingbroke or Blenheim, at first the "Wonder Bomber" lived up to its name. It was fast, aerobatic, and the Mercury engines never failed — even at low altitudes over the ocean. Yes, its cockpit was a tight fit (the crew squeezed into it through a roof hatch and the poor radio operator through an aperture in front of his turret). A bigger disappointment was the poor instrument layout. Crew comfort must have been an afterthought to Bristol, pilots said, and one could always tell a Blenheim pilot because of the cuts and scratches on the backs of his hands — from sharp springs and screwheads on the valve controls, flaps, and turret selectors. All of this made for a busy, cramped, painful exercise — especially during takeoff.

By 1939, it was also the most numerous bomber in the RAF and an obvious choice for the first raid of the war. But in four short years the rapid advance in technology had caught up with the "Wonder Bomber." When

Bristol Blenheim

used as a fighter during the Battle of Britain and the Blitz, its obsolescence was severe. A gun pack of four .303 Brownings was attached to the bomb bay (making the aircraft 37 miles per hour slower than *Britain First*), and the Mercury engines were boosted, but it was too slow and defenceless to escape cannon-firing, single-engined fighters like the Bf-109 in Europe or North Africa or the A6M Zeros in the Far East. Now called the "Flying Coffin," by 1941, in daylight raids Blenheims fell prey to flak and fighters. The horrific casualties of the raid on the Rotterdam docks on August 28, 1941, was typical. So few Blenheims returned from it that Winston Churchill sent a famous message to the survivors: "The devotion of the attacks on Rotterdam … are beyond all praise. The charge of the Light Brigade at Balaclava is eclipsed in brightness by these almost daily deeds of fame."

Five RCAF squadrons — 404, 406, 407, 415, and 419 — flew Blenheims in Europe on coastal patrol and escorting convoys to the USSR. In May 1942, Blenheims from 404 Squadron attacked the German cruiser *Prinz Eugen*.

By 1943, Fairchild had turned out 626 aircraft plus 51 airframes, which for a company that had only built bush planes was outstanding. Except for the first Bolingbrokes, the Mark IV Blenheims all had American instrumentation and seating for a fourth crew member. Bristol Mercury engines were mainly used, but in case the supply failed, Pratt & Whitney Wasp engines equipped fifteen of them. Some went to the eight RCAF squadrons on home defence duties in Canada and Alaska, and it was in a Bolingbroke on patrol from Annette Island, Alaska, that RCAF Flight Sergeant P.M.G. Thomas of 115 Squadron attacked a Japanese submarine that would later be sunk by American naval vessels. But most saw service in the British Commonwealth Air Training Plan, where as the "Boly" or "Bole" they served as target tugs and gunnery trainers, the last remaining in RCAF use until July 21, 1947. Although a total of 6,260 Blenheims/Bolingbrokes were built in Britain and Canada between 1935 and 1944, sadly too few survive in Canadian, British, Belgian, and Finnish air museums.

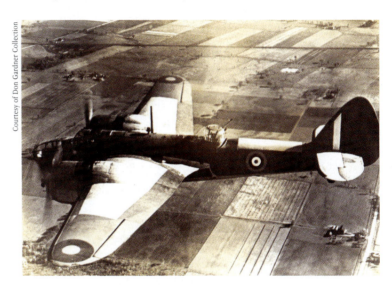

From "Wonder Bomber" to "Flying Coffin." By 1941 Blenheims fell easy prey to flak and fighters.

The Blenheim/Bolingbroke is significant in Canadian aviation not only because it gave Fairchild a chance to show what it was capable of but also because it bridged the gap between biplane and modern bombers.

ON CANADIAN WINGS | A CENTURY OF FLIGHT

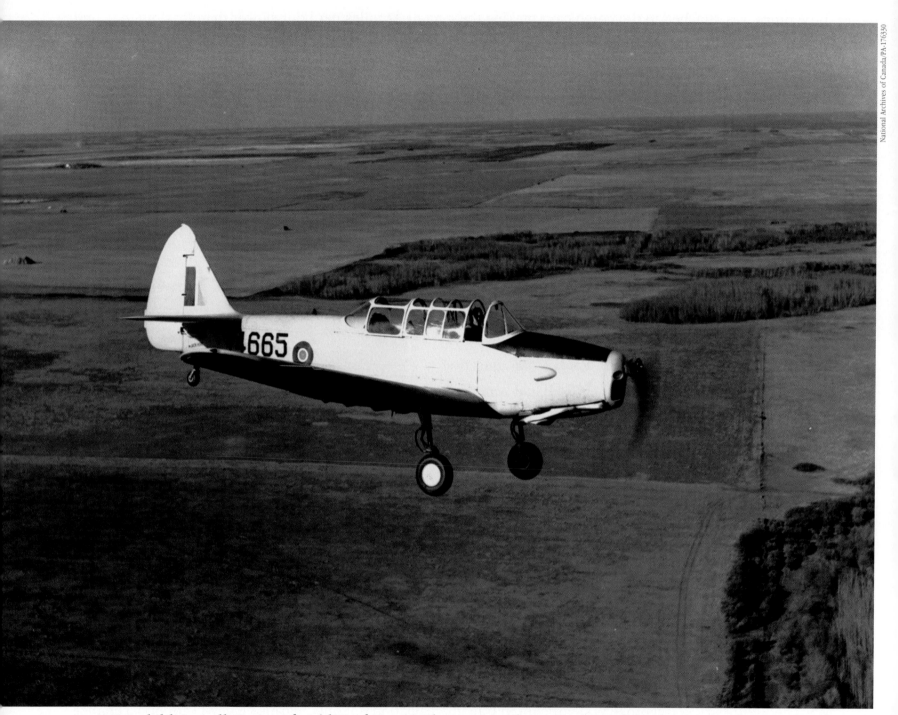

Fairchild Cornell II aircraft 14655 of No. 19 Elementary Flying Training School RCAF, in the vicinity of Virdin, Manitoba, October 1944.

Fairchild Cornell

It had lain in a Yorkton, Saskatchewan, field for forty years, home to plants and rodents. "We had learned from past restoration projects to look beyond the piles of debris," wrote Don O'Hearne, "and see the beauty that can result." The trainer had also been damaged by fire, and as one of the Vintage Aircraft Restorers who brought former British Commonwealth Air Training Plan aircraft to life for display at the Moose Jaw Western Development Museum, Don thought it was "not a promising start." Cornell #15037 would need a lot of work.

There were three versions of Cornells — for the USAAC, the RAF, and the RCAF. Each version differed slightly from the others, and all were made by the Fleet Aircraft Company of Fort Erie, Ontario. In 1938, the Fairchild Aircraft Company of Hagerstown, Maryland, was contracted to build a primary trainer for the USAAC. Designed by Armand Thiebolt, the M-62 was a low-wing, open-cockpit monoplane powered by an inverted, 6-cylinder, 165-horsepower Ranger engine. To be a basic trainer, it had two-place, tandem seating and a fixed landing gear. The military asked that the engine be upgraded to 200 horsepower and designated it the PT-19A. Fairchild first supplied the PT-19 to the British under Lend-Lease, where the RCAF noted it. In spring 1941, the PT-19 was selected by the RCAF to replace the Tiger Moth, and in November of that year,

Fleet Aircraft of Fort Erie, Ontario, was chosen as the contractor. Fairchild Canada was not involved as it had long since broken away from the American parent.

Fleet Fairchild Cornell restored by Vintage Aircraft Restorers, Moose Jaw.

Originally named the Freshman, as with the Harvard and Yale, in 1942 it was renamed Cornell after another American university. In case the supply of Ranger engines was depleted, the RCAF investigated other types: the 175-horsepower Scarab, the 240-horsepower Continental radial, the 190-horsepower Lycoming, and the 225-horsepower Jacobs. Fairchild was also asked to look at getting a supply of De Havilland Gipsy engines from England. When the Gipsy was unavailable, the RCAF settled for the Lycoming. The supply of Ranger engines did become a problem, and a single Cornell was fitted with a Lycoming and flown on March 13, 1943. Fleet closed its Finch and Fort production lines and concentrated on building the Cornell II for the RAF and the III for the RCAF — the first ten with many Fairchild parts. On July 9, 1942, Fleet test pilot Tommy Williams flew the prototype RCAF 10500 at Fort Erie. The first production Cornell was received by the RCAF on July 22, 1942 — less than a year after Fleet had been given the contract. In February 1942, the USAAC placed an order with Fleet for ninety-three Continental-powered PT-23s. The Canadian version differed from the American, as it had metal flaps.

Fairchild Cornell

A year after the first flight, Fleet was turning out 161 Cornells monthly — 11 aircraft above the scheduled rate. On October 21, 1943, the one thousandth Cornell came off the line. Paid for by the employees of Fleet and christened *The Spirit of Fleet*, it was given to the RCAF as their contribution to the war effort.

Half a century later, the restoration of Cornell #15037 began. After an inventory of the parts, the restorers sanded the metal fuselage, cleaned it, and gave it a coat of Tremclad. The wings were rebuilt, and "call it luck or good workmanship, everything fit," wrote O'Hearne. "We obtained a pair of damaged ailerons, a fairly good set of tyres ... as the metal elevators and rudder were still intact, we were able to use them as patterns to fabricate new ones." Through a casual conversation, the restorers heard that the Regina Flying Club had a Ranger engine, and after a cleaning and overhaul it was installed. For the fabric to cover the Cornell's wings, "we opted to use 'Ceconite,' a form of Dacron, and a special cement to attach it to the plywood after which heat [electric iron or heat gun] was used to shrink it to a taut condition." Six years after it had been a rodent home, in June 1993 Cornell #15037 was ready for display. Thanks to the dedication of the Vintage Aircraft Restorers, a part of Canada's aviation heritage would be enjoyed by all who visited the Moose Jaw museum.

Between Canada and the United States, a total of 7,260 Cornells were built. Fleet made 1,902 for the RAF and RCAF and 93 PT-23s for the USAAC — at an average cost of $1,338 per aircraft. The beloved aircraft replaced Tiger Moths at all BCATP Elementary Flying Training Schools and was used by the RCAF until 1947, when it was replaced by another De Havilland trainer — the Chipmunk.

Vintage Aircraft Restorers at dedication of Cornell #15037. Front row: Anne Meyer, Walter Rowan, Bill Edgar, Bill Prowse, Jim Mason, Frank Brattan. Back row: Don O'Hearne, Bob Meyer, Roy Hiles, Jim Gushuliak, Harold Jackson, Roger Mackin, Russ Ferguson, Jim Morrison.

ON CANADIAN WINGS | A CENTURY OF FLIGHT

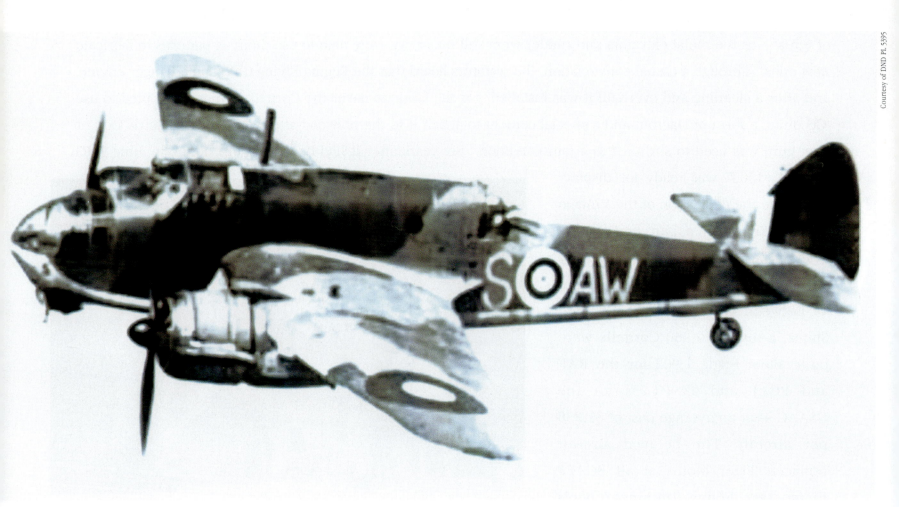

Bristol Beaufort torpedo bomber.

Bristol Beaufort

At Victoria International Airport today, one would be hard pressed to imagine that in 1942, as Pat Bay, it was the third largest RCAF station in Canada. The adjoining British Columbia Aviation Museum occupies the site of the old East Camp, and in its Memorial Room are photographs and models commemorating the men and aircraft that defended Canada's west coast during the Second World War, from October 1942 to August 1943. This included RCAF 149 (TB) Squadron and their Bristol Beauforts, the only instance in which this aircraft was used in Canada.

An unprepossessing aircraft with none of the Blenheim's fame or the bulldog look of the Beaufighter, the Beaufort was designed in 1937 as a compromise between a torpedo bomber and a reconnaissance aircraft. The addition of an extra crewman made it heavier than the Blenheim, and to enable them to effectively deliver 1,500 pounds of bombs or a 1,605-pound torpedo, some were powered by Bristol Taurus engines and others by Pratt & Whitney Wasps. Overseas, the RCAF's 404 and 415 squadrons flew Beauforts for a brief period, but several Canadians did serve in them with the Royal Air Force — two of those with great distinction.

Vancouver-born Flight Lieutenant Oliver Lawrence Philpot of 42 Squadron was awarded the Distinguished Flying Cross with the following citation:

> This officer was the pilot of a Beaufort aircraft taking part in a bombing attack on an enemy aerodrome and shipping in Norway on the night of 9/10th May 1941. In spite of considerable anti-aircraft fire and an enemy night fighter on his tail, he dived to about 200 feet and released his bombs, scoring hits in the target area. As he recovered from his dive, the aircraft was hit by anti-aircraft fire which killed the navigator and seriously wounded the wireless operator.
>
> In spite of his compass having been hit also and rendered unserviceable, Pilot Officer Philpot brought his aircraft back and landed it safely on an aerodrome, even though the hydraulic controls had been shot away and he had the use of neither flaps nor undercarriage.

"Woe to the unwary" is the motto of RAF 217 squadron, and in May 1940, based at St. Eval, its Beauforts attacked enemy shipping and performed minelaying duties. Transferred to Ceylon in September 1942, the squadron flew out via Malta, where they spent two months sinking enemy ships in the Mediterranean. Canadian Pilot Officer Ralph Manning had trained at No.2 ITS, No.5 EFTS, and No.3 SFTS before joining 217 Squadron. When he was awarded the Distinguished Flying Cross in 1944, the *London Gazette* carried the citation:

> Flight Lieutenant Manning has taken part in several torpedo bomber attacks with good results. In April 1942 he participated in an attack on an enemy convoy in the Skagerak, and in May 1942 he was pilot of a formation of aircraft which penetrated the heavy defences around the *Prinz Eugen* off Norway and made a successful attack on the cruiser. On this occasion his aircraft sustained severe damage. In October 1942, Flight Lieutenant Manning destroyed an enemy tanker, which was of the utmost importance to the enemy. On a recent sortie he was forced to bring his aircraft down on to the sea. The dinghy failed to operate and Flight Lieutenant Manning gave great help and encouragement to his crew, two of whom were non-swimmers, while they were in shark-infested waters. He has at all times displayed exceptional valour and determination on operations.

What the citation failed to mention was that the tanker that Manning's Beaufort sank was carrying fuel critical to German General Irwin Rommel's advance, and its loss severely affected the capabilities of his

Afrika Korps. Having made history, Manning became an RCAF historian himself and in 1966 was Deputy Director of the Canadian War Museum in Ottawa.

A total of 2,080 Beauforts were built, with 700 in Australia. There are two in museums in Britain and more in Australia, where crash sites are still being discovered.

Beaufort pilot Ralph Manning.

ON CANADIAN WINGS | A Century of Flight

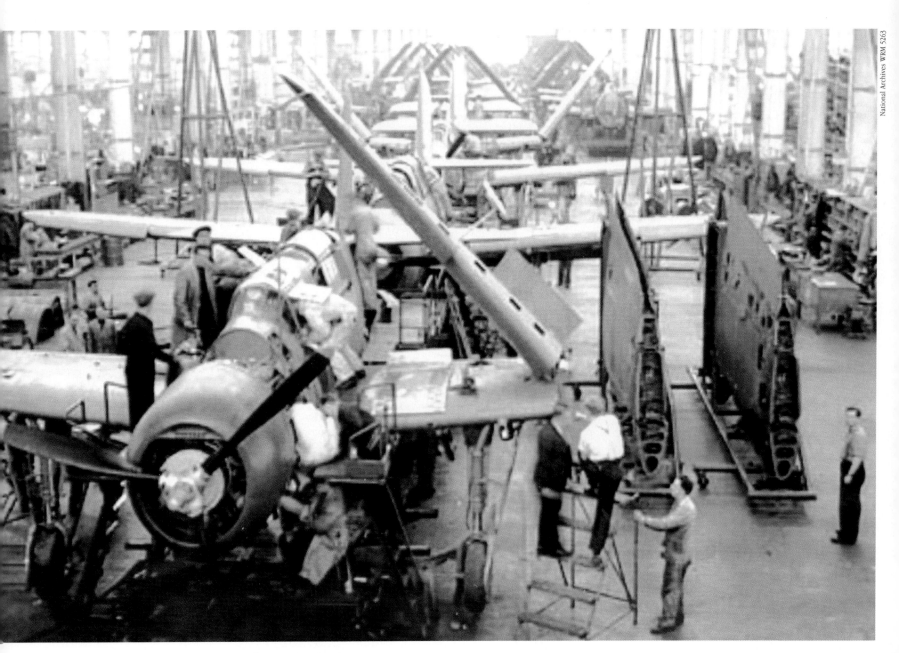

Curtiss SB2C1 Helldiver production line, Canadian Car and Foundry, Fort William, Ontario.

Curtiss Helldiver

Built in Canada, the Helldiver was never flown operationally by Canadians. This was fortunate, as the Curtiss Helldiver was sluggish, unstable, poorly designed, and tops the list as one of the worst aircraft of the Second World War. The two-seat monoplane has earned its place in our aviation history not for its aeronautical qualities but because its production epitomized the country's manufacturing ability during the Second World War.

In 1938, the United States Navy realized that its Douglas Devastator and Dauntless SBDs (for shipborne dive-bomber) were approaching obsolescence and placed an order with Curtiss for its dive-bomber, the Helldiver. It was a hastily made arrangement that soon went bad. The Curtiss-Wright Corp. of Columbus, Ohio, combined the two oldest, most respected names in United States aviation history and was then living in past glory. But the navy was so stampeded for a Dauntless replacement that even when the Helldiver prototype crashed on the first flight on December 18, 1940, it ordered two hundred of the aircraft. Rather than re-engineering the design, Curtiss just added more armour, more guns, and more fuselage, and to no one's surprise, this aircraft also crashed on December 21, 1941. But as the Japanese had just attacked Pearl Harbor,

and given the national mood, Curtiss was told to disregard the Helldiver's poor record and turn out thousands with all speed. With its main plant in Buffalo, New York, making P-40s, the company had no facilities to produce all of the order, and in 1942, as its founder, Glenn Hammond Curtiss, had once done, it looked across the border for help. Fairchild in Montreal and Canadian Car & Foundry at Fort William, Ontario, were contracted to build the aircraft.

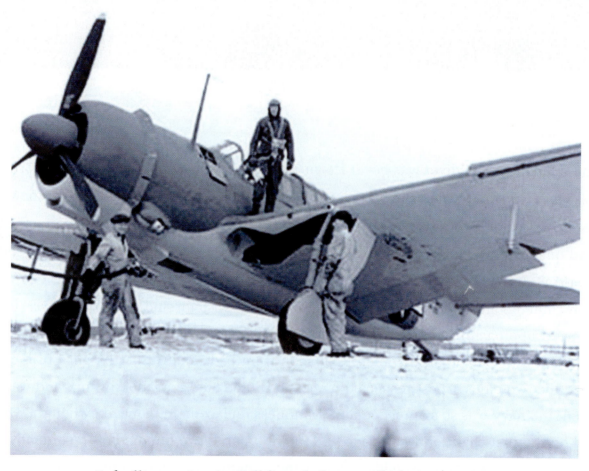

Refuelling a Curtiss Helldiver before test flight, Fort William, Ontario.

Curtiss Helldiver

Canadian Car and Foundry Company had built railcars at Fort William (now Thunder Bay), Ontario, since 1912 and kept busy through the First World War building minesweepers for the French Navy. It closed during the Depression, only to reopen in 1937 as an aircraft plant. Canadian Car had minimal success with its own designs, like the Maple Leaf Trainer, until it was contracted to build Hawker Hurricanes. Both Canada and the company were fortunate that the program's chief aeronautical engineer was the talented Elizabeth (Elsie) Muriel Gregory MacGill, who, despite acute infantile myelitis, a form of polio, supervised the production of 1,500 Hurricanes and 835 Helldivers. On July 22, 1943, test pilot Orville J. Weiben took the CCF Helldiver prototype into the air. For a local workforce that had previously built only a few Grumman Goblins, turning out so many Helldivers would be a worthy achievement.

The Fort William plant built 66 of the SB2C-1 variant with its larger fin and rudder, 683 of the SB2C-4 model with its perforated dive flaps, and, in 1945, 86 of the final SB2C-5 type. The U.S. Navy knew of the Helldiver's inadequacies from its carrier pilots on the USS *Yorktown*; when they were grabbed by the arrester wire, Helldivers had a tendency to break in half. On June 20, 1944, when the American carriers launched fifty-two Helldivers toward the Japanese fleet, forty-three didn't return, and only four of those were lost in enemy action. The remainder had ditched due to engine problems. But by 1944, the U.S. Navy had invested too much time and money to cancel the program, and Curtiss itself churned out six thousand of the aircraft. Many aircraft carrier commanders astutely managed to keep their reliable old Dauntlesses as well. The pilots had it right: the SB2C stood for "Son of a bitch, second class."

After the war, the remaining Helldivers were freely given to the Portuguese, Italian, and Greek naval air arms. The Canadian-built aircraft were sent to operational training units in the United States and perhaps the French Aeronavale, where they flew in Indochina. As for Canadian Car and Foundry, after the war its workforce built anything that came their way — buses, trailers, and subway cars. Beginning in 1955, the company's Fort Erie plant was bought by a succession of Canadian aerospace companies, including Avro, Bombardier, and finally Magellan Aerospace Corporation. After years of losing money and a four-month labour strike, in 2003, Fleet Industries closed down permanently.

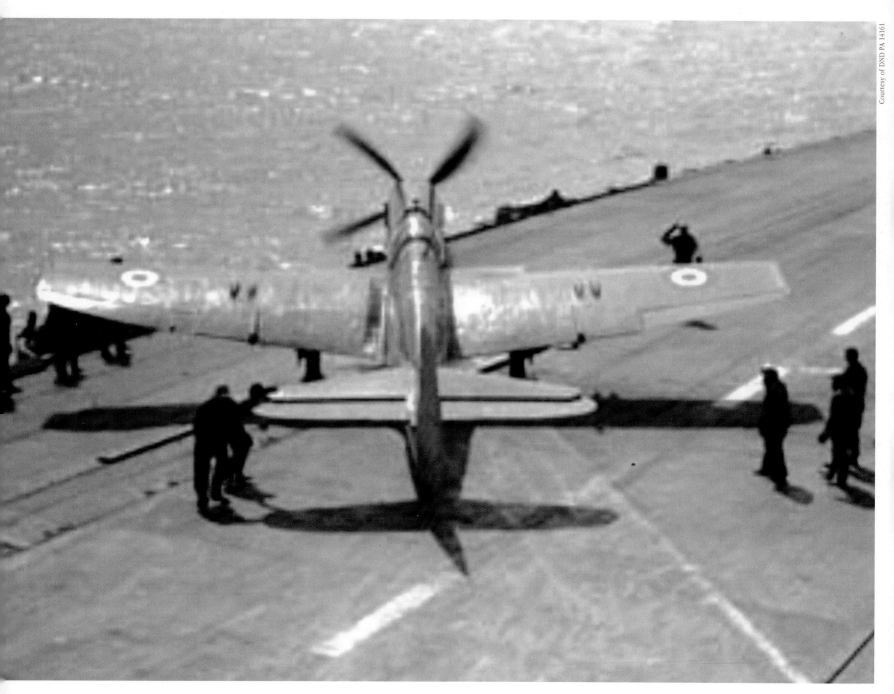

Fairey Firefly being brought up on HMCS Warrior *flight deck, November 1946.*

Fairey Firefly

Ernie Pyle once said that carrier pilots were the best in the world. They had to be, or none would have been left alive. So many Canadians served with distinction on Royal Naval aircraft carriers throughout the war that in 1944, when Ottawa decided to embark upon naval aviation, there was a ready pool of talent and tradition to draw from. Integral to that tradition was the Fairey Firefly.

To get the Firefly operational as soon as possible, Fairey had utilized as much as it could from the plane's predecessor, the Fulmar. A naval version of the Battle, the Fulmar was outdated even before the war began and barely held its own in the Mediterranean against the equally obsolete aircraft of the Regia Aeronautica. Fairey kept the low-wing monoplane from the Fulmar but gave the Firefly a Rolls Royce Griffon engine like that being used in the Supermarine Seafire and advanced Youngman flaps for easier landings on carrier decks. Because of this, when the Firefly went into production in August 1942, it could speedily be delivered to RNAS Yeovilton in March 1943. The concept of a single-engined shipboard fighter carrying both a pilot and a navigator was controversial even then, but the Fleet Air Arm, pleased with the service of its Swordfish and Albacores, saw no reason to question it. Fairey would develop the two person idea later with its bulbous Gannet.

Nothing if not versatile, the Firefly served the Fleet Air Arm in a variety of roles and locations — bombing the *Tirpitz*, countering V1 buzz bombs, striking the Japanese in Sumatra and Okinawa, and becoming the first British carrier aircraft to overfly Tokyo. Firefly squadrons also took part in the Korean War, notably as air support for the landing of the U.S. Marines at Inchon. A total of 1,702 were built, the last in 1956, ending their days as target drones.

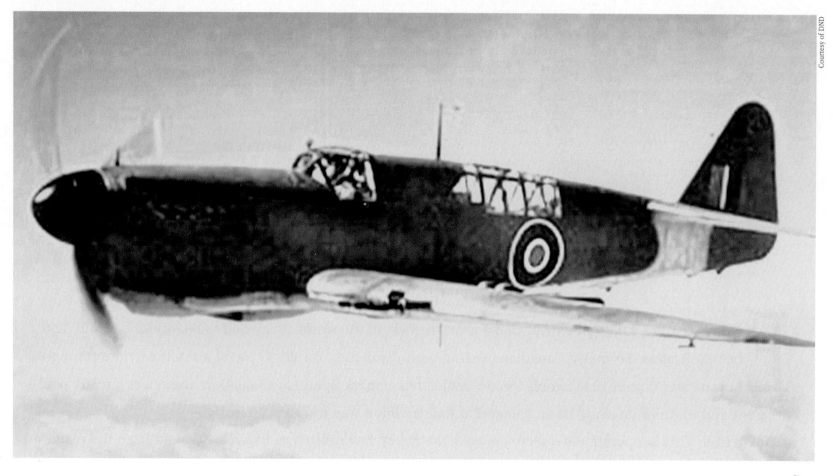

Fairey Firefly.

Anticipating a role in the Pacific, on May 24, 1945, Canada accepted from the Royal Navy the loan of two light fleet carriers, *Warrior* and *Magnificent*. With the end of the war, the Canadian government began having second thoughts, and only *Warrior* was accepted. But equipping it still required setting up two fighter and two torpedo-bomber squadrons, and naval headquarters in Ottawa wanted the Grumman Hellcat for the former. But influenced by its former Royal Navy pilots, the navy chose Fairey Fireflies instead, and of the four Royal Canadian Navy (RCN) squadrons put on board *Warrior*, 825 and 826 were equipped with

Fairey Firefly

Fairey Fireflys FR-Is and 803 and 883 with Supermarine Seafire Mark XVs. Later, when it was discovered that HMCS *Warrior* was ill-prepared for the cold North Atlantic — it had poor heating and had to winter on the West Coast in 1947 — it was returned and replaced with the other RN carrier, *Magnificent*.

The Firefly was a good post-war export for the British, having been sold to the naval air arms of Australia, Canada, and the Netherlands — all of whom had ex-British aircraft carriers. The RCN bought sixty-five Fireflies of the anti-submarine Mark AS-5 version; the purchase faced strong opposition from the "Buy American" lobby, who wanted the Grumman Hellcat. Because the anti-submarine Firefly AS-5s were not available, in February 1948, the RN also loaned them thirteen Firefly FR-IVs. These flew in the RN paint scheme of dark sea gray on the aircraft's upper surfaces and sky blue on the under surfaces, fuselage sides, and vertical tail. The FR-IVs were similar to the FR-Is, differing only in that the wings were clipped, a coolant radiator replaced the bearded type, and a more powerful Rolls Royce Griffon engine made it faster — 386 miles per hour compared with 316 miles per hour.

When it did arrive, the AS-5 was worth the wait. With the latest in electronics, it was able to detect submerged submarines through dropping sonobuoys. In 1951, after serving on the *Magnificent* and from shore, the Firefly was retired from RCN service, and some were sold to the Danish and Dutch air forces. In 1954, Canadian Fireflies were sold to the Ethiopian Air Force, then engaged in a war with its breakaway province of Eritrea. This proved fortunate, as in June 1993, an abandoned former RCN/Ethiopian Air Force Firefly was donated by the government of Eritrea to Canada, and that October, it was transported to the Canada Aviation Museum in Rockcliffe for renovation.

The Fireflies still flying dwindle every year. On July 12, 2003, a pilot and crew member were killed in the crash of the Royal Navy Fairey Firefly aircraft at the Imperial War Museum in Duxford, near Cambridge. Remaining are one at the Canadian Warplane Heritage Museum in Hamilton, Ontario, another at the Royal Navy Historic Flight at the Fleet Air Arm Museum at Yeovilton in Somerset, and a third, the Royal Australian Navy Historic Flight, at NAS Nowra in Australia.

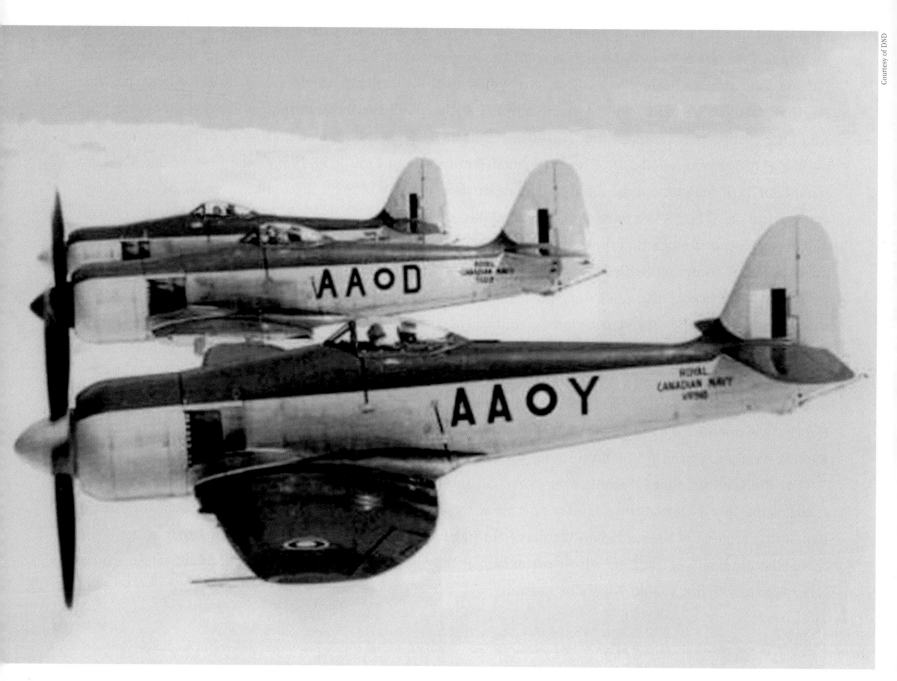

Hawker Sea Fury.

Hawker Sea Fury

Luftwaffe pilot Oberleutnant Arnim Faber had a bad day. On June 23, 1942, he landed his brand new Focke-Wulf 190A at RAF Pembrey, mistaking it for his own French airfield. The gift of the fearsome FW 190 was enough for the British Air Ministry to put out a specification for a similar machine to be built for the RAF. The first off the mark in 1943 was Hawker with a prototype called the Fury, but with the advent of jet fighters the RAF lost interest, and it was decided to make this aircraft a carrier-borne fighter instead. The Seafire, the Royal Navy's main fighter, had always been too delicate for carrier operations, and the rugged-looking Hawker Fury with its massive Centaurus engine and five-bladed propeller was the complete opposite. When the first production Sea Fury flew in 1944 with arrester hook and folding wings, it was the most comprehensive naval piston-engined fighter.

Unlike the Seafire and the Firefly, the Sea Fury was also to be a fighter bomber; it had a maximum speed of 460 miles per hour and two ninety-gallon drop tanks at range of one thousand miles. A total of seven hundred Sea Furies would be built, and Fleet Air Arm squadrons flew them in the Korean War until replaced by the Sea Hawk jet fighter in 1953.

Between May 24, 1948, and November 1953, the Royal Canadian Navy took seventy-five Sea Fury FB Mark IIs on strength for use by 803 Squadron and 883 Squadron on HMCS *Magnificent*. Like its predecessor, HMCS *Warrior*, the carrier was also on loan from the Royal Navy. Sea Furies were also flown operationally from the Canadian Naval Air Station HMCS Shearwater. In November 1952, to closer ally itself with the U.S. Navy, the RCN had 803 and 883 squadrons respectively renumbered as VF 870 and VF 871 squadrons.

While in RCN service, the Sea Furies never fired a shot in combat. In a twist of fate, in 1953, twelve of VF 871 Squadron's Sea Furies were loaned to the Royal Navy for the Korean War and were put on board on the British carrier HMS *Warrior*, the RCN's previous carrier. By 1956, the Sea Furies were gradually replaced by the Banshee, making the aircraft the RCN and the RN's final piston-engined fighter. The last Sea Fury was retired from the RCN on April 18, 1957.

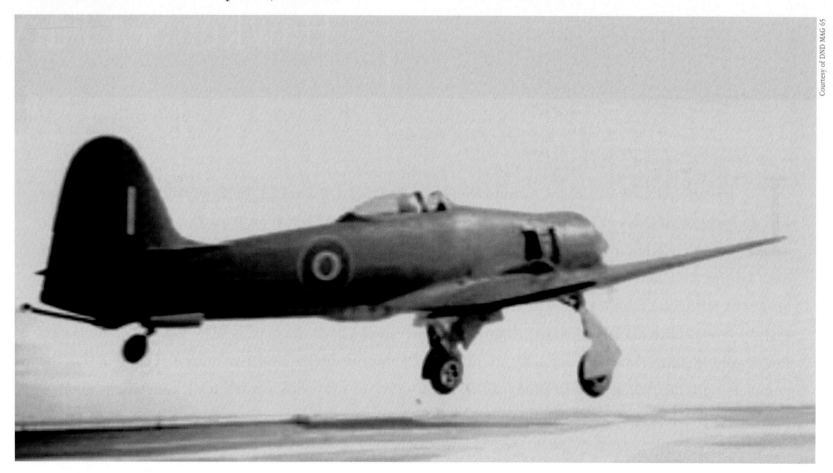

A Hawker Sea Fury on HMCS Magnificent.

De Havilland 83 Fox Moth

The DH 83 Fox Moth came into existence because De Havilland's chief designer, Arthur Hagg, loved sailing. But how was he to get himself and his family from the London plant to the coast on a Friday afternoon? Typically British, Hagg improvised. De Havilland was turning out Tiger Moths then, and Hagg took the wings, tail, undercarriage, and 120-horsepower Gipsy engine from that aircraft and put them onto a plywood fuselage with a cabin into which four people could squeeze. And so was born one of the most pleasing — and one of the tiniest — airliners in history.

Flying was still a very personal mode of transport when the Fox Moth was designed in 1932. Few were inclined to entrust their lives to canvas and wire devices when that mass people-mover, the train, was so dependable, solid, and safe. Thus, being able to carry a maximum of four passengers was all that small feeder airlines needed. The pilot sat above, in the open, behind the passengers, like an old-fashioned hansom cab driver. Later, in Canada, he enjoyed an enclosed cockpit. The Fox Moth's wing roots were low to allow them to fold — small companies and private owners could not afford hangars and used sheds and barns instead. The prototype Fox Moth, G-ABUA, flew at Stagg Lane on January 29, 1932, and was immediately

sent to Downsview, Ontario, for evaluation on skis and floats. It performed so well on both that, registered as CF-API, it was still flying in 1950. Six others followed it to Canada, and in total ninety-eight Fox Moths were built in Britain and two in Australia. They were so affordable and cheap to operate that they actually made their owners money. The DH 83 was also popular as a "starter" for small operators, and in January 1937, the first aircraft that Ginger Coote bought to begin his company with was CF-API.

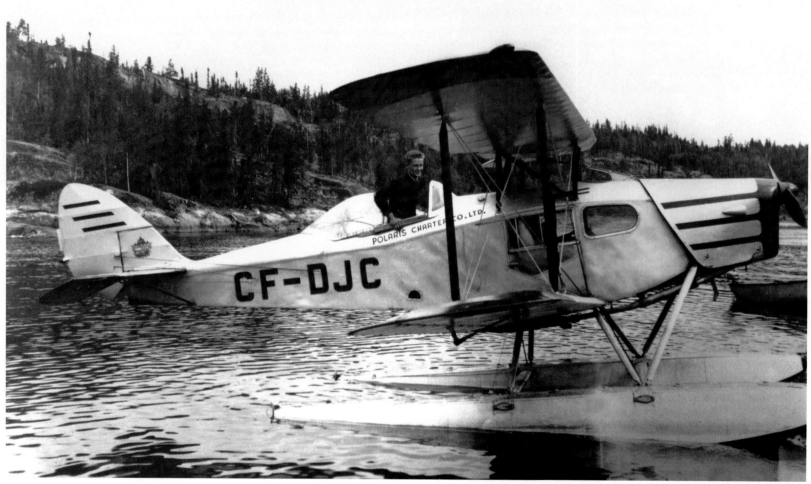

Max Ward, proud owner of Polaris Charter Co. Ltd. Saving up enough after instructing in the BCATP and flying for Jack Moar's Northern Lights, Ward bought Fox Moth 83C CF-DJC directly from the De Havilland plant at Downsview.

Immediately after the Second World War ended, De Havilland Canada, feeling the loss of its Mosquito production, looked around for an aircraft to make. The Downsview plant still had plenty of plywood and

De Havilland 83 Fox Moth

Tiger Moth parts, and the workforce that had built that aircraft (and all the Mosquitos) was still available. Company president Phil Garratt knew that former De Havilland customers would return to upgrade if an improved version of the DH 83 was available. From 1946 to 1948, De Havilland built a Canadianized version of the 1932 Fox Moth, the DH 83C (for Canadian). Bush pilots liked the post-war improvements: a more powerful 145-horsepower Gipsy engine, a strengthened cabin floor, and an enlarged left-hand door for freight. Proving Garratt correct, Arthur Fecteau, a pre-war DH 83 customer from Senneterre, Quebec, bought the first post-war DH 83, CF-BFI, when it came off the line in early 1946.

Another customer was the young Max Ward. Using his savings from instructing during the British Commonwealth Air Training Plan and a loan from a friend, Ward bought No. 29 for his air company, Polaris Air Charter Co. Although there were many trials, tribulations, and types of aircraft ahead for the young man, the little Fox Moth would be instrumental in launching Wardair, one day to become Canada's third largest airline. In 1980, in appreciation of the aircraft, Ward had a replica of his original DH 83C built and donated it to the National Aviation Museum in Ottawa.

In total, De Havilland Canada would build fifty-three DH 83Cs, exporting sixteen. Garratt had guessed right. As there had been in 1932, there was still a market in Canada for Arthur Hagg's family runabout.

ON CANADIAN WINGS | A CENTURY OF FLIGHT

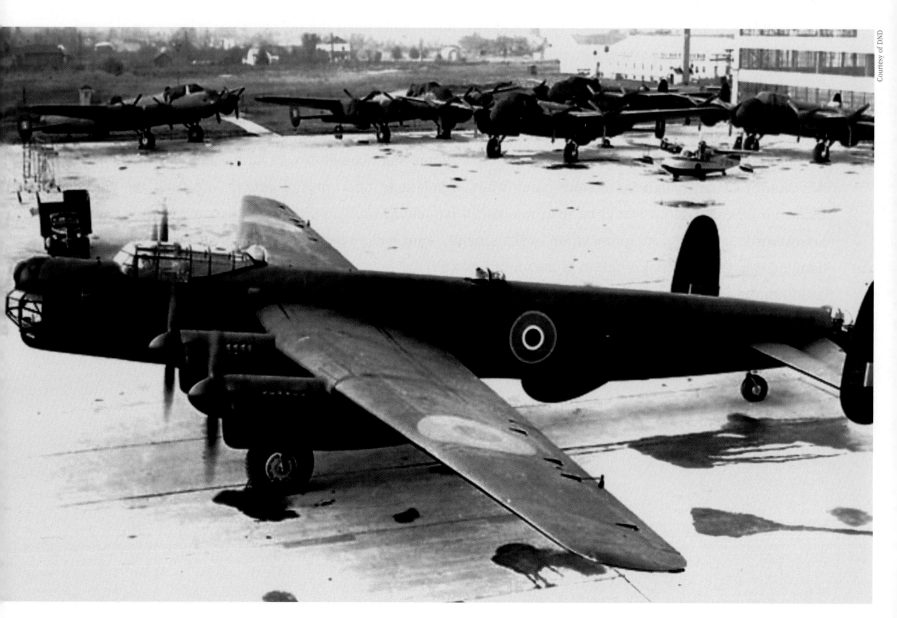

AVRO 694 Lincoln.

Avro Lincoln

Here was the natural progression from the Lancaster bomber. Had the atomic bomb not been used or the jet engine invented, the Lincoln might have achieved the fame of its predecessor. Instead, it served out its time in the Royal Air Force as an anachronism and the single example in Canada as an aeronautical curiosity.

In 1943, the Air Ministry was already considering the Lancaster's replacement and drew up specification B14/43. Avro obliged with the Lincoln, a high-altitude bomber that used many of the Lancaster's components. The prototype flew on June 9, 1944, and by VE Day, fifty had been built and test-flown. In all, Avro would build 582 Lincolns, and for twenty years they served as the RAF's last piston bomber. Thirty were exported to Argentina, and the Government Aircraft Factory in Australia built forty-three. In Canada, a single Lincoln was built by Victory Aircraft and orphaned, a story in itself...

By late 1944, with the war in Europe near its end, both the Royal Air Force and the Royal Canadian Air Force could consider transferring their long-range bombers to the Pacific theatre. Aware that the United States had shouldered the entire bombing campaign against the Japanese homeland, the British wanted to

make a major contribution. To that effect, three very long range bomber groups (one RAF, one RCAF, one a British Commonwealth formation), each consisting of twenty-two squadrons, were created and code-named "Tiger Force." The new Avro Lincoln was to be their mainstay.

For Tiger Force, the Canadian government terminated the Lancaster X contract with Victory Aircraft and ordered two hundred Lancaster XVs, designated Lincolns. The company must have welcomed this: having gained considerable experience with its Lancaster X production and having also built an Avro 683 X transport and a York, it was well positioned in the long-range bomber field. It also wanted to retain its trained personnel for civilian contracts after the war. Using the X airframe, the Lincoln FM 300 was given a new nose, a stretched rear, enlarged rudders with larger trim tabs, and more powerful 1,750-horsepower Merlin 68 engines in new nacelles. The nose and tail gun turrets were upgraded with the new Boulton-Paul F & D turrets fitted with .50-inch guns instead of the old Fraser-Nash turrets of the X.

But time was running out for the Lincoln. In March 1945, Tiger Force was scaled down to two groups, considerably smaller than originally proposed, and the Lincoln's future did not look so bright. By May, the RCAF units earmarked for Tiger Force were being returned to Canada for training and reorganization. The plan was for the wings to commence training for the Pacific in August, with the first wing to arrive there by December. The bombing of Hiroshima and Nagasaki, and the subsequent capitulation of Japan on August 14, 1945, made Tiger Force unnecessary, and on September 5, 1945, the conversion wings were disbanded.

As a result, when FM 300 was test-flown on October 25, 1945, it was the only Lincoln B Mark XV built. It was also the only Lincoln ever purchased by the RCAF, and it was put on strength from August 17, 1946, to March 4, 1947. Victory Aircraft was now owned by A.V. Roe Canada, and they wanted to build transports for the RCAF. Called the Tudor, the sixty-passenger aircraft was to use as many of the leftover Lancaster parts as possible, and the Lincoln was abandoned and possibly cannibalized. In September 1946, the RCAF cancelled the Tudor project, opting instead for North Stars.

The RAF's Lincoln squadrons saw action only once, when a detachment bombed terrorists in Malaya. The Australians and Argentinians scrapped their last Lincolns in 1965. If the Lincoln did live on, it was in the RAF's Avro 696 Shackleton.

Vickers Viscount

In promoting the Viscount with its turbine engines, Trans Canada Airlines president Gordon McGregor loved quoting Sir Frank Whittle, the inventor of the jet engine, who said, "Reciprocating motion might be all right biologically, but mechanically it stinks!" After the airline's experiences with its North Star Merlin engines, the turbine-powered Viscount was quiet, smooth, and reliable.

After the war, rather than compete with the United States in developing piston engines, the British ventured into turboprop power. Vickers-Armstrong decided that their next aircraft would be a pressurized, low-wing monoplane with tricycle undercarriage, single fin, and four turboprop engines. Three such engines were tested: the Rolls Royce Dart, the Armstrong Siddeley Mamba, and the Napier Naiad. The Dart was chosen because the sturdy, centrifugal-compressor type of engine attained full operational reliability faster than the others, which were axial flow units. Designed to carry thirty-two passengers and cruise at 275 miles per hour, the new aircraft was tentatively called Viceroy after the British viceroy of India, Lord Louis Mountbatten. When India became independent in August 1947, the office of viceroy was abolished and the aircraft was renamed the Viscount.

ON CANADIAN WINGS | A CENTURY OF FLIGHT

On July 16, 1948, Vickers test pilot Captain J. Summers took the prototype Model 630 into the air for the first time and was so successful that Vickers showed it off at the Farnborough Air Show that year. When Gordon McGregor went to the 1949 air show, he was given a demonstration flight in the 630. He later wrote

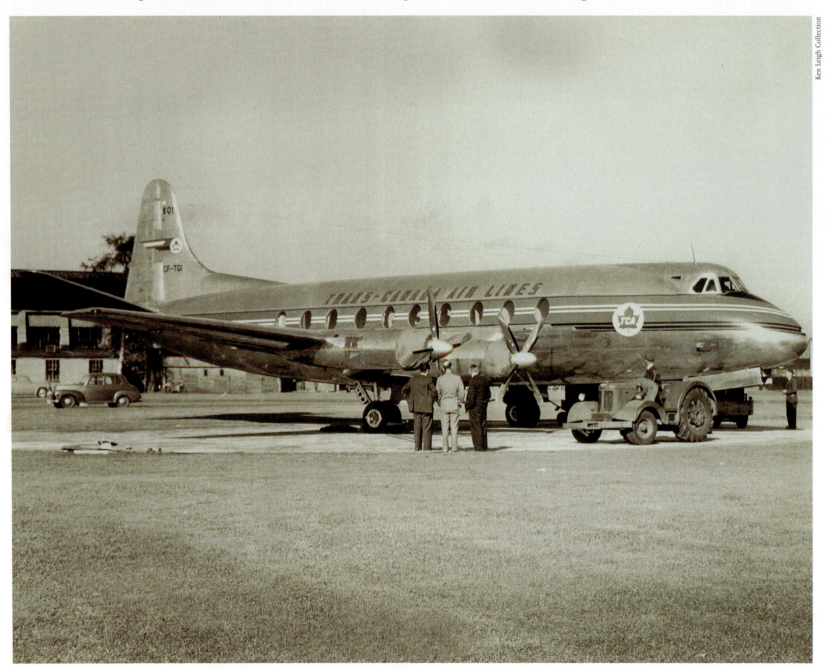

TCA's first Viscount at Weybridge immediately prior to delivery.

of it, "Never having flown other than piston-engined aircraft I was tremendously impressed with the smoothness of the four Dart turboprop engines. As I sat in the cabin, a coin was balanced on its edge on the table in front of me, and a mechanical pencil stood on its non-business end." McGregor, a former fighter pilot, then flew the Viscount himself — and was smitten.

The Viscount's lack of vibration and noise was due to the Dart gas turbine engine having no reciprocating parts, such as pistons and valves. More powerful Rolls Royce Type R Da-3 Darts were fitted to later Viscounts, allowing them to cruise at speeds in excess of 300 miles per hour. But turboprops were still unknown in North America, and when McGregor recommended the purchase of seventeen Viscount 724s, many in TCA Engineering favoured the piston-engined Convair-Liner 340 instead. It took the combined force of McGregor's popularity and Vickers's promise to make any design changes required by the Canadians to carry the sales through.

TCA sent a team in the fall of 1954 to the Vickers plant at Weybridge, where the Viscounts were being modified for the Canadian market, and by December, the first TCA Viscount was ready. On December 6, 1954, with Jock Bryce of Vickers and TCA's George Lothian as crew, CF-TGI took off for Montreal. The flight across the Atlantic was memorable. On the way, they were delayed at Iceland for two days because of the weather and then made for Bluie West One, Greenland. They entered "Tuna," or Tununggassdg Fjord, the only way into the Greenland airport, and for forty-eight miles flew down the twisting waterway

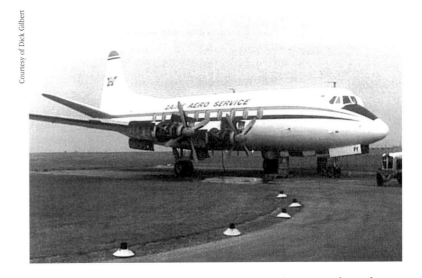

Former Air Canada Viscount prior to leaving for Africa.

with mountains towering on either side until they saw the plateau with the single runway. The flight was made worse when the centre cockpit window cracked. On the final leg between Goose Bay and Montreal, a TCA North Star filled with the media came out escort them. At Dorval, asked to do a "shoot up" of the airport, Bryce and Lothian complied, skimming about five feet above the hangars and executing a vertical bank inside the perimeter — with the wingtip three feet off the ground. Among the welcoming crowd at the terminal was Gordon McGregor. The Viscount had officially joined TCA — an airline that it would serve faithfully for two decades. For TCA and Vickers, the Viscount was a public relations coup. Passengers loved the quiet ride and

panoramic windows. No other airline in North America flew turboprop airliners then, and no other British aircraft was bought by American airlines in such quantity — nor would one ever be again. There was great curiosity about the aircraft in the United States, and one day even the reclusive Howard Hughes showed up at Dorval to be checked out on it by George Lothian.

As with every aircraft, the Viscount had its stories. There was the "ghost" problem. In humid conditions, the ventilation system created heavy condensation that came up from under the passengers' seats like steam. Some passengers thought that the aircraft was on fire, others that an extrasensory phenomenon was manifesting itself from under them. The "stroboscope effect" was even spookier. One night, an elderly lady sitting at the window asked the stewardess if they were in any danger because the two propellers on the wing outside were no longer turning. The stewardess saw that she was correct and ran to the flight deck to report that the starboard engines had stopped. The crew laughed and pointed to the instruments to assure her that all four engines were indeed working, but she stuck to her contention that they had stopped. Eventually, for the sake of peace, the captain had the first officer return with her "to see what all the fuss was about." He came back and said, "They sure appear to be stopped, but of course they are not." Subsequent investigation determined that the anti-collision lights were illuminating the propeller blades at the instant they were in the same radial position. As all engine speeds were synchronized, the blades appeared to be stationary.

Trans Canada Airlines also bought thirteen Viscount 757s in 1955. Four Viscounts would be lost in service. On November 10, 1958, a Seaboard & Western Airlines Super Constellation on takeoff at Idlewild Airport suffered a propeller reversal and, out of control, hit the empty TCA Viscount, CF-TGL, that was about to be boarded. The second accident occurred at Malton on October 3, 1959, when the crew on CF-TGY was carrying out an instrument landing system (ILS) approach in heavy rain. In the poor visibility the pilot misjudged the distance, and the Viscount hit a water tower, landing thirty-four hundred feet short of the runway. None of the thirty-four passengers was injured. On June 13, 1964, CF-THT landed short of the runway at Malton and was written off. Finally, CF-THK burned on the runway at Sept Isles, Quebec, on April 7, 1969, with one fatality — the only one in four Viscount emergencies.

What killed the little airliner was seat economics. By the mid-1960s it was too small for the high-density inter-city routes and didn't have the range for the medium ones. To pack more passengers in, TCA reconfigured its Viscount several times, but as it had once replaced the DC-3, the Viscount was itself replaced by another Douglas machine, the DC-9. On April 27, 1974, the last two Air Canada Viscounts landed at Toronto and Montreal and marked the end of an era.

Vickers Viscount

The Viscounts were stored at Winnipeg until gradually sold off, some crossing the Atlantic once more. In 1978, some of them were bought by Alidair and Field Aircraft Services, two British companies that specialized in refurbishing Viscounts, and were flown to East Midlands Airport in the United Kingdom. They were then repainted in various liveries and sold again, mostly to African companies. In October 1978, four were made ready to depart to Zaire, where CF-TIF became 9Q-CPY, CF-THU became 9Q-CPD, CF-THV became 9Q-CKB, and CF-THY became 9Q-CKS. They flew for Zaire Aero Service, an airline that lasted three years. As late as 1995, the former TCA/Air Canada Viscounts' hulks could still be seen at Kinshasa Airport.

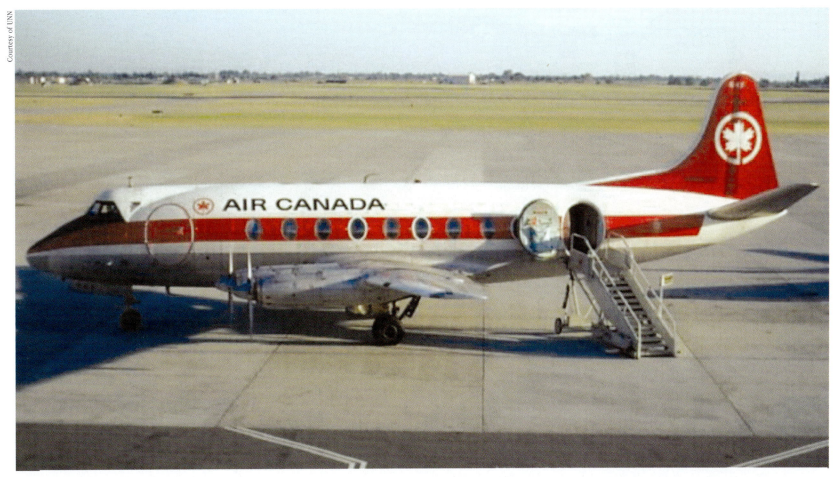

Viscount in Air Canada service.

ON CANADIAN WINGS | A Century of Flight

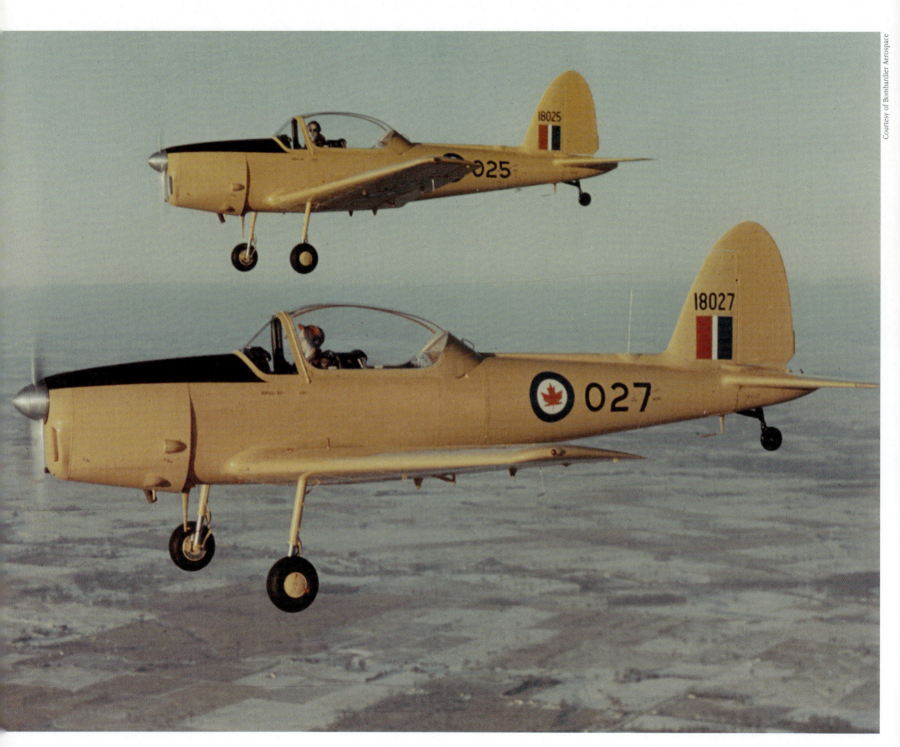

De Havilland Chipmunks in flight.

De Havilland Chipmunk

Bob Fassold is a former RCAF/CF pilot and civilian airline transport pilot, and no one knows the De Havilland Chipmunk better. He tells his story below:

The Chipmunk entered RCAF service over fifty years ago. Who would have thought back then that it arguably would be the most pilot-popular training aircraft ever made, would be used in more countries (over sixty) and be in longer continuous military service (forty-eight years in the U.K.) than any such aircraft in the history of aviation? It also was the first Canadian designed aircraft to be manufactured overseas.

In 1995, Fassold acquired a 1956 ex-RCAF Chipmunk with civilian registration CF-RRI. The RCAF tail number was 18025, and it had served with the RCAF at Centralia from 1956 to its retirement in 1964.

Curiously, this impressive Canadian achievement seems not to receive the recognition it deserves. Despite the fact that it was the first of de Havilland Canada's world famous flying mammals

(Chipmunk, Beaver, Otter, Caribou, Buffalo) — all brilliantly designed for their roles — unawareness of the Chipmunk seems widespread in Canada, even among those claiming to be aviation enthusiasts. Perhaps this is because, as a pilot trainer, it was more or less confined to the training environment, mainly in the military, and not very visible beyond. Nevertheless, this apparent lack of appreciation is an annoyance to Chipmunk enthusiasts!

Actually, most RCAF pilots of the day knew little of the Chipmunk. Of those who did, few were enamoured with it — or at least not with its role. It was used in the RCAF as a primary trainer and selection tool for aptitude to become an RCAF pilot. Initially pilot intakes were alternated between going directly to the Harvard or going first to the Chipmunk and, if successful there, then to the Harvard. Comparison of failure rates apparently supported the cost-effectiveness of initial training/selection on the Chipmunk.

For many, therefore, the Chipmunk was simply a stepping stone to the Harvard, eventually their RCAF "pilot wings," and they never flew it again. Some instructed on them, but usually a tour of duty as a basic flying instructor was something to be endured en route to the desired flying job ... hopefully. For many other Canadians, though, the Chipmunk was pivotal in their lives: encountering it was the beginning and the end of their aspirations to be an RCAF pilot! When I joined the RCAF my intake of pilot candidates went straight to the Harvard. I flew RCAF Chipmunks only years later when on military-sponsored university training. Though a student I was still an RCAF pilot and had to get in my quarterly flying hours to get my flying pay. I had flying postings in the summers, but during the academic year I would have to get my flying hours on weekends ... somewhere. For one of those years I did this at RCAF Station Centralia. There were lots of Chipmunks there at the time and it was hard to get your hands on something more "impressive" such as a Harvard or Expeditor. I enjoyed it, even though it was sort of a toy compared to what I had been flying, but of course flying anything was a welcomed change from university studies. I recall, though, that trying to get in a bunch of hours on one visit to the base was "bum-numbing" on those hard seatpack parachutes.

I certainly never then had any thoughts of ever owning and operating one privately, let alone commercially. Indeed, my eventual acquisition of a Chipmunk was a consequence of a number of factors, but these did not include any intimate knowledge or real appreciation of its attributes. I wanted a simple, vintage, all-season aircraft that would be fun to fly. I always liked the appearance of the Chipmunk, it is a simple vintage aircraft, Canadian designed and built, and historically important. In addition, it is a former RCAF trainer which I had flown (a bit), it has an authentic WWII fighter-type cockpit with bubble canopy, and it has a

De Havilland Chipmunk

cockpit heater which makes it reasonably comfortable in Canadian winters. Finally, there were two or three for sale in Canada at the time. But it was only after acquisition and getting to know each other intimately (so to speak) that I realized what a treasure is the Chipmunk … and talk about fun to fly!

To most aviation enthusiasts the lines of the Chipmunk are very appealing. Just sitting on the ground and from any angle it seems to be saying: "I want to go flying!" Indeed, it always does, and its enthusiasm is infectious. You don't need to be going anywhere because as soon as the wheels leave the ground you both are where you want to be. The controls are beautifully balanced and so fingertip light in all phases of normal flight that the aircraft seems to fly itself to whatever your whim. So little trim is ever required that the elevator trim control could be removed from the cockpit and you'd never miss it.

Due the sensitivity and responsiveness of the flying controls, the Chipmunk does require close attention to fly accurately. It also has its own personality … bordering on mischievous. For example, landings, regardless of experience, effort, and concentration, always seem to end up being a little different than intended or expected. More significant, like nearly all training aircraft of the 1950s, it is a tailwheeled aircraft, commonly called a "taildragger." These are more unstable and trickier to handle in take-offs, landings, and taxiing than are most nosegeared aircraft ("tricycles"), on which nearly all pilots now learn to fly. This is especially so in strong winds when taildraggers (large or small) are poised to demonstrate their intolerance of poor judgment, carelessness, or inadequate skills on the part of their pilots. They can quite happily take

The very agile "Chippie": the Duke of Edinburgh and Prince Charles both learned to fly on Chipmunks.

you on an unintended tour of the airfield. But in comparison to many other types of taildraggers, the Chipmunk is really quite docile with respect to such willfulness.

Certainly for pilots accustomed to tailwheels, the Chipmunk is not a difficult aircraft to manage in takeoffs or landings. In the latter it is quite forgiving of reasonable misjudgments due to the wide track and excellent shock-absorbing design of the main gear. For most pilots, though, the hand-brake system, in conjunction with the freely castoring tailwheel (non-steerable, non-lockable — all as in the Spitfire), requires a bit of getting used to. And in the Chipmunk (unlike the Spitfire), the brake lever is a completely separate control. Therefore, since few pilots have three arms, differential braking is not safely available for directional control on takeoff or the initial phase of landing.

Adding to the "interest" in Chipmunk handling, its Gipsy Major engine runs in the opposite direction to most aircraft piston engines: as viewed from the cockpit the propeller rotates counterclockwise. This means that the *left*, rather than the usual right rudder, is required to counter torque effects in the take-off and climb. Through reflex, pilots new to the Chipmunk may apply rudder in the wrong direction on their first few takeoffs. This can lead to a not very pretty and sometimes a bit too exciting departure.

In the air the Chipmunk is a very nimble aircraft and revels in steep turns. Fully aerobatic, it performs all standard manoeuvres gracefully and with only light positive G loads. However, negative G must be avoided because of the simple design of the fuel system. Also, care must be taken not to overspeed the engine in dives. Ordinary stalls are routine in the Chipmunk and recovery is easy. Response to high-speed stalls (induced from very steep turns) can be rather unpredictable but are easily managed with proper technique. Spin entries sometimes can be a bit exciting, and some believe (especially in the U.K.) that recovery from spins can be difficult. In fact, the Chipmunk will recover from a spin on its own if the pilot releases all controls.

It is not a particularly good cross-country aircraft, nor was it intended to be. Although the cruising speed is reasonable at about 100K, and it has adequate range between necessary fuel stops, there is no storage space. With two on board, occupants can carry little more than a toothbrush. On the other hand, with its bubble canopy and unrestricted visibility from the cockpit, it is a great aircraft for sightseeing. In warm weather, flying with the canopy open doubles the enjoyment.

It should be noted that there are some differences between Chipmunks made in Canada and those produced overseas. The most obvious is the bubble canopy on the Canadian Chipmunk versus the "greenhouse" canopy on the British Chipmunk. There are other small differences, but the handling and performance are

essentially the same for all "stock" Chipmunks. Over the years, however, a number of Chipmunks have been modified with a more modern and more powerful engine. This changes the shape of the nose of the aircraft and usually the size and shape of the vertical tail and rudder, all of which are appealing features of the original Chipmunk. Aircraft so modified are commonly called "super" Chipmunks, and the handling and performance differs from the original. A few Chipmunks have been modified more extensively, and their origin is barely detectable on first sight. To the purist at least, none of these are really Chipmunks, but they have their advantages, are usually attention-getters parked among other aircraft, and can be very popular with owners.

From a pilot's perspective the nature of the Chipmunk was beautifully and succinctly described by [Squadron Leader] Ced Hughes (RAF) with many years and thousands of hours instructing on Chipmunks. In a 1996 BBC interview in connection with the RAF's commemorative around-the-world flight with two Chipmunks he summed it up as follows: "The Chipmunk is a very simple aircraft and easy to fly in many respects, but it's very difficult to fly the aircraft accurately. You think you've got the measure of the beast and then it suddenly lets you know that you are not quite the master— and so it's always a challenge!"

S/L Hughes is right, flying the Chipmunk is always a challenge, but it also is always fun. It is simply a joy to fly ... or fly in, but the feelings generated cannot be captured adequately in words. They perhaps can best be imparted to the uninitiated through observing a Chipmunk taxiing in after a flight: both the aircraft and the occupants all will be sporting wide grins!

Fassold has operated his Chipmunk commercially from Ottawa since 1996. Due the nature of his year-round flying operation (pilot training and short duration passenger flights), he has now enjoyed thousands of flights in 18025 and even more takeoffs and landings. Being responsible for all maintenance and repair (and the cost thereof), he has also, as he puts it, been forced to learn more than he ever really wanted to know about the Chipmunk and its Gipsy Major engine. Consequently, he now is quite widely regarded as a practical expert in the operation of a Chipmunk. Fassold, however, notes, "There are others in Canada and the U.K. who are far more of an expert on the Chipmunk than I, but I will admit there likely are few if any who currently fly it as regularly or as much, on a per-flight basis." Since this has included as many as 40 flights in one day, over 160 flights in one month, and well over 700 flights in one year, there can be little doubt that he is well qualified to comment on this unique aircraft.

ON CANADIAN WINGS | A CENTURY OF FLIGHT

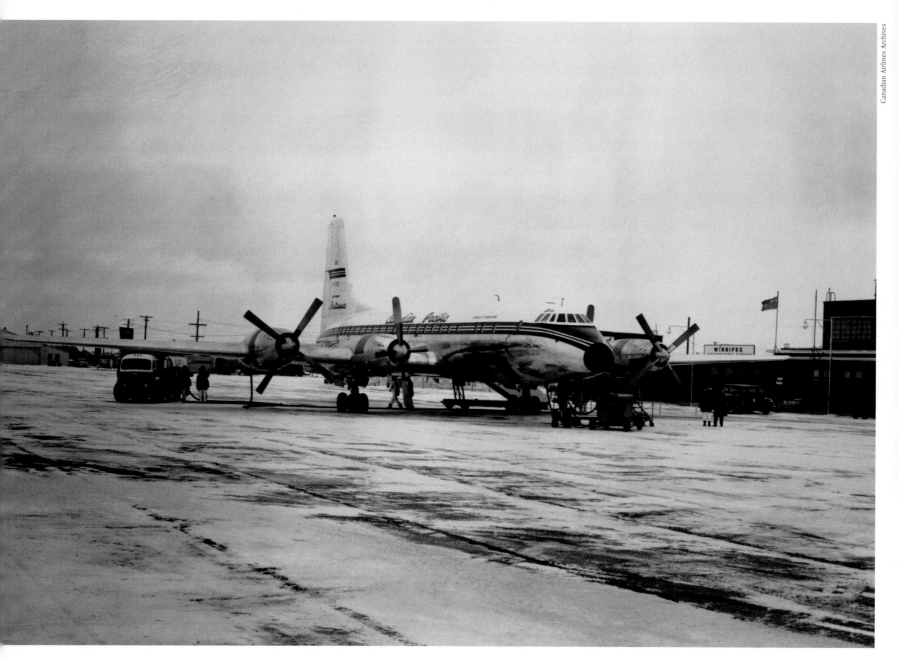

Lion in winter: Bristol Britannia at Winnipeg.

Bristol Britannia

In Greek mythology, Proteus tried to kill Bellerophon, the rider of the winged horse Pegasus. In aeronautical history, Proteus the turboprop engine almost did the same to Britannia, the "Whispering Giant." An aircraft that could have captured for Britain the lead in post-war commercial aviation, the Britannia was effectively sabotaged by its engine and its prime customer.

Jupiter, Pegasus, Mercury, Hercules ... Bristol's aero engines set industry standards, and in 1945, its Centaurus 660 radial was so superior to any American engine that Bristol wanted British Overseas Airways Corporation (BOAC) to buy Lockheed 749 Constellations to put them into. Lacking the dollars to do so, the British government told Bristol to build its own passenger aircraft. The company did so, naming them Britannias, and BOAC ordered twenty-five of the aircraft but then demanded that they use turboprop Proteus engines instead of the Centaurus. The Proteus was being developed to power the elephantine Saunders-Roe Princess flying boat, and in 1950 it was still in the experimental stage. Re-engining meant that the Britannia prototype, G-ALBO, did not make its first flight until August 16, 1952. It was still faster than the DC-6B, but, as Bristol warned, the Proteus was prone to flaming out in mid-flight. Then BOAC

wanted a stretch version of the "Brit" fuselage to compete with the Lockheed Constellation, especially on the Atlantic crossing. While Bristol extended the fuselage by ten feet, three inches, BOAC, fretting at the delay, bought Douglas DC-7Cs for its transatlantic route and cut back on its Britannia order. It would not be until February 1, 1957, that the Britannia's first revenue flight took place, and by then Pan American had its 707s in service. Because of the airline's intransigence, Bristol had lost out. Had the Britannia appeared in 1950, when it was faster than every American aircraft, it would have put the British in the forefront of commercial aviation sales. Now, competing with the Boeing 707s, the turboprop airliner had become passé.

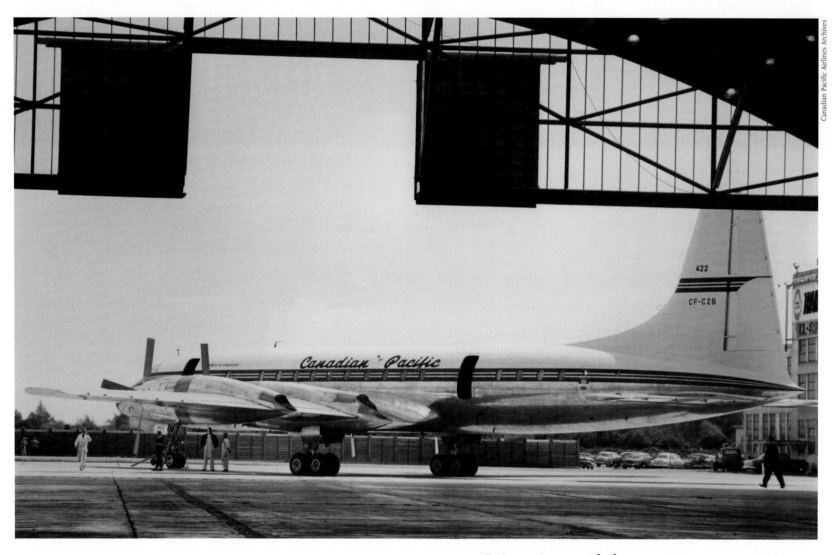

Britannia outside hangar, Vancouver, 1958.

Bristol Britannia

On April 1, 1958, with its special Britannia Hangar at Vancouver Airport completed, Canadian Pacific Air Lines took delivery of CF-CZA, the first of six Series 314 Britannias. They were followed by two of the 324 series, which were leased from Bristol in October 1959. All the Canadian Pacific aircraft were built at Short's in Belfast. They were the airline's first turboprop aircraft, and with the exception of the short-lived Comets, its first British airliners. Airline president Grant McConachie used the Britannias to break the transcontinental monopoly that the government-owned Trans Canada Airlines had. But up against TCA's DC-8s, they lost out in speed and popularity, and CPAL switched them to its northern routes.

BOAC had capitalized on the relative quiet of the Proteus engines by advertising their Brits as "Whispering Giants," and on the ground the Britannia inspired awe. Stately and imposing, almost Edwardian in style, it looked as though it should be flying the colours of steamship companies like Cunard or the White Star Line. To the Canadian Pacific Air Lines crews the aircraft were less imaginatively known as the "Brutes." To the passengers and ground crew, because of the peculiar smell from the engine exhausts, they were the "Anglo Saxon Bunsen Burners."

Canadian Pacific pilots referred to the Proteus as the "Greek God of the Flame-out." Bristol had installed an excellent relighting device so that when an engine flamed out, it relit within seconds. Despite its size, the aircraft could cruise on three or even two engines. But the most memorable of all features was the Britannia's ice protection system. While it used heat bled from the engines for most functions, the tailplane, the leading edges of the fin, and the elevator horn balances had electrically heated Napier spray mats instead. When these short-circuited in ice conditions at night, the result was spectacular. The wires that were embedded in the mats would start arcing, and from the cockpit it looked like the northern lights. The passengers thought that the tail was on fire!

BOAC put 139 passengers into the aircraft, but CPAL carried only 89 on the long routes and 110 otherwise. As they would to their Douglas and Boeing airliners, Canadian Pacific elevated their Britannias to the status of Empresses — the title befitting so regal an aircraft. One, CF-CZB, was lost when it crashed at Honolulu on July 22, 1962. What killed the others was the incoming jet age; BOAC retired its Brits in 1965, to be followed by CPAL, which by February 1966 had disposed of all of its own. The Canadian Pacific giants went to charter carriers Caledonian Airways, Transglobe, or Cunard Eagle. A total of eighty-five Britannias were built. The final flight took place in 1997, when EL-WXA landed at the aviation museum in Kemble, England. But a good airframe never dies, and in Canada, the Britannia (or parts of it) was reincarnated as the Canadair CL-28 Argus and CL-44 Yukon.

ON CANADIAN WINGS | A CENTURY OF FLIGHT

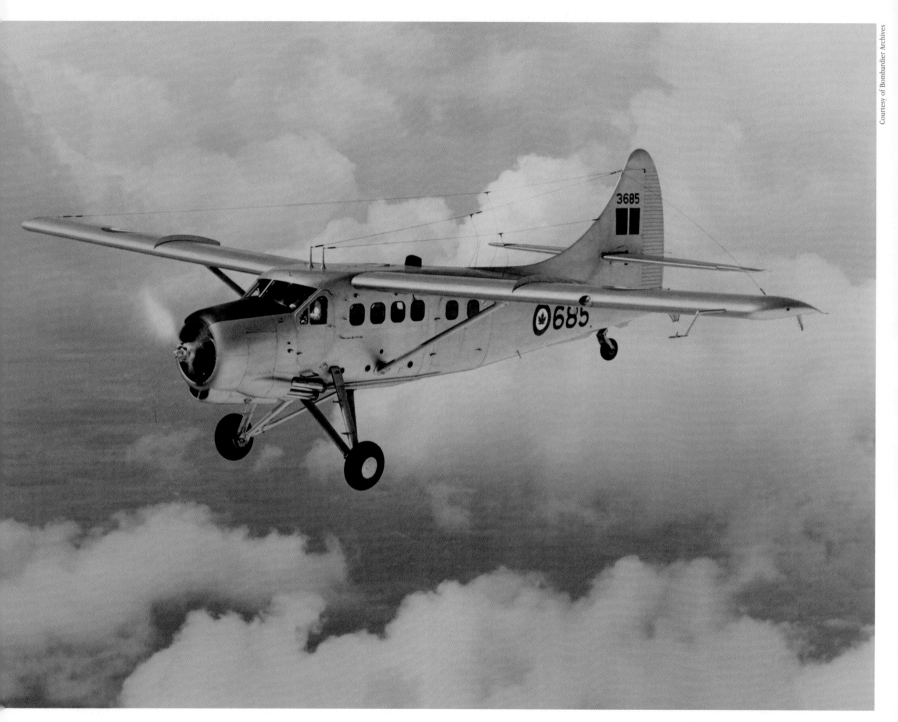

De Havilland Canada Otter.

De Havilland Canada Otter

On a rainy day in March 1972, at Shannon Airport in Ireland, Karl Hayes saw his first Otter, "a somewhat shot looking former U.S. Army aircraft, still in its drab military colours, with ferry registration crudely applied. It was on its way home after many years of service in Europe, about to set off on the long Atlantic crossing." He thought it a beautiful aircraft. "My admiration for the courage of the pilot about to fly it across thousands of miles of ocean knows no bounds. More than thirty years later, my affection for the Otter remains undiminished." Hayes never forgot that moment and wrote this all too brief assessment of the Otter's place in history.

When De Havilland Canada in the late 1940s turned their attention to building the DHC-2 Beaver, they created what is arguably the world's finest bush plane, certainly the most successful. With a massive production run of 1,692, Beavers were flowing off the production line at Downsview for all of twenty years, from 1947 until 1967.

With the Beaver program well established, DHC went on to consider their next aircraft. They decided to build on the Beaver's success and to develop the basic concept into a larger aircraft, which would

carry twice the payload but with the same performance. The DHC-3 was initially to be known as the King Beaver, but was renamed the Otter before the prototype's first flight on December 12, 1951. Chief Test Pilot George Neal taxied the prototype Otter, CF-DYK, onto the airfield at Downsview and took off from the same six-hundred-foot stretch of runway that the Beaver had used to become airborne, indicating that the design team had been successful in their efforts.

With the test program completed, and certification achieved in November 1952, deliveries to customers commenced. Like the Beaver, the Otter would also remain in production at Downsview until 1967, and during its 16-year production run, a total of 466 were built which were sold to military customers (350), airlines/bush operators (69), government customers (36), and corporate exploration (11).

The first deliveries were for Canadian bush operators like Arthur Fecteau in Quebec and Max Ward in Yellowknife, Northwest Territories. But as the sales figures show, the Otter sold primarily as a military aircraft. The RCAF, which had not ordered the Beaver, acquired sixty-six Otters. The Otter was to have a long and distinguished career with the Canadian military until it was phased out in 1982. It flew with Communications and Rescue Flights and Station Flights throughout the country, as well as with Auxiliary Squadrons and then with the Reserves.

An order for 190 Otters from the U.S. Army assured the success of the project. Legend has it that Russ Bannock, the DHC sales director, "slipped" an Otter into a run-off competition which the army was conducting between two helicopter types at Fort Bragg, North Carolina. So successful was the Otter compared to both helicopters that the army decided it could not do without the type, which in army service was designated the U-1A. On one particularly oppressive midsummer afternoon, the Otter astounded everyone at the competition by beating the takeoff distance of a helicopter of identical power over a fifty-foot obstacle while carrying double the helicopter's load.

The DHC-3 also saw widespread service with the United Nations in many of the world's trouble spots. The UN operated eight of its own Otters, flown by Swedish personnel in the Belgian Congo and by Canadians in the Yemen. RCAF Otters were flown on UN missions in the Sinai desert for all of ten years from 1956 to 1966, and for shorter periods in New Guinea and Kashmir.

Over the years, the military retired their Otters, which migrated home to Canada. There is now only one active military Otter anywhere in the world, that honour falling to the U.S. Navy's tail number 144670, based at Patuxent River Naval Air Station with the Naval Test Pilots School. They plan to keep it in service indefinitely, as it is ideal for giving experience of a large, piston-engined, tailwheel

aircraft to aspiring test pilots. 670 is colloquially known as "The Humbler," as many of the navy's finest have found it a handful.

There are some 160 Otters still flying, mostly in their native Canada and in Alaska, but a handful in such exotic places as Australia and Fiji. There is only one active Otter in all of Europe, with a skydiving club in Sweden. Today, Harbour Air in Vancouver and Kenmore Air Harbor in Seattle both operate large fleets of Otters on such commuter services, showing that the Dash 3 is as useful in built-up areas as it is in the bush.

If there is one criticism which the Otter has consistently suffered from, it is its P&W R-1340 engine, which did leave the aircraft somewhat underpowered, and there have been many instances of engine failure over the years. Realizing that the Otter needed a more powerful and reliable engine, a number of projects tackled the problem and came up with different solutions. More than half of the 160 or so Otters still flying have been re-engined, and the "classic" Otter will soon be a rarity.

Bush pilot Ken Webster, who has also had experience with the Otter, and especially with the re-engined Otter, wrote:

The Turbo Otter is in many ways much like the old standard Otter, but the addition of a turbine engine has changed the performance significantly. The new and improved Otter breaks the water much like the old standard Otter, but once airborne the flaps come up and you can pull the nose up, unlike the conventional Otter. There is little vibration and the smell of burnt avgas no longer exists, but the exhaust pours out the smell of jet fuel through the cockpit side windows while you are taxiing. Water operations are great; a fully reversible prop allows for great docking capabilities as long as you don't forget about the "sail" tail, which can weathercock the aircraft in even a small amount of wind. The prop is ahead of the floats, which can cause problems with high docks and windy conditions, as it could strike the dock. Once in the air the aircraft is very stable and is dream to fly; the reliability of a turbine engine on this Canadian legend turns it into the ultimate bush plane. Addition of a four-hundred-pound upgross kit (extra floatation and wing strut cuff) makes it a real heavy hauler, ideal for any outfitter.

Also the appearance has changed from a blunt nose, oil-dripping beast to that of a sleeker, more aerodynamically advanced aircraft of its time. The longer snout has increased the length 4 feet, from 41 feet, 10 inches to 45 feet, 10 inches, giving it the appearance of a larger aircraft. There are few different turbine engines available to strap on the "stone boat," one being the Pratt & Whitney PT6-135/A. This

increases the horsepower from 600 to 750, and also decreases the weight of the aircraft dramatically. The Power Loading changes from 13.3 pounds/horsepower to 10.67 pounds/horsepower.

One lead acid battery from the rear of the aircraft has been removed and replaced by two twenty-four-volt batteries in the front engine compartment, which provides ample power for cool starts on even short hauls. Lead shot can be added or removed from a tube in the engine compartment for centre of gravity.

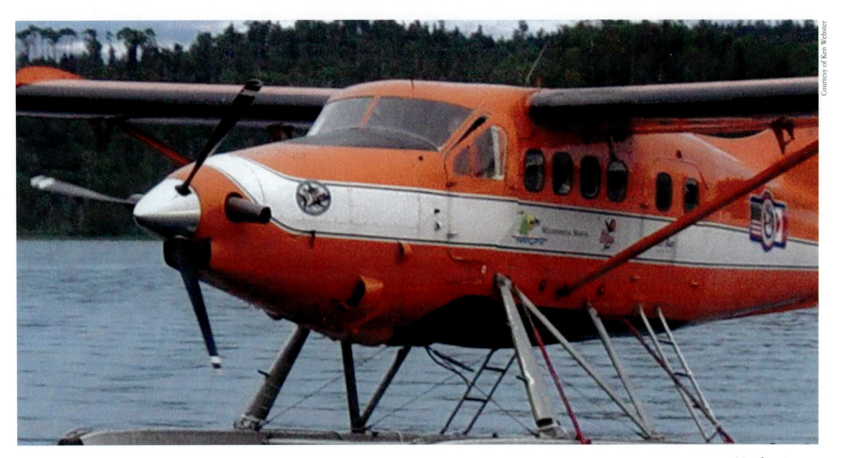

Turbo Otter.

The Otter's fiftieth birthday was celebrated in October 2002 at a Victoria, British Columbia, conference jointly sponsored by Bombardier (DHC's current incarnation) and Viking Air for out of production DHC aircraft. Not all that many aircraft types make it to age fifty. For this to happen, the aircraft has to be something special, which is exactly what the Otter is — a Canadian icon.

Boeing 707/AWACS E-3A

On a July day in 1954, hundreds of fans were watching hydroplane racing on Lake Washington outside Seattle. Among them was Boeing president Bill Allen with airline VIPs and the press. Allen had an idea for a public relations stunt: could the company's test pilot, "Tex" Johnston, fly the Dash 80 over the racecourse? Johnston was contacted, and at the agreed time he brought the highly secret airliner across the lake. Then he did a chandelle followed by a one-G roll, flew the length of the lake, and then pulled up into another roll. The crowd gasped — as did Allen. The last jet airliner had been the unfortunate De Havilland Comet, and Allen was trying to sell the Dash 80 as a "safe" aircraft. But as Johnston later explained, there was no undue stress in flying upside down, as an aircraft doesn't know if it's level or on its back; it only responds to G forces. More significant than the roll was that the flight marked a turning point in history — the age of mass jet travel had begun.

The de Havilland Comet and the Avro C-102 Jetliner, the first jet transports, had had short if stimulating lives. On May 20, 1952, Boeing, which until then had been more of a military aircraft manufacturer, announced that it would build the 367-80 Jet Stratoliner. With four turbojets slung beneath the 35-degree

swept-back wings, it led the Comet in speed, cruising at 550 miles per hour, which was 100 miles faster than the British jet. Why the number 367-80? As a transport, it fell into Boeing's numbering system: numbers 100–200 were for aerofoil designs, 200–300 for aircraft designs, 300–400 for airliners (like the famous 314 Clippers), 400 for bombers, 500 for industrial products, and 600 for missiles. It was also good camouflage to hide the aircraft from competitors. But now Boeing planned a whole series of jet transports and entered the 700 series. Someone in the sales department thought that the 367 Dash 80 would be better introduced as the 707. The number was carried in the early advertisements and has almost become a generic term for a jet airliner.

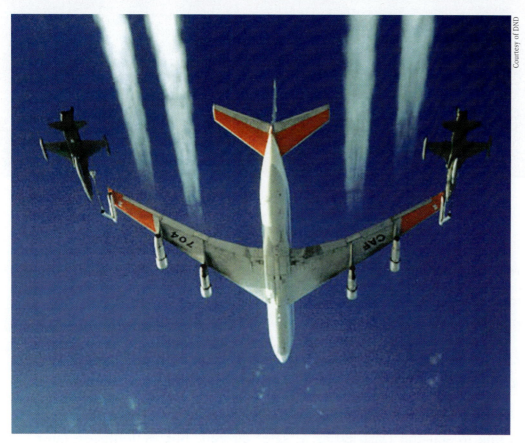

CF Boeing refuelling CF-5s.

Neither Trans Canada Airlines nor Canadian Pacific Air Lines bought the 707, preferring instead the DC-8-43, and the only 707 that was ever in Canadian Pacific livery was wet leased (the crew was leased along with the aircraft) on October 15, 1967, from Standard Airways of Seattle. As CPAL had no flight crews to fly it, only the cabin crew were Canadian Pacific personnel. In a freak accident, this aircraft was destroyed at Vancouver Airport on February 7, 1968. It took the second-tier airlines like Wardair, Quebecair, and Pacific Western Airlines to introduce 707s to Canada.

In 1957, Canadair was contracted to develop a transport version of the CL-28 Argus, a design already approaching obsolescence, and from 1960 to 1969, as the CC-106 Yukon, this aircraft flew Canadian troops and VIPs around the world. But the lumbering Yukon was hardly the image that Pierre Trudeau's jet-setting government wanted to project, so five Boeing 707s (13701–13705) were purchased, the first three delivered to 437 "Husky" Squadron at Trenton, Ontario, on April 10, 1970. The squadron's motto, *"Omnia Passim"*

Boeing 707/AWACS E-3A

("Anything anywhere"), typified the service lives of the hardest working, most elastic aircraft that the Canadian Forces has ever owned. Designated CC-137, the 707 would be configured to carry all freight (up to 90,000 pounds), all passengers (from 170 to 212 people, depending on seating), or a combination of both. Fitted with Beech 1050 air-to-air pods in May 1972, two 707s gave the air force an air-to-air refuelling capability, allowing Canada to fulfill its commitments to reinforce NATO's northern flank by refuelling CF-5s heading towards Norway. The twice-weekly scheduled flights from Comox and Shearwater to Lahr, Germany, might have been routine, but the five aircraft also carried famous people. Fitted out for its dignitary role, the 707 had either a stateroom for 8 with 115 seats aft or a mini-capsule for 6 with 155 seats aft. In these modes, CC-137s took Prime Minister Trudeau on his historic visit to China in October 1973 and carried members of the royal family, governor generals, and visiting foreign heads of state to and from Canada — even flying Pope John Paul II to Canada in 1984. The air force 707s were gradually retired in the 1990s: 13702 was declared surplus in June 1993, 13705 in April 1995, with refuelling tanker 13704 the last to go in April 1997. But that wasn't the end of the Boeing for the Canadian Forces. Like an old movie star, the 707 made a comeback.

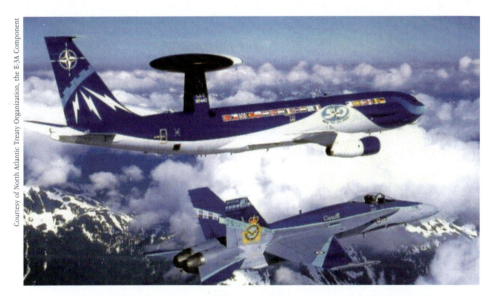

E-3A commemorating fiftieth anniversary of NATO with CF-18 commemorating seventy-fifth anniversary of Canada's air force.

Canada had participated in the NATO Airborne Early Warning and Control Force (NAEW&CF) since its inception in 1978, and after the United States and Germany, Canada remains the third largest contributor. Relief flights to Sarajevo, Yugoslavia, patrolling a "no-fly zone" over Bosnia-Herzegovina, Partnership for Peace deployments ... being a sky shepherd is an exhausting job for a venerable jet airliner. A modified Boeing 707-320, the E-3A Sentry aircraft, was purpose-built for the Airborne Warning and Control System (AWACS) program in the early 1980s. The Sentry has a range of approximately 5,000 nautical miles, can cruise at speeds of up to 480 miles per hour, and has a radar that can "see" further than 200 miles. The NAEW&CF operates seventeen Boeing E-3A Sentry AWACS aircraft (one Sentry was lost

when it ran off the end of a runway in Greece without fatalities in 1996). The NATO AWACS variant is equipped to refuel from a boom-equipped air-to-air refuelling tanker, increasing the endurance to twenty hours.

An E-3A Sentry crew consists of a minimum of seventeen personnel. There are two pilots, a navigator, and a flight engineer who are responsible for flying the aircraft. The mission crew comprises thirteen personnel under the command of a tactical director. A surveillance controller is in charge of operating the radar and supervising three surveillance operators, who in turn manage the data links and maintain the air picture. A passive controller operates the ESM equipment, and a fighter allocator is responsible for the aircraft control portion of the mission and for supervising two weapons controllers. The crew also has integral technical support, including a display technician who runs the mission software computer and maintains the display terminals, a radar technician who is responsible for monitoring the condition of the mission radar and troubleshooting when necessary, and two communications specialists who manage the twelve UHF, two VHF, and three HF radios. The Canadian Forces employs personnel in all of these crew positions.

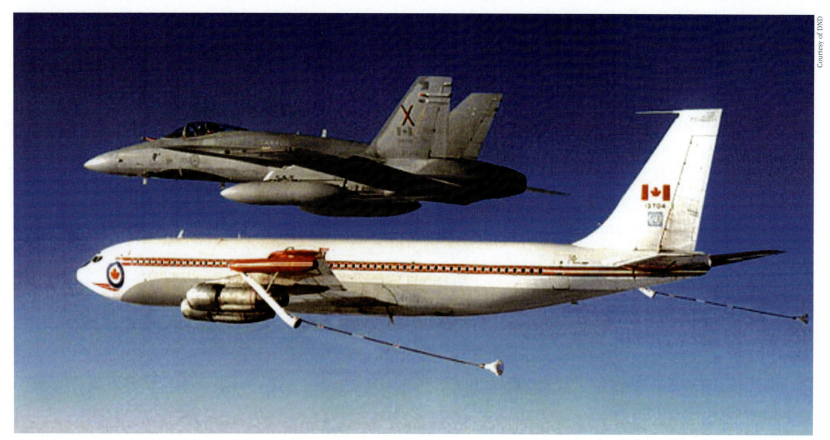

CF Boeing refuelling CF-18.

Boeing 707/AWACS E-3A

Captain Brian D. Ward's background was seven hundred hours on civilian light aircraft and about five thousand hours on military aircraft, which included the Tutor, Musketeer, Cosmopolitan, and King Air. He thought that while the E-3A was an old design it was a good airframe.

The cockpit has a clean layout with the standard "T." The instruments and avionics are not modern but suffice to get the job done. It has only 1 VHF, 1 UHF, 1 Transponder, 2 Tacans, 2 VOR/ILS, 1 ADF, and 2 INS in the cockpit. ACAS and RVSM capabilities are coming soon, so we will not be limited in our flight altitudes. The flight deck crew is made up of four positions (aircraft commander, first pilot, nav, and flight engineer). It is good to have the four people when flying around Europe in the busy airspace, as it lightens the load any one person has to carry. As the crew can be made up from thirteen different nations, it can be challenging and interesting, as each person has a different level of English and flying background. The pilots can come from transport aircraft (light or heavy) and fighters. A pilot can upgrade to Aircraft Commander in as low as three hundred hours on type, depending on his/her background.

The E-3A is not that difficult to fly if you come from a transport background, because it is heavy and slow in the roll. But it takes some time for fighter pilots to get use to its performance in flight (or lack of). It is slow to accelerate, but it is not easy to slow its momentum once it is moving. Because it has the radar dish on top, its top end speed is lower than a B707, and for takeoff and landing on wet runways its rudder effectiveness is limited by the radar supports; therefore, the E-3A has to take off with less fuel. Because this aircraft operates like an airliner — it goes to an orbit and then returns to base — the pilots tend to hand fly as much as possible. Flying tight visual patterns are fun as we do descending turns to final from downwind, to roll wings level at about three hundred feet AGL.

But the real challenging aspect of the E-3A is the air refuelling. To take a 707 and fly it behind another 707 at about forty feet and let someone stick a probe into you just above your head, does not feel natural at first. As Canadians and most other nations we do not take fuel from other aircraft in the transport role. The fighter pilots also find it different, as the reaction of the E-3A is not quick as in a fighter. This aircraft takes time to start moving then the momentum takes time to slow. So when you are air refuelling you need to have patience when making power adjustments.

Overall, Captain Ward concluded, the 707 is a good, safe aircraft to fly. Which was what Boeing test pilot "Tex" Johnston had said fifty years before.

ON CANADIAN WINGS | A CENTURY OF FLIGHT

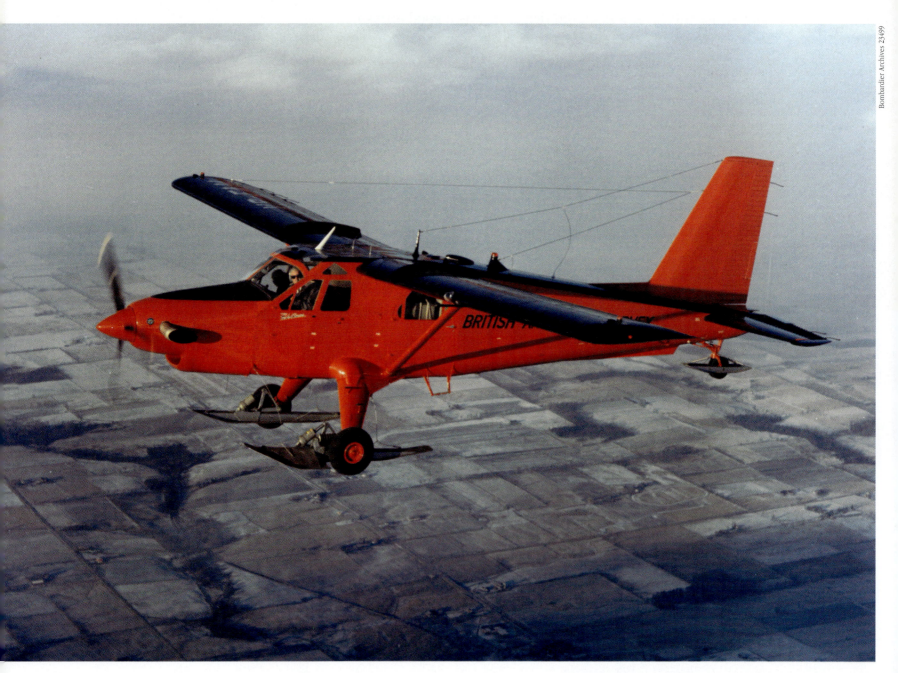

British Antarctic Survey Turbo Beaver.

De Havilland Canada Turbo Beaver

Sequels of successful enterprises are a gamble, begging the question, "How can one improve on perfection?" With the proper engine, the De Havilland Turbo Beaver demonstrated that it was possible, and that its long nose would be seen in as many exotic locations as its older brother's.

The success of the Beaver with the Wasp engine led De Havilland Canada to consider offering it to prospective customers with more powerful engines. On March 10, 1953, a prototype Beaver Mark II, CF-GQE, was flown at Downsview with a 550-horsepower Alvis Leonidas engine. The aircraft was sent to the parent company in England and registered as G-ANAR, but the increased performance was not enough to generate interest there, and when it returned from a demonstration tour, the project was shelved.

The availability of turboprop engines in the early 1960s caused many Beaver operators to consider converting to them. In December 1962, Pacific Western Airlines announced that it intended to re-engine its Beaver fleet with the new 550-horsepower Pratt & Whitney PT6A-20 gas-turbine engine and then market the conversion kit to other operators. De Havilland had been considering building a Turbo Beaver III with either the Pratt & Whitney PT6 or the Turbomeca Astazou engine, and in light of the Pacific Western Airlines idea,

in February 1963, they went ahead with it. The choice of engine had the advantage of being Canadian, and, lighter than the Wasp, it allowed for a longer fuselage to accommodate a bigger fuel tank and two more passengers. On December 31, 1963, test pilots Robert Fowler and J.G.H. (Jock) Aitken flew the first Turbo Beaver, CF-PSM. The Turbo Beaver's biggest client turned out to be the Ontario Provincial Air Service, which had previously purchased the Otter, and its interest allowed sixty aircraft to be made.

Turbo Beaver in STOL mode.

For fifty years, the British Antarctic Survey (BAS), once known as the Falkland Islands Dependencies Survey, has undertaken scientific research on and around the Antarctic continent. BAS supported three stations in the Antarctic (at Rothera, Halley, and Signy) and two stations on South Georgia (at King Edward Point and Bird Island). To provide reconnaissance and an air link between each, especially using blue-ice strips, in 1959, BAS bought Beaver float plane VP-FAJ. The Americans, Australians, and Belgians also used Beavers in the Antarctic to great success. Unfortunately, the BAS Beaver was destined for a very short life and today lies somewhere under the polar ice. It was being transported aboard MV *Kista Dan* when on March 12, 1960, during a storm off Deception Island, the vessel collided with RRS *John Biscoe* and the aircraft was badly damaged. After it was repaired, it broke through sea ice on September 16, 1960, while taxiing at Argentine Islands and sank.

Nine years later, the BAS bought a Turbo Beaver, VP-FAM, directly from Downsview to replace it. It was fitted with long-range tanks and ferried out by Royal Air Force Flight Lieutenants B.J. Conchie and D. Brown to the Antarctic. The BAS operated the Turbo Beaver on supply flights out of Adelaide Island Station. The aircraft's only mishap occurred in January 1971, when its tail-ski and fuselage were damaged. When the station was closed in April 1972, the aircraft was returned to De Havilland Canada and registered as CF-OEQ. The survey remained strong users of De Havilland aircraft, and in 2003, it operated four Twin Otters from Rothera and Halley and a Dash 7 between Rothera and the Falklands Islands.

To commemorate a successful sequel to the Beaver, Bombardier Canada donated Turbo Beaver prototype CF-PSM to the Canadian Bushplane Heritage Centre in Sault Ste. Marie, Ontario, where it is on display today.

Cessna L-19 Bird Dog

Cheap and cheerful, quaint in today's high-tech warfare, by the time the Bird Dog appeared the days of light planes on the battlefield had passed. The L-19s were to be the Royal Canadian Artillery's last fixed-wing aircraft, serving as spotters, liaisons, and light transports until replaced by the Kiowa helicopter. When it left the regular forces, a tradition that could be traced to the observation balloons used by the British Army during the Sudanese War in 1885 ended.

Clive Cessna began building aircraft in 1911, his plants becoming a mainstay of the economy in Wichita, Kansas. In 1948, entering a U.S. Army competition for a liaison aircraft, Cessna designed his Model 305A, a light, two-seat observation aircraft. The company was awarded the contract in June 1950, and Cessna began delivering the aircraft, now designated as the L-19, soon after. The name "Bird Dog" for the aircraft was an inspired one, and it appealed to pilots and journalists alike. Re-engined later as the L-19E for higher performance, it was also licence-built by Fuji in Japan. In total, 3,431 L-19s were manufactured.

Beginning on October 8, 1954, Canada acquired sixteen L-19As and later nine L-19Es through the Military Assistance Program. The military needed an observation platform from which the artillery could

be directed, and by this time the Austers were Second World War relics. Like its namesake, the Bird Dog scouted for targets; on finding one, its pilot would relay the coordinates to the artillery. The L-19 pilot flew under the artillery arc, staying with the target to direct the gunners. It would do the same for advancing infantry, scouting ahead for the enemy. In 1973, when helicopters replaced the L-19s, they were struck off and passed on to the Air Cadet League for glider towing and familiarization flights.

RCA L-19 in flight.

Those who flew it were unanimous in their praise for the Bird Dog. It was the way flying was meant to be, said one pilot — enjoyable. Its high lift flaps and powerful 213-horsepower Continental engine could get it in to or out of any tiny makeshift airstrip. The tandem-seat cockpit with wraparound windows and overhead

Cessna L-19 Bird Dog

Plexiglas gave a view equal to that of helicopters. Everyone agreed that its performance was closer to that of a bird than an aircraft. It took 20 degrees of flap and 300 feet to lift off with no wind — it only needed a 550-foot run to clear a 50-foot barrier. With a good headwind, pilots said that the Bird Dog's ground run was thirty-eight feet. Landings were made with 30-degree flap and a 70 mile per hour approach speed, but short field landings were usually done at 65 miles per hour. As for hovering over a target, in the Vietnam War, its pilots discovered that the forty US gallons in the port and starboard wing tanks could be "leaned out" to a lengthy 4.7 hours. The little aircraft's angle of climb always surprised those who watched it take off. This was because of its big 7 foot, 6 inch diameter McCauley propeller, which pitched at 47 degrees. The propeller's only drawback was that the Bird Dog's cruising airspeed was barely 104 miles per hour with a fuel burn of seven US gallons an hour. Because of its lack of speed and its need to circle a target, a Bird Dog made a good target itself, and it took a brave man to fly it as a forward air controller. When used in Vietnam for calling down fighters, the Bird Dogs were armed with phosphorous smoke rockets under each wing.

Royal Canadian Artillery Observation Corps crest.

Besides the United States and Canada, the Bird Dog served with seventeen other nations, France, Chile, Vietnam, Korea, Norway, Austria, Italy, Jordan, and Brazil among them. As a result of its use, the civilian market was flooded with ex-military Bird Dogs by the 1970s. When the U.S. Army retired its Bird Dogs in 1973, Cessna stopped making them, but, renamed the Mountaineer, the aircraft continued in production with the Ector Aircraft Company of Odessa, Texas.

ON CANADIAN WINGS | A Century of Flight

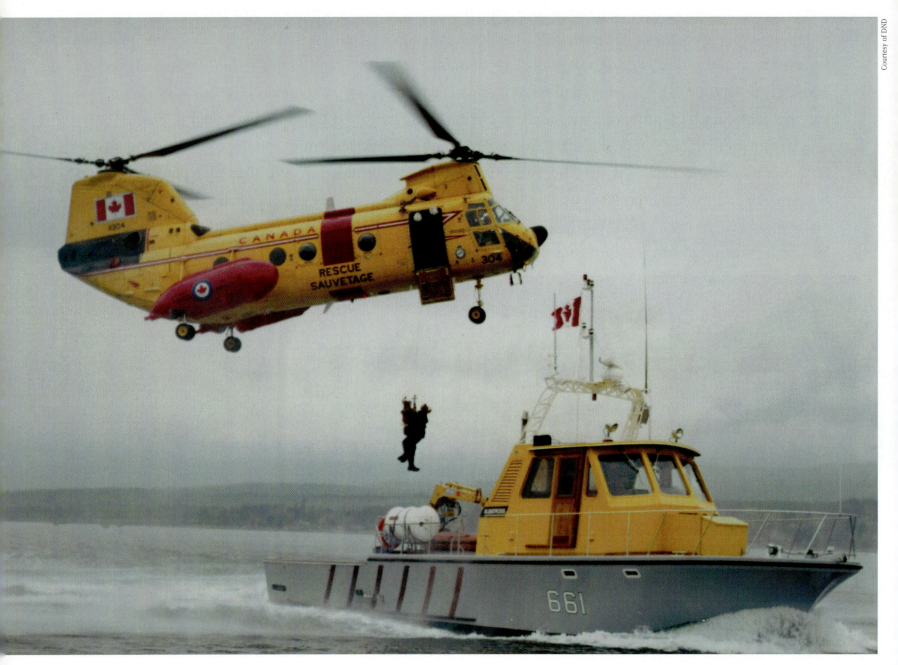

CH-113 Labrador.

CH-113 Labrador/CH-113A Voyageur

The Royal Canadian Air Force purchased the six Labrador aircraft as purpose-built search and rescue platforms. The Canadian Army ordered twelve Voyageur aircraft as medium troop transports. Deliveries of each aircraft type commenced in 1963, and the survivors were serving long after their parent organizations had been consigned to the dustbin of political expediency. Captain Jay S. Medves flew the Labrador and the Voyageur with 413 Transport and Rescue Squadron from 1986 to 1989. "In an ironic parallel to the unification process," he writes, "both types of aircraft did eventually end up performing the same job for a single master."

The tandem-rotor configuration of the aircraft made it an outstanding platform for search and rescue operations. All power was directed to the two main rotors — as they both counter-rotated, there was no need for any power-sapping anti-torque device (or tail rotor). It was also possible, although never desirable, to fly the aircraft in out-of-wind conditions that would have proved to be a real problem for tail-rotor-equipped machines. Aircraft handling was no different from that of a more conventionally configured machine. Manipulate the pedals, cyclic or collective, and the aircraft did what it was supposed to — but

how it translated those control inputs to the rotors was something different altogether. In tail-rotor-equipped aircraft, deflecting pedal control increases or decreases the pitch on the tail rotor, allowing the pilot to counteract, or not counteract, the torque of the main rotor. In a hover, if you input sufficient pedal to cancel out the main rotor torque, the aircraft's nose will remain stationary; increase or decrease pedal input and the aircraft's nose will swing to the left or right. With some practice (and other control inputs) the aircraft can be pivoted around its nose, tail, or central axis. You could do the same thing in the CH-113A, except it didn't have a tail rotor! All control inputs in the CH-113A were routed through a mixing box to two hydraulic actuators. Somehow the mixing box, through certain algorithms, would translate what the pilot intended to do into actuator inputs that would put the aircraft into the attitude desired by the pilot.

How the system worked Medves could not say — and he never talked to anyone that did. "We used to joke that only the designer of the system knew how it worked and that he went insane thinking about it," he wrote.

One peculiarity of a tandem-rotor machine was that left to its own devices, the aft end of the machine would want to try to catch up to the front end. The end-swapping desire of the machine was counteracted with a stability augmentation system (SAS). There were no computers in the system (remember, the aircraft was built with 1950s technology); it functioned by comparing static pressure on either side of the aircraft. The SAS had two independent channels. In the event of the failure of a single system the other could pick up the entire load. The SAS selector switch had four positions: both, system 1, system 2, or off. The functionality was checked during the pre-takeoff checks by isolating the two systems and comparing the effects on the aircraft — if everything was functioning correctly the systems would work in harmony. It was possible to fly the aircraft with no SAS, but it was very squirrelly and required constant pedal input to keep things straight — no problem if you were flying visually and were expecting the system to be turned off, but a completely different story if the failure was unexpected or if the aircraft was being flown on instruments. The static ports were located to the front of the aircraft, and given the critical nature of the SAS they were always covered to prevent the intake of moisture or insects when the aircraft wasn't being run. The static port covers resembled large linked suction cups with red "Remove Before Flight" tags. The frames for the covers were affixed directly to the aircraft. The static ports were automatically heated whenever aircraft power was turned on. Although the SAS could require a significant amount of tuning it was reliable, and there do not seem to have been any complete failures.

CH-113 Labrador/CH-113A Voyageur

Of the two types of machines, the CH-113A was the nicer machine to fly: the hydraulic accumulators were different from those in the Labrador, and the aircraft was much lighter on the controls. Differences between the two were mostly indiscernible to the casual observer, but there were many. The Labrador came with mirrors for the pilots, allowing them to see behind and underneath the aircraft. The Voyageur had more glazing around the cockpit area and had its main hydraulic system controlled by a "both," "number 1," or "number 2" switch. Lose pressure in a hydraulic system in the Voyageur and the problem could be isolated — a highly desirable feature as the aircraft was uncontrollable without hydraulic power. The Labrador had no such attribute; irreversible valves in the crossover system were guaranteed not to allow fluid in the functioning system to transfer to the system that had lost pressure.

Two GE T-58F engines rated at 1350-horsepower each powered the aircraft. Each engine powered both rotor systems. Power was distributed through a combining gearbox. The upper fuselage housed the synchronization shaft that provided power to the forward transmission and kept the rotor blades from meshing. The aft rotor assembly also had its own transmission.

The Voyageur had more fuel capacity — not that that was much of an issue, as they were always weight limited to some extent, and to exceed the normal four-thousand-pound fuel load (three thousand pounds in the summer) one had to strip kit from the aircraft. To maintain single-engine cruise flight in either type almost always required dumping fuel to lighten the aircraft. Single-engine hovering wasn't possible at any weight; it would blow an engine in the hover (pilots used to say), and you had better like what you saw through the chin-bubble because that where you were going to come to rest.

Cockpit instrumentation in the CH-113A was for the most part conventional and well laid out. Each pilot had a full set of flight instruments arranged in the classic "T" pattern. Engine instruments were positioned centrally and could be read easily by either pilot or by the flight engineer from the jump seat. Sometimes flight engineers would rotate the engine instruments so that when all engine parameters were normal the needles of each gauge would be at the same position. Long-range navigation was provided by Omega and later complemented by Loran.

The cyclic position indicator was particular to the CH-113A. As the aircraft's flight controls were hydraulically powered, there was no "feel" to position the cyclic in the correct fore and aft position. The cyclic position indicator was a transparent tube with a rod inside to indicate how far the cyclic was displaced from neutral. The aircraft was equipped with radar that was very useful for locating ships in fog or at night. Regrettably, the aircraft was not equipped with even a rudimentary autopilot. All flying had to be done by

hand instrument flying, and night flights over water were labour-intensive. The aircraft had minimal icing protection — both pilots' windshields were fitted with heated panels. The fibreglass blades were wired for de-icing, but the system was disabled, as the aircraft's electrical supply was unable to power it. The engine intakes were particularly susceptible to aircraft icing, as the intake screens would quickly become clogged, causing the engine to flame out. A new design of intakes did much to reduce the problem.

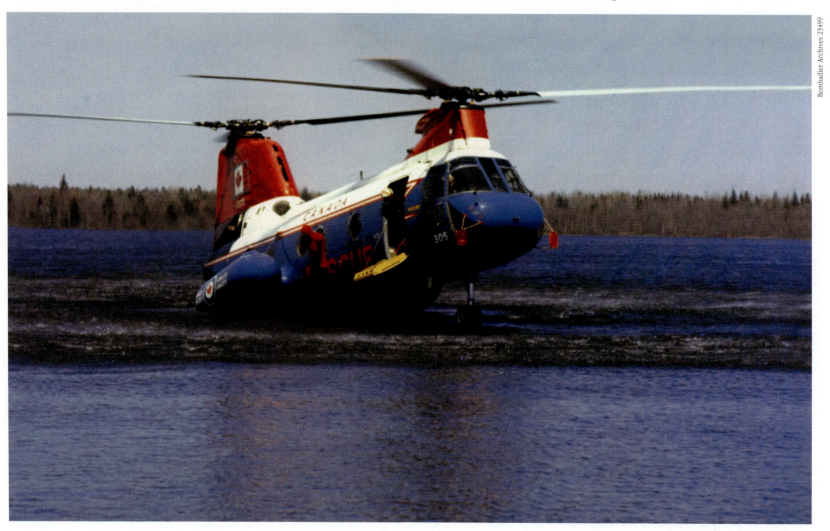

Amphibious Labrador.

The CH-113A was amphibious, and pilots were required to conduct water operations on a yearly basis. Medves recalls, "The aircraft taxied on water pretty much as it did on land. In a helicopter the captain sits in the right seat. Accordingly the main aircraft door, where the primary hoist was located, was on the right of the aircraft immediately aft of the front bulkhead. We'd practice front door pickups where we'd

CH-113 Labrador/CH-113A Voyageur

water-taxi by a survivor and the flight engineer would recover the individual." The aircraft's aft ramp could also be opened in the water, provided that the water dam was installed. At one time, part of the concept of operations involved launching a Zodiac from the aft ramp to recover survivors from the water; however, by the time Medves was flying the aircraft that particular method of rescue was no longer practised. The hoist was a quicker and more effective method and did not require relatively benign seas. Preparing the aircraft for the yearly water sessions required the technicians to tape all the fuselage joints in the bottom of the aircraft. Despite the technicians' efforts the aircraft leaked. They didn't stay in the water for more than ten or twelve minutes before popping up into a hover to allow the water to drain out from the aircraft before recommencing whatever training sequence was being practised. The crew's fear was that if they allowed too much water into the aircraft its weight might prevent them from getting airborne.

For rescue work the aircraft's hoist was reliable and powerful, and the flight engineers were masters in its use. Should the aircraft's regular hoist system become disabled, the centre hatch hoist could be rigged. Hoisting from the centre hatch was much more difficult for the crew. The flight engineer was forced to work from a prone position, and his vision was restricted, making it more difficult for him to con the aircraft. It was also much more difficult to recover personnel or the Stokes Litter through the centre hatch. To further complicate matters there was greater distance between the pilots and the flight engineer. If the aircraft was hovering over a small object then to position the centre hatch hoist over the target the flying pilot could find himself with very minimal or no hover references. The aircraft was equipped with a Nightsun searchlight that the flight engineer usually operated. Use of the Nightsun generated countless UFO reports. In later years Medves had the dubious pleasure of staffing some of those reports.

Over the years a third of the Labrador and Voyageur fleet has been destroyed in accidents: CH-113A 417 on September 27, 1965; CH-113A 409 on August 14, 1966; CH-113A 414 on July 15, 1971; CH-113A 313 on March 20, 1974; CH-113A 311 on April 30, 1992; and CH-113 305 on October 2, 199. (CH-113 306 was administratively written off after an accident in start-up on March 11, 2002.) There were a total of eleven fatalities in these accidents.

"I have been asked to write a few words about operating the aircraft and its systems. After the passage of almost fifteen years I am bound to have made a few errors," wrote Medves. "What hasn't faded in my memory is the respect I had for the people I worked with. In a world that suffers from a chronic over use of superlatives I can honestly say that they were the most professional, talented, and dedicated individuals I have ever met. Their story deserves to be recorded."

ON CANADIAN WINGS | A CENTURY OF FLIGHT

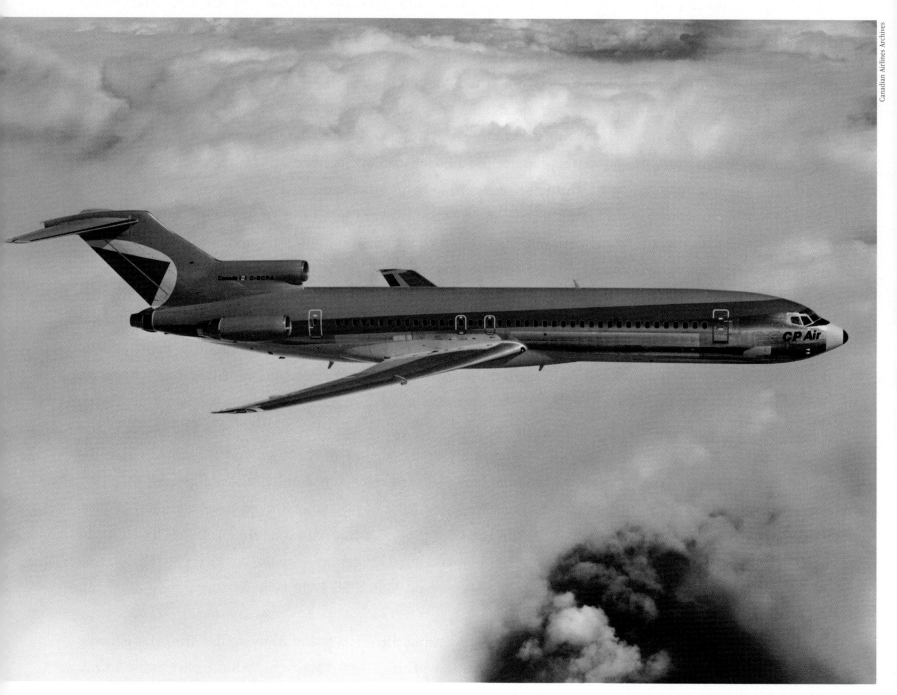

Boeing 727-200.

Boeing 727

On January 13, 1991, the very first Boeing 727 built, having been in continuous service with United Air Lines since 1964, made its last flight to the Museum of Flight in Seattle. If ever an aircraft symbolized the 1970s, it was the trijet. Its competitors were hub and spoke jets like the Hawker Siddeley Trident, the BAC 1-11, and the DC-9. But perhaps because it was the biggest of them all, the Boeing 727 had a special allure. CP Air and Braniff splashed theirs in garish colours; Eastern Air Lines packed its 727s on the New York–Washington shuttle. Because of the rear stairs, on November 24, 1971, hijacker D.B. Cooper jumped out of a Northwest Orient 727 clutching $200,000 in used bills.

The 727's tenure was due to Boeing continually anticipating the changing market. In 1956, when Boeing planned the short-to-medium-range airliner, it was to complement its 707. But when the first production 727-100 flew on February 9, 1963, there were two versions: the 100 was configured for 131 passengers, and the 100C (for convertible) had a main deck-side cargo door that allowed it to carry either pallets or passengers. The 727s created the intercity commuter. The three Pratt & Whitney JT8D-9As, along with its triple-slotted trailing edge flaps and slats, allowed it to get in to and out of downtown airports

like New York's La Guardia, Chicago's Midway, and Washington's National Airport. Within a year Boeing had a stretched 727 planned, inserting two 10-foot plugs to increase capacity to 189 passengers. In all its

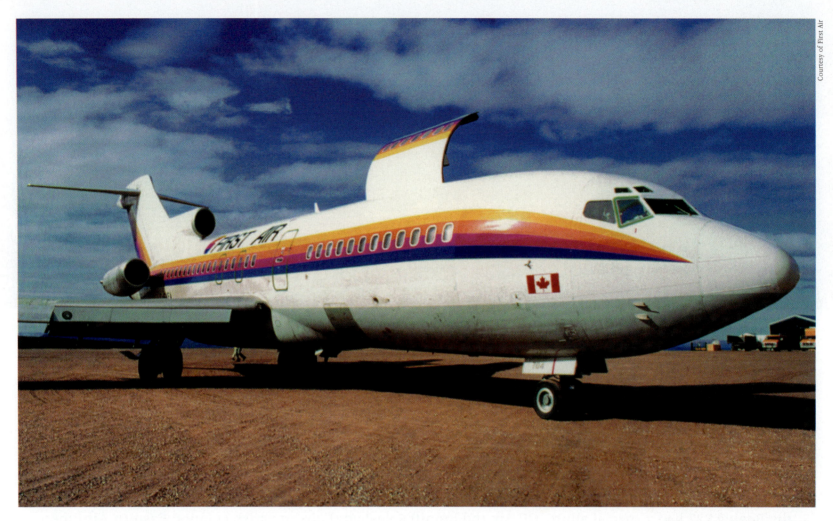

First Air Boeing 727.

variations, 1,245 of the 727-200s were sold, the last to Federal Express as freighters. Because the 200 had the same engines, fuel, and performance as the 100, Boeing brought out the Advanced 200 in 1970 with improved noise suppression and wide body cabin. In September 1972, when orders for the 727 passed one thousand, it had become the bestselling aircraft in history. By 1984, when the last 727 was built, 130 customers had bought the aircraft, and Boeing had rolled out a total of 1,831 — not bad for an aircraft whose original market forecast was 250 airplanes. Today the Boeing 737 has surpassed the total, but the 727 has gone down in aviation history as the first inter-urban jet airliner.

Boeing 727

CP Air did not embrace the 727 as other airlines had — it had no downtown hubs to jet out of. The aircraft was too large for its rural routes but did not have the range for its international ones. Four 727-117s were bought in 1970 for the transcontinental route but were sold in 1977 when two 727-217s replaced them. When the airline standardized on 737s in 1982, the 727s were sold to British charter operator Dan Air. Air Canada did better, buying thirty-nine 727-200s in 1974 and building a large hangar in Winnipeg to service them. It began selling them off in 1986, the first three to Federal Express.

Noise restrictions and more fuel-efficient aircraft meant that the 727s ended up as hacks for second-tier airlines. In Canada, 727s were seen in Greyhound and later First Air colours. The 1970s icon designed to rocket commuters out of downtown hubs was now delivering supplies to the crews of resource companies in northern Greenland. First Air engineers converted the inside of the 727 so that it could haul cargo and fuel from Thule to Nord during its mission. First Air established a routine whereby before the 727 would land on the ice in the fjord (after a Twin Otter would first check it out).

And as for the 727's most notorious passenger — each year on November 24, celebrations are held at restaurants and bars named D.B. Cooper in southwestern Washington, where, legend has it, he has been known to appear anonymously. Needless to say, after his jump, no 727 operator has ever advertised the aircraft's rear stairs.

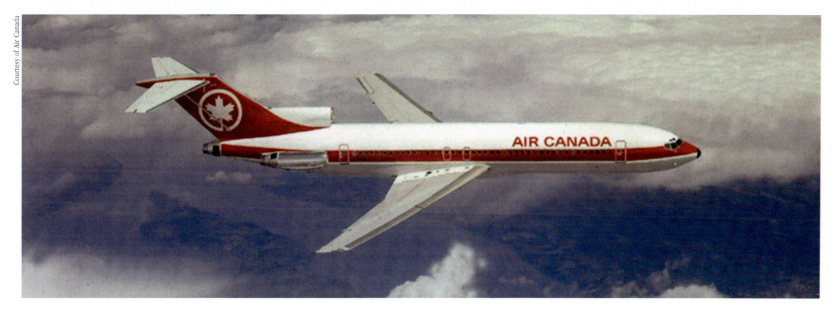

Air Canada Boeing 727.

ON CANADIAN WINGS | A CENTURY OF FLIGHT

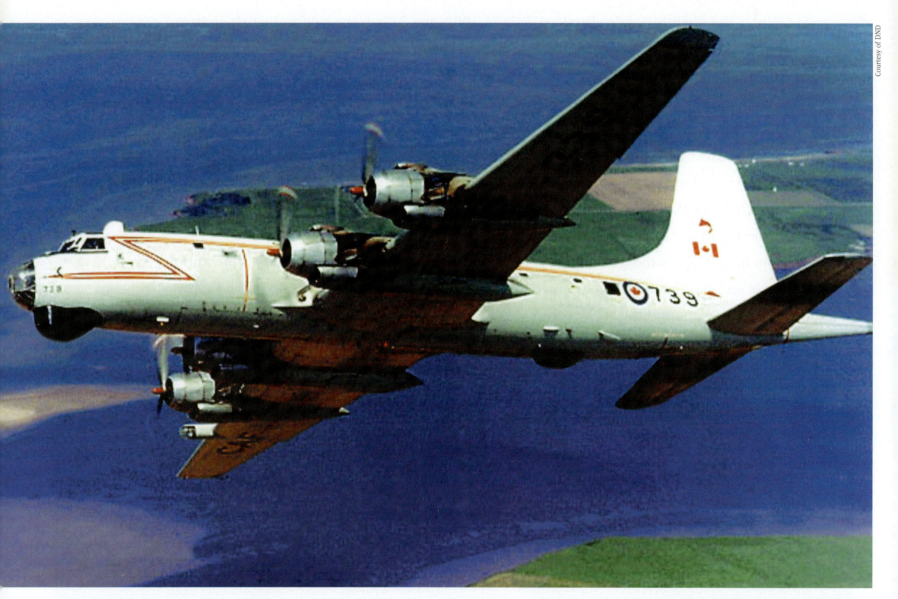

Canadair Argus CP-107.

Canadair Argus CP-107

When future international anti-submarine competitions for the Fincastle trophy are held, the unique thunder of four Wright 3350s will forever be absent. Each year there are fewer aircrew who know what the initials "ETI" or code names "Jezebel" and "Julie" mean. Soon the generation of aircrew who enjoyed the meals cooked on board the Argus — lobster, crab, steaks, and especially those fluffy, light omelets — will be no more. The Argus will live on only in the hearts, ears, minds, and taste buds of those who flew her.

The Greek mythological figure of one hundred eyes who guarded Zeus's girlfriend, Argus was also the name of Odysseus's old dog — the one that recognized him when he came home. Both connections suited the aircraft. In 1952, the RCAF's Avro Lancaster 10MRs were nearing the end of their operational lives and, like the North Star transports, were in need of replacement. To cover both requirements, RCAF Chief of Staff Air Marshal W.A. Curtis selected the Bristol Britannia airliner, and as its Proteus turboprop engines would be unsuitable for low altitude, Wright R-3350 turbo-compound piston engines were chosen. On February 23, 1954, Canadair was given the contract to use the Britannia airframe and develop it as an

anti-submarine patrol aircraft. It was a very complex, exacting program for Canadair, which until then had built only fighters and the North Star, but thanks to the personal direction of company president Geoff Notman, the first Argus flew from Cartierville on March 28, 1957.

Canadair president Geoff Notman wib Argus model, 1957.

Designated the CL-28, the Argus may have resembled the British airliner superficially, but only its wing, tail surfaces, and undercarriage were the same. In place of the Proteus were four powerful, reliable 3,700-horsepower Cyclones that the Wright company had developed for the B-29 Superfortress of the Second World War. As the aircraft was to fly low, the fuselage was unpressurized, and in warm weather the hatches could be left open.

The Argus equipped 404 and 405 squadrons based at Greenwood, Nova Scotia, 415 squadron at Summerside, Prince Edward Island, and 407 squadron at Comox, British Columbia. When the Canadian Forces were integrated in 1968, the aircraft was re-designated CP-107. Twice as big as the Lancaster, it was nicknamed the "aluminum overcast," as its tail reached four stories high. It was so large that it was said it flew itself, especially on landing, when the crew were just along for the ride. It cruised comfortably at 150 knots but could work up to an attack speed of 330 knots. Fully loaded, with a crew of five and relief crew of four, plus observers, the aircraft weighed 157,000 pounds. An emergency landing after takeoff meant that the pilot dumped as much fuel as he could as quickly as he could — an agonizingly slow experience to his crew — or on touchdown he risked crumpling the undercarriage and scraping down the runway with burst fuel tanks.

There was an eighteen-foot weapons bay fore and aft of the wing, and the Argus was fitted with the usual accoutrements of anti-submarine warfare — bombs, torpedoes, mines, and depth charges. On the wings there were strong points for missiles and rockets. Electronic equipment included electronic countermeasures, explosive echo ranging, magnetic anomaly detection, and search and rescue homing. The strangest of all was the exhaust trail indicator (ETI), which detected smoke particles from diesel submarine exhaust but seemed to work only if the aircraft was flying over a pulp and paper mill. The "Jezebel" equipment used for monitoring the "Julie" serial sonobuoys in submarine detection wasn't popular, as it stank.

Thirty-three Arguses were built in two marks — Mark Is (20710 to 20722) had huge radome chins housing the American-built APS radar, while Mark IIs (20723 to 20742) had smaller chin radomes of the British ASV

radar. The four wing fuel cells held 6,694 Imperial gallons, which allowed the Argus to fly a thousand miles from its base, patrol for a full eight hours, and return home with five hundred gallons left over to divert if necessary. It truly gave Canada a global reach — in 1959, 405 Squadron flew an Argus from Hawaii to North Bay, a distance of 4,570 miles, in 20 hours.

By 1962, the Argus was seen in flypasts and exercises across Canada and around the world in Europe, the United States, Australia, New Zealand, and Bermuda, the last a favourite base for operations. Because of its size and power, the Argus could also carry passengers (once as many as eighty-nine) and freight, including pianos, boats, a submarine propeller, and Christmas trees.

In 1967, Canada's centennial year, an Argus crew from Summerside flew to Thule, Greenland, and from there to the North Pole, where the crew dropped a canister containing the centennial flag. That same year, an Argus escorted Her Majesty Queen Elizabeth II in the Royal Yacht *Britannia* on the St. Lawrence. With less fanfare, besides NATO exercises, there were anti-pollution and photo mapping patrols, northern patrols (NORPATS) or sovereignty "show the flag" flights, and goodwill tours to New Zealand and Australia. Normal ASW flights were eighteen hours in length, although the aircraft had a thirty-hour flight capability. That these marathon patrols were endured in an unpressurized fuselage with a noise level of eighty-five decibels was to the credit of the maritime patrol squadrons.

There were operations that got the Argus media attention: for example, on January 24, 1978, in Operation Morning Light, 415 Squadron was tasked with searching out the debris of a Soviet nuclear-powered satellite that had crashed in the Canadian North. And there were events that didn't: a seagull once shattered an aircraft's Plexiglas nose, and once, on taxiing in, the bomb bay doors opened up by chance and the torpedo dropped onto the tarmac. There were also sad events. On March 23, 1965, an Argus on a night exercise crashed into the ocean off Puerto Rico with the loss of all fifteen crew, and on March 31, 1977, another Argus crashed on emergency approach to Summerside with the loss of three of the crew.

The Argus's end came in June 1981, when 415 Squadron converted to the Aurora; on July 24, Argus 736 made a final flypast over Summerside. Rather than sell the aircraft off, DND decided to scrap the whole fleet, and the giants were melted down by Bristol Metal Industries. Those saved for posterity are on display at Ottawa, Summerside, Greenwood, Comox, and Mountain View. When the last Argus 742 was delivered from Summerside to the National Aviation Museum in Rockcliffe on February 10, 1982, it closed a nostalgic and noisy chapter in Canadian aviation. The creature of the hundred eyes and with the faithfulness of an old dog had been let out to pasture.

ON CANADIAN WINGS | A CENTURY OF FLIGHT

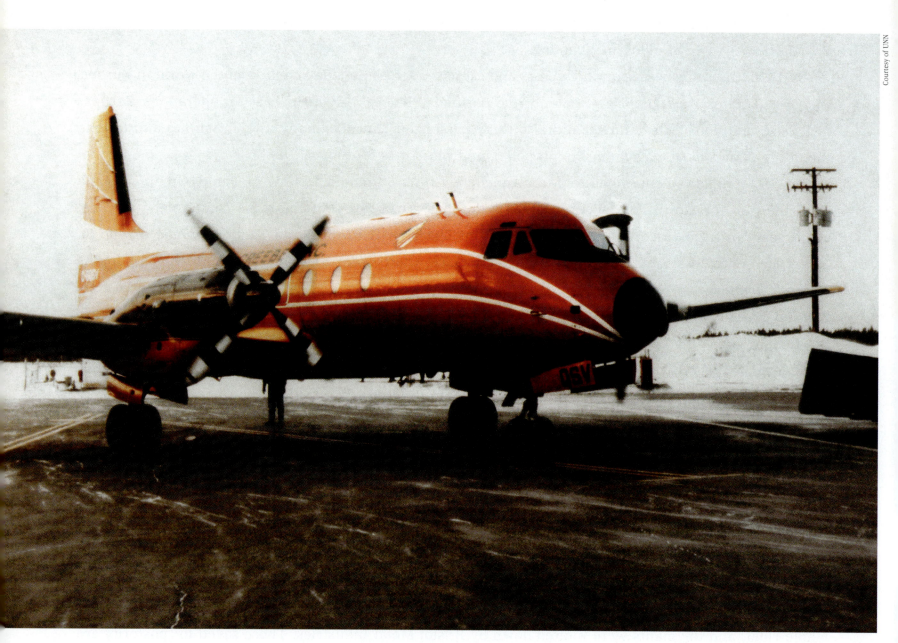

Hawker Siddeley 748.

Avro 748

The 748 was conceived in desperation by Avro, creator of such classics as the Lancaster, the Shackleton, and the Vulcan. In 1957, when the Sandys White Paper advocated that the RAF would no longer need manned aircraft, it succeeded where the Luftwaffe had failed. The paper killed off much of the British aircraft industry, and manufacturers like Avro never recovered.

Adapting to the new realities, Avro entered the regional airliner market, in competition with Vickers and Handley Page, to design yet another replacement for the immortal Douglas DC-3. Using Rolls-Royce Darts as the power plants, Avro turned out a handsome, thirty-six-passenger aircraft in low-wing configuration. The first 748 flew from Woodford on June 24, 1960, and was built in Series 1, 2, and 2A, each with a progressively more powerful Dart engine. Dan Air and Skyways bought the first 748s, but this didn't stave off the inevitable, and soon after Avro was taken over by Hawker Siddeley, which had itself become part of the British Aerospace conglomerate. The aircraft did achieve a measure of fame as part of the Royal Air Force Royal Flight, and one also served as Britain's "Open Skies" treaty arms monitoring aircraft. A total of 360 BA 748s would be built, with more under licence in India.

Air Maritime introduced the BA 748 to Canada in 1982, its four aircraft becoming familiar sights in Fredericton, Charlottetown, St. Pierre, and Miquelon. When Air Atlantic took over the company, the BA 748s were replaced with BA 146s and were sent to join their brothers in third-tier air companies in the north. Wearing the colours of Air Inuit (Dorval, Quebec), Wasaya Airways (Thunder Bay, Ontario), West Wind Aviation (Saskatoon, Saskatchewan), Calm Air International (Thompson, Manitoba), and Air Creebec (Timmins, Ontario), the 748s found a second life as hacks in the Canadian North.

In 2003, First Air, wholly owned by the Inuit of northern Quebec, operated five of the little airliners in the world's most unforgiving environment. The airline's route system covered 15,500 miles from the Yukon in the west to Nunavut in the east; now configured to carry from four to forty passengers in either combi-configurations or bulk cargo loading, their 748s worked from gravel and ice strips with equal security. As part of the North Pole Environmental Observatory project, in May 2003 a First Air 748 flew a team of Arctic scientists from Resolute, Nunavut, to the military station in Alert for refuelling and then on to Borneo, located within sixty miles of the North Pole, a total of five and a half hours of flying time. The Hawker Siddeley made four trips to the remote ice station, landing on a thirty-one-hundred-foot strip built on the floating ice station by the Russians. Explained the First Air logistical organizer of the North Pole flights, "With some airplanes, you cannot get in or out on a thirty-one-hundred-foot strip. The Hawker is the perfect aircraft to make the trip because it is renowned for its long-range flying abilities and its large cargo capacity. We were moving about seven thousand pounds of gear and people per flight. And the five-and-a-half-hour flight is quite a long haul."

He might have added that the 748 is a worthy successor to the legendary DC-3. As the last aircraft designed by the company that A.V. Roe founded, that is appropriate.

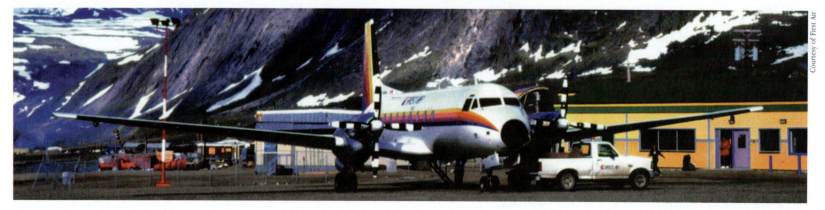

Configured for four to forty passengers in either combi-configurations or bulk cargo loading, the First Air 748s operate from gravel and ice strips.

Bell CH-136 Kiowa

In 1970, to replace the L-19 Bird Dogs and the tiny Hiller Nomad, the Canadian Forces ordered seventy-four Bell CH-136 Kiowas. The military version of the Bell Jet Ranger, the light helicopter was bought to fill roles in observation, reconnaissance, target acquisition, and adjustment of fire. Between 1971 and 1996, it was flown both by regular force units across Canada and in West Germany and by reserve squadrons in Toronto and Montreal.

The high inertia rotor and Allison turbine gave it the speed and manoeuvrability needed in tactical air support and nap of the earth flying, and it had a maximum speed of 138 miles per hour, a range of 356 miles, and a ceiling of 19,000 feet. The Kiowa was bought by the military in the United States, Canada, and Australia.

Captain Jonathan Knaul, who would later fly Griffons in Kosovo, remembered the Kiowa fondly: "Doing counter-drug operations with the reserves in a Kiowa was an incredible amount of fun — because they had to fly low and fast and because it was always real." Knaul detailed two typical Kiowa type missions he had flown:

COUNTER-DRUG OPERATIONS

Situation: An organized crime group is known to be cultivating massive amounts of marijuana in the local area.

Mission: Phase I: Conduct a reconnaissance of the implicated area. Phase II: Direct RCMP ground forces to exact location of plants for eradication.

Execution: Fly to the target grid reference, direct ground teams, and maintain top cover.

Support: Local police forces and RCMP.

Command and Signals: RCMP has command of the operation. The Kiowa pilot will be accompanied by two RCMP tactical-response members and a drug spotter.

TARGET-MARKING OPERATIONS

Situation: West Germany — Cold War period. Soviet tanks and troops are amassed at the East German border and as a result of mounting political tensions between East and West, these forces may attack at any time.

Mission: Conduct forward observation manoeuvres in support of artillery targeting.

Execution: Fly low to the target areas, use pop-up manoeuvres from behind tree lines to maintain cover, and avoid detection at all costs.

Support: One observer will fly with the Kiowa pilot. Both he and the pilot are trained in forward air control of artillery fire.

Command and Signals: Friendly forces are under NATO command.

"The Kiowa was one of the finest machines I have ever flown," remembered Captain John de Boer, a Canadian Forces qualified test pilot and Kiowa veteran from 408 Squadron.

> It was very well suited for its role — easy to hide and manoeuvrable. It was also in a front-line role. We called in and adjusted artillery from concealed locations, and we practised firing target-marking rockets for close air support and the self-defence Gatling gun. (The gun was too heavy to carry all the time; we only mounted it for range practice.) It was also a tremendous responsibility for a young

Bell CH-136 Kiowa

pilot to have an observer as crew and to be aircraft captain in a single-pilot aircraft. The flying was second-to-none. The orders stated that we were to keep the "skids clear of vegetation and obstacles." We all got very proficient at low flying and map reading. The Kiowa was like a sports car — except for the power. With a third person on board or a full tank of fuel, it sometimes took some creativity to get the helicopter out of ground effect. But any of us who flew that chopper would go again in an instant.

The Kiowa was retired in March 31, 1996, to be replaced by the CH-146 Griffon.

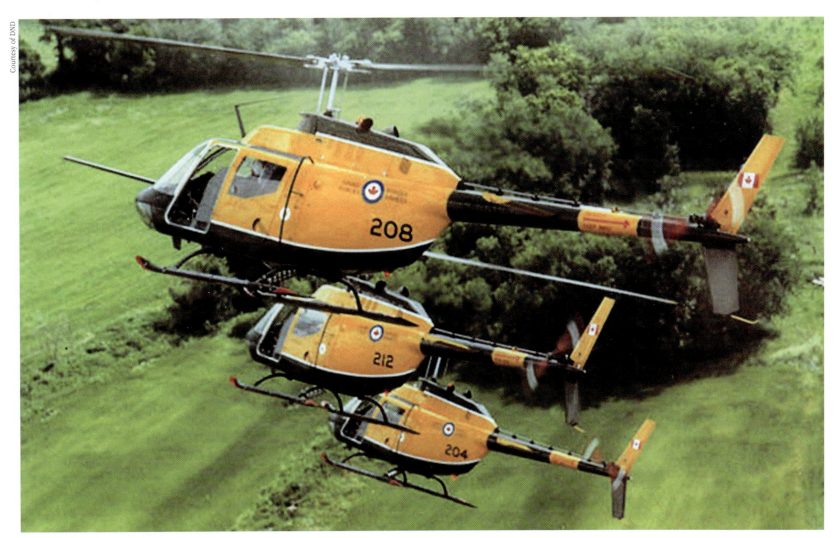

Kiowas 208, 212, and 204 were photographed flying in formation near Winnipeg, Manitoba, in 1978, resulting in this much-publicized photo. During this period all three aircraft were on strength at No. 3 Canadian Forces Flying Training Schools (3CFFTS) Basic Helicopter School flying out of CFB Portage la Prarie, Manitoba.

ON CANADIAN WINGS | A Century of Flight

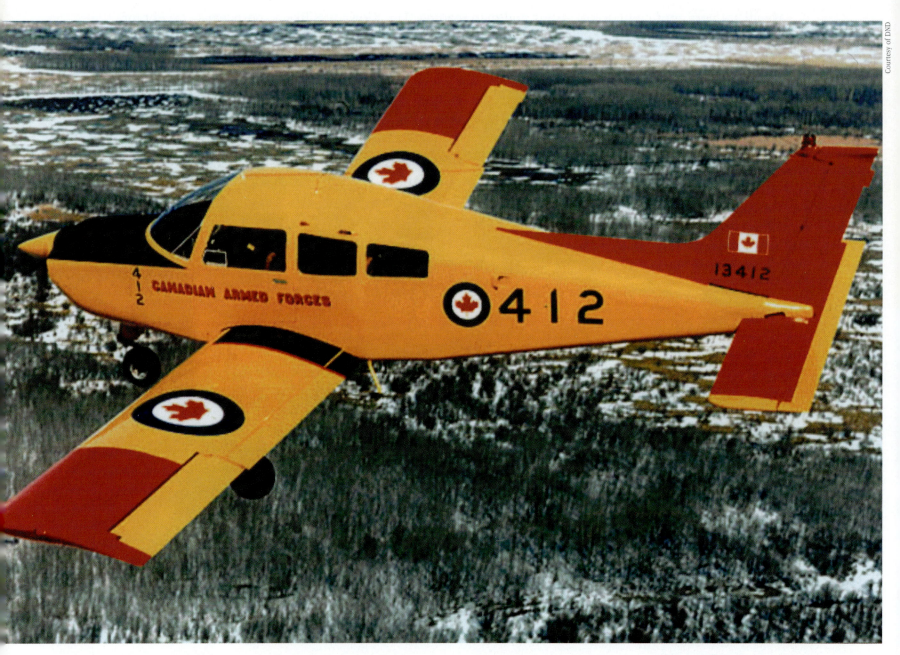

Beech Musketeer CT-134.

Beech Musketeer CT-134

"Maintain thine airspeed, lest the ground come up and smite thee," is good advice for flustered students as well as for aircraft manufacturers. The market for light, basic, cheap training aircraft has always been a vast and varied one, and to keep ahead of Cessna and Piper, Beechcraft developed the Model 23 Musketeer in several variations. A cheaper version of its four-seater Bonanza, it was aimed it at customers who were considering the Cessna 172 or Piper Cherokee. The prototype first flew on October 23, 1961, and the first production aircraft were delivered the following year. In 1965, Beechcraft had expanded the Musketeer family into three main types: the Musketeer A23A, the Custom III, and the Musketeer A23-19 Sport III.

By the end of the 1960s, the De Havilland Chipmunk was long in the tooth and ready for retirement as a basic trainer from the Canadian Forces. As its replacement, the off-the-shelf Musketeer was chosen. The first of twenty-five Musketeers arrived at No. 3 Flying Training School at CFB Portage la Prairie on March 23, 1971. Ten years later, a further twenty-one, with the designation CT-134A Musketeer II, were delivered to replace the earlier batch.

ON CANADIAN WINGS | A CENTURY OF FLIGHT

The Musketeer was also the last of the air force owned and operated training aircraft. In 1993, when Bombardier was given the training contract, twelve British-built Slingsby T67C3 Fireflies replaced them. All Musketeers were struck off strength in March 1994.

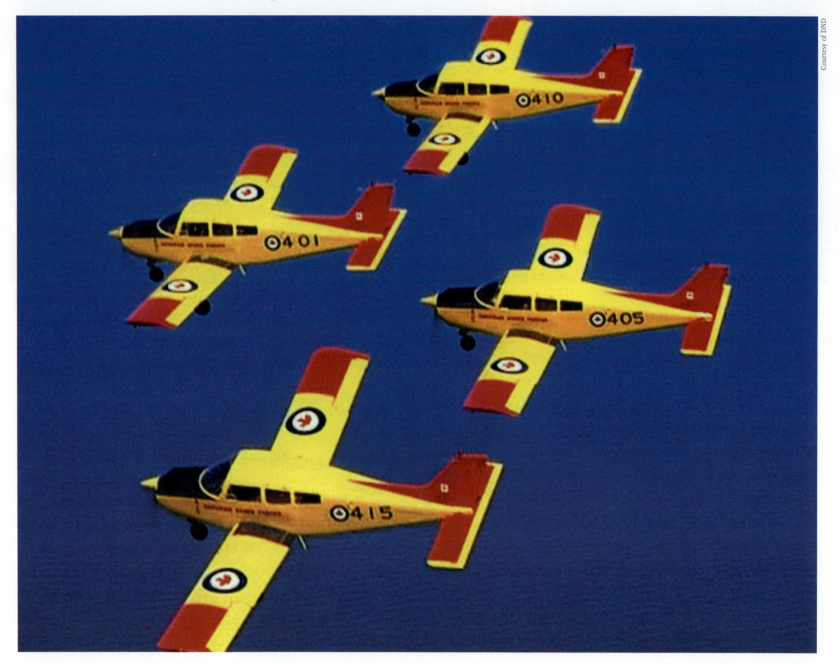

Beech Musketeers.

Lockheed L-1011 Tristar

The Lockheed Tristar was initially designed in 1966 as a twinjet for the domestic market, and especially for American Airlines' Chicago–Los Angeles route. It received its distinctive trijet shape when Trans World Airlines wanted a trijet for its Midwest–to–West Coast flights. The airline thought that the Rocky Mountains would be a problem and that a three-engine configuration would allow the airliner to take off from short runways with a maximum payload. Lockheed chose the Rolls Royce RB2111 as the power plant, a choice that jeopardized the aircraft's development when Rolls Royce went into bankruptcy in February 1971. The Tristar's fuselage design allowed for comfortable eight-abreast seating in economy and a six-abreast arrangement in first class. Like its rival, the DC-10, it featured an underfloor galley for preparing in-flight meals and storing carts during takeoff and landing.

The L-1011's first flight was on November 16, 1970 (the DC-10's first flight had been on August 29), and Eastern Air Lines was the launch customer. In 1973, Air Canada ordered the long-range version of the L-1011 to replace its stretch DC-8s on North American routes. The first Air Canada Tristar was delivered from Palmdale on January 14, 1974, for service on the Toronto-Miami route. Two of the airline's L-1011s, C-FTNA and C-FTNC, flew in

Eastern Air Lines livery in the winter and Air Canada livery in the summer. One of them, C-FTNA, now in Air Transat service, was written off after suffering severe damage in a hailstorm outside Lyon, France, in 2001.

The introduction of extended twin-engined operations (ETOPS) gave the aircraft a new lease on life and allowed Air Canada to shift them to its busy European routes, and in April 1981, the first long-range Tristar Dash 500 with seating for 244 was placed in service on routes to Europe. Air Canada began retiring their standard-length L-1011s in October 1990 but kept their Dash 500s until early 1992, when their Boeing 767-300ERs took over the routes. One former Air Canada Tristar was converted in 1993 by Marshall Aerospace into a satellite launch platform for the Orbital Sciences Corporation and called *Stargazer*.

The charter vacation carrier Air Transat made its inaugural flight on November 14, 1987, from Montreal to Acapulco and acquired some of the ex–Air Canada Lockheed L-1011s. Eventually, its fleet consisted of C-FTNL L-1011-100 1073, C-FTSW L-1011-500 1246, C-GATH L-1011-500 1235, C-GATM L-1011-500 1236, C-GTSP L-1011-500 1242, C-GTSQ L-1011-500 1243, and C-GTSR L-1011-500 1239, with C-GTSZ L-1011-50 1103 leased from Interface Group.

Air Transat Tristar.

Bombardier Learjet

He dropped out of high school and began inventing things, from the first jet aircraft autopilot to the eight-track tape player. In 1960, William (Bill) P. Lear moved the family to Switzerland to manufacture a twinjet, high-speed executive aircraft, the SAAC-23. Developed from the FFA P-16 fighter, the Learjet 23 was built in Wichita, Kansas, and first flew on October 7, 1963. Followed by models 24, 25, 35, 36, 28, 29, 55, and 31, the sleek aircraft was synonymous with a millionaire's toy, the pride of drug barons, championship golfers, and pop stars. But it was equally comfortable with owners that ranged from the U.S. Army to the Peruvian Air Force to geological survey companies.

Purchased for $75 million by Bombardier Aerospace in June 1990, the Wichita plant has continued to turn out Learjet aircraft under the Bombardier name. Three years later, the first Bombardier Learjet 60 mid-size business jet was delivered, followed by the delivery of the first 31A in 1991 and the unveiling of the 45 in 1992. The Learjet 45 cruises at speeds up to Mach 0.81 (534 miles per hour). With a maximum range of 2,098 nautical miles, it can connect cities such as Toronto and Phoenix, Vancouver and Los Angeles, Calgary and Montreal, and Halifax and New Orleans. In July 2003, Bombardier confirmed that the Irish government was

to acquire a Learjet 45 for ministerial travel, of which over 50 percent of the major components were built in the company's Belfast plant. One of the reasons for the purchase was that the Learjet 45 had a range that permitted non-stop flights from Dublin to cities as far afield as Moscow and Istanbul.

Bombardier Learjet 45: custom-crafted, sleek, sporty.

Bill Lear would have appreciated the first flight of the Bombardier Learjet 40 prototype. Taking off at 5:05 p.m. on August 31, 2002, it returned at 7:24 p.m., having reached an altitude of 47,000 feet and a speed of 312 miles per hour. The prototype was actually a "deplugged" Learjet 45 shortened by 24.5 inches and modified slightly to conform to the systems and dimensions of the Bombardier Learjet 40. The flight test and engineering test pilot said, "We had a very good idea of what to expect from our extensive experience with the Bombardier Learjet 45, but this was still a unique experience. The modifications didn't result in any perceptible change to the flight characteristics."

Bombardier Learjet

The jet surpassed two major milestones within a week when the first production model made its maiden flight six days later on September 5. "We found the airplane to be very stable and predictable, which is a tribute to the people who built it," the pilot commented. The flight test engineer on both flights later said, "I can't recall any other aircraft program where the test article and the first production model have flown so close together. Normally, once an aircraft concept is announced, it takes months before a prototype is produced and flown, and traditionally the first production airplane follows significantly later. To fly both within six weeks of the announcement of the concept is pretty extraordinary." Like the Bombardier Learjet 45 from which it is derived, the Bombardier Learjet 40's fuselage is built at Bombardier's Belfast facility, while the wing is manufactured at Downsview and then shipped to Wichita, where the aircraft is assembled.

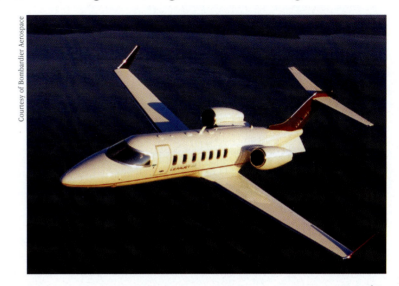

Learjet 40.

The Bombardier Learjet 40 has a cruising speed of Mach 0.81 and a maximum range of 1,857 nautical miles with four passengers, two crew, and IFR reserves; it was certified for operations at altitudes of up to 51,000 feet on July 21, 2004. With full fuel and a maximum payload, it will fly up to 1,696 nautical miles at Mach 0.73 (481 miles per hour) and will lead its class in terms of payload range capability for all missions up to 1,699 nautical miles, with payloads equal to or greater than one thousand pounds. The Learjet 40 provides a cabin 17.67 feet long, 5.12 feet wide, and 4.92 feet high. The typical configuration sports a forward club seating arrangement and a flat floor that translates into outstanding seated comfort for up to seven passengers. The improved interior also offers redesigned seats, which are two inches wider and result in additional legroom, a full-size galley, a full-across aft lavatory, and an LED lighting system, which lasts longer, is more robust, and emits less heat. The Learjet 40 is currently priced at US$7.73 million for a typically equipped aircraft. On June 8, 2003, the Bombardier Learjet 40 light business jet made history by successfully completing its first transatlantic flight, less than one year after its introduction at the 2002 Farnborough Air Show.

Bill Lear died on May 14, 1978. Those who worked with him remember him saying, "The secret of success is really hard work. It won't happen by itself." He would have been proud of those who made today's Learjets.

ON CANADIAN WINGS | A CENTURY OF FLIGHT

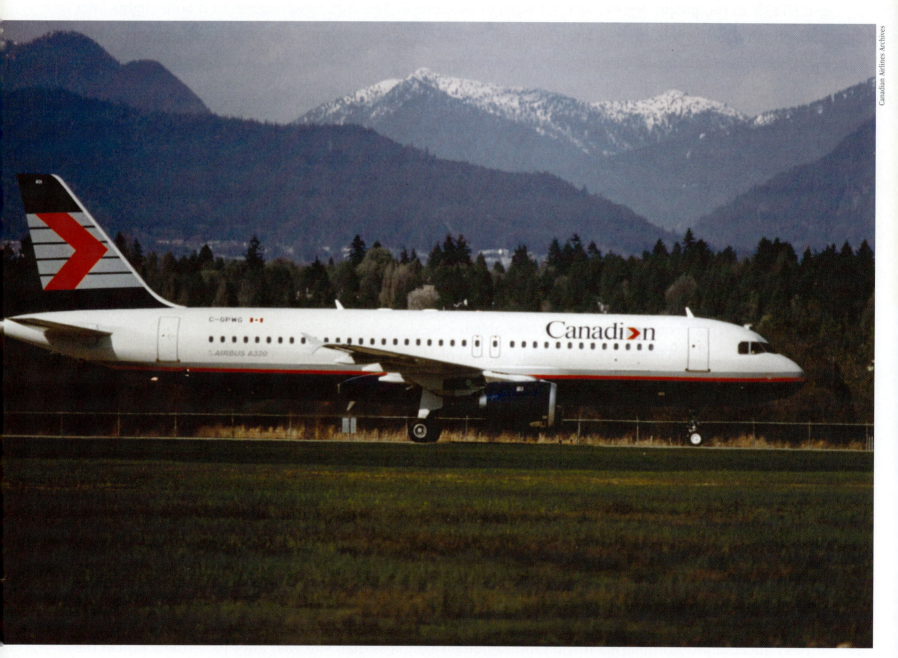

Canadian Airlines A320-211 with new logo symbolizing "Wings Across Five Continents."

Airbus 319/320/321

Here is an airliner that has caused more destruction than most bombers and guided missiles. In 2003, Air Canada operated forty-seven 319s, forty 320s (with eleven in Tango colours), and thirteen 321s. In company with many other airlines worldwide, the company knew the Airbus as a cost-efficient, versatile aircraft. Yet history will link the aircraft with kickbacks, side payments, corruption in Kuwaiti palaces and Belgian banks, shell companies in Liechtenstein, and skulduggery in Mexican resorts. The Airbus has led to the downfall of Syrian ministers, Interpol investigations, the tarnished reputation of a former Canadian prime minister, and the interception of messages by the American National Security Agency. Purchase of the aircraft has even caused the collapse of such well-respected airlines as Swissair and SABENA.

Given the billions of dollars involved, buying aircraft has always had a whiff of scandal, especially as the airlines play Boeing and Airbus off against each other. And Airbus Industries, the makers of Airbus, are not the first to be so investigated. Bribery by Lockheed in the 1970s led to a Japanese prime minister and a member of the Dutch royal family being disgraced. But by attempting to catch up with Boeing, the Toulouse

company has outdone Lockheed a hundredfold. The Airbus sales pitch was so persuasive that after the American-led coalition liberated Kuwait in 1990, it was expected that Kuwait Airways Corporation (KAC) would replace their destroyed fleet with Boeing 767s. But although President Bill Clinton personally intervened, and the Boeing bid was cheaper, today the reconstituted KAC flies mainly Airbuses.

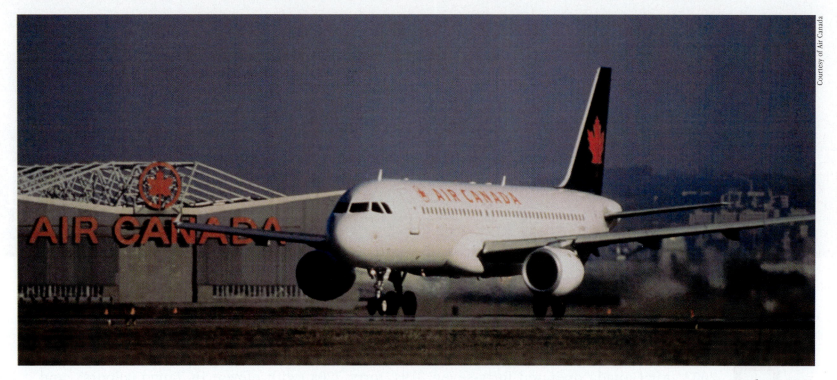

Airbus 319.

Airbus Industries is now part of European Aeronautic Defence and Space and BAE Systems. Its A320 family comprises the 107-seat A318, the 124-seat A319, the 150-seat A320, and the 185-seat A321. All of the aircraft share the same airframes — only the fuselage lengths are different — cockpits, systems, and engines, delivering operational commonality and savings to airlines. The first big sale in North America was to Air Canada in 1988. The Crown corporation had signed for thirty-four aircraft (with an option for twenty more) to replace its Boeing 727s at a cost of $1.5 billion. There was considerable opposition from Air Canada pilots who had always flown Boeings. At the same time, in April 1988, the airline was being privatized by the newly elected Conservative government of Prime Minister Brian Mulroney, and the cost-efficient A320/321 would give it a competitive advantage. With the later addition of the A319 to the long-range A340 to replace old DC-9s and Boeing 747s, the airline had committed itself to Airbus. One A320, C-FDSN, was even painted in the Toronto Raptors' colours.

Airbus 319/320/321

When on December 12, 1996, Air Canada received the first of its A319s, it became the first North American airline to fly the twin-engined jet — just in time to take advantage of the "Open Skies" treaty with the United States. The 319 had almost twice the range of the DC-9 but burned 32 percent less fuel.

It had commonality with the A320 in its CFM56-5 engines, spare parts, and flight simulators. At Toulouse for the delivery, President and CEO Lamar Durrett said, "We are launching a 'flying competitive advantage.'" To celebrate its sixtieth anniversary as an airline, Air Canada had A319 C-FZUH painted in vintage Trans Canada Airlines livery. In 1998, Canadian Airlines also used A320s, hoping to purchase more in 2001.

Airbus 320-211 in Raptors mode.

Then that whiff of scandal, characteristic of Airbus, appeared. Through an investigative television program and bestselling book, Canadians soon became familiar with Karlheinz Schreiber, the middleman in the Airbus deal. They also heard that Airbus had a consultancy agreement with International Aircraft Leasing, a shell company in Liechtenstein owned by Schreiber. Between September 30, 1988, and October 31, 1993, as Air Canada took delivery of the aircraft, Airbus paid a total of $22,540,000 in commissions into IAL's accounts in Liechtenstein and Switzerland as a reward for "greasing" the sales. When rumours circulated that the kickbacks went as high as Prime Minister Brian Mulroney and his cronies (beginning with a letter to the Swiss claiming evidence of such), the Royal Canadian Mounted Police launched an eight-year investigation into what became known as the "Airbus Affair." The miserable saga concluded with an out-of-court settlement to Mulroney and reflected no good on anyone: the RCMP, the government of Prime Minister Jean Chrétien, Schreiber, and least of all, Airbus.

ON CANADIAN WINGS | A Century of Flight

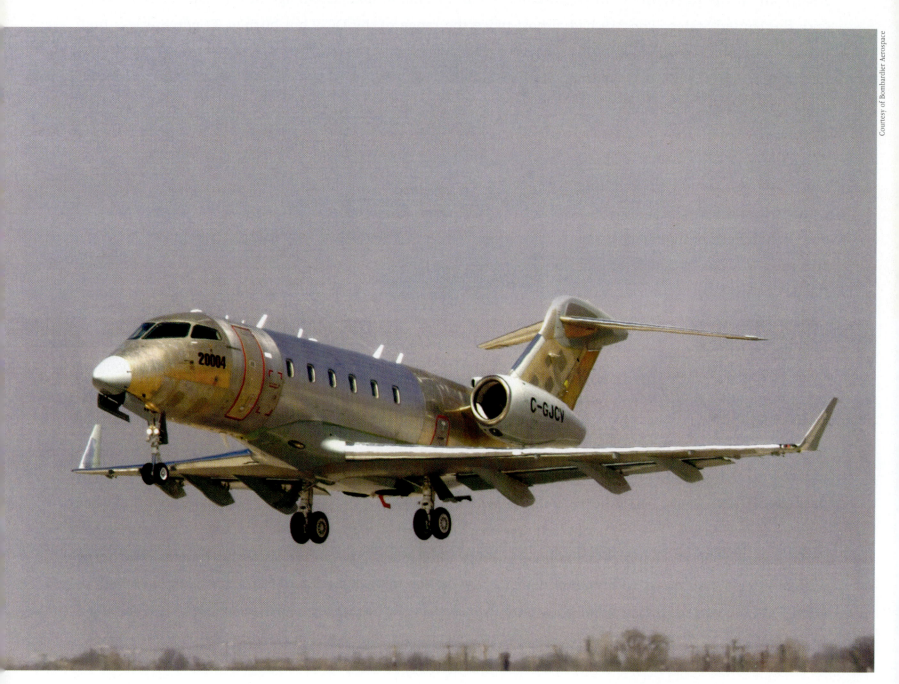

Bombardier Challenger 300.

Bombardier Challenger

"The first thing every pilot notices is the large cockpit and the cleanest glass panel arrangement on the market. The company met a goal to simplify and reduce pilot workload in the cockpit," said one aviation analyst. "The cockpit is exceptionally comfortable, even for the tallest and largest pilots. Visibility out the windows is superb, making it possible to fly either left- or right-turn circling approaches with good visual reference to the runway," said another. Pilots talked of the width and spaciousness of the flight deck, comparing it with a Boeing 747-400. All this praise wasn't directed at a Burt Rutan creation or a Seattle-built corporate jetliner but at the Bombardier Challenger, a Canadian-designed and -built aircraft.

Since the launch of the 601-R in September 1994, the Challenger family had done well for Bombardier, and variants had been sold in more than fifty countries, as the aircraft was popular among corporations, governments, and air charter companies alike. With proven General Electric CF34-3B1 high bypass turbofan engines, the 604 can operate up to 4,077 nautical miles and has a maximum cruising speed of Mach 0.82 (541 miles per hour). Within was the widest available cabin of any true business jet — eight

feet, two inches wide with a comfortable stand-up room of six feet, one inch. Its range allowed it to connect London and Chicago, Riyadh and Paris, and other key city pairs. Cabin size also means the Challenger is well suited for a variety of other roles, including air ambulance, flight inspection, electronic systems training, and maritime surveillance. In November 1999, Bombardier announced that it had sold two wide-body Challenger 604 business jet aircraft to the Royal Jordanian Air Force. If aircrew knew that they could count on its improved high temperature/high altitude airfield performance, company accountants liked its low fuel consumption. The 604 was upgraded in June 2001 with Rockwell Collins PrecisionPlus Pro Line 4 avionics, which reduced pilot workload.

Bombardier Aerospace celebrated the delivery of its six-hundredth Challenger widebody business jet aircraft when s/n #5557 rolled off the assembly line.

Sharing attributes with Bombardier's CRJ aircraft, the Challenger 800 is a variant of the Bombardier Regional Jet airliner. Its 45-foot long cabin compares in size with the Global Express, along with its 3,120-nautical-mile transcontinental range. Configured to the operator's choosing, this wide-body business jet can seat from fourteen to nineteen passengers in armchairs, club seating, and divans. With reserves, zero winds, and at Mach 0.74, a Bombardier Challenger can fly non-stop from New York to Los Angeles or London and from London to Jeddah. When Aircraft s/n #5557 rolled off the assembly line in March 2003, the company celebrated the delivery of its six hundredth Challenger business jet. The popularity of the Challenger as an executive transport is due to its cabin, the largest in the industry, providing corporate and government leaders with a quiet, comfortable atmosphere in which to work and rest.

Bombardier Challenger

Originally named the Continental, the eight-passenger Bombardier Challenger 300 was designed to fill a gap in the Learjet series between the Learjet 60 and the larger Challenger 604. With rivals Raytheon Hawker Horizon, Cessna Citation X, and Gulfstream 200, the field was heavily competitive: all were good value, but Bombardier thought that its family needed a medium cabin aircraft with transcontinental range that came with a $16-million price tag — $4 million less than the 604. The prototype 300 flew in August 2001, and by June 2003, when the aircraft was certified, there were 115 orders.

If the 604, 800, or 300 have a fault, it is that they are too visible and thus make easy targets. The first perk to go when dissident shareholders howl for the head of the chief executive officer is the CEO's Challenger. Perceived by employees and shareholders alike as his personal toy, corporate jets like the Challenger figure prominently in business shake-ups and scandals such as those at Tyco International, Hollinger, and Enron Corporation. In fact, when former Enron CEO Kenneth Lay was asked to defend the use of his jet for family reasons, he responded, "Well, I think it gives my senior people something to aspire to." Owning a Challenger is something that we could all aspire to.

The Challenger 604 aircraft entered corporate service in April 1996, offering the widest cabin available in a true intercontinental jet.

ON CANADIAN WINGS | A Century of Flight

NATO Flying Training in Canada (NFTC) trains pilots at 15 Wing Moose Jaw, Saskatchewan, for Canada, NATO allies, and friendly, non-NATO countries as well.

Raytheon CT-156 Harvard II

The Pilatus PC-7 Turbo Trainer is an opportune marriage of Swiss craftsmanship and Canadian power. Not only for entry-level aviation students, the low-wing monoplane's capability covers all aspects of basic training: aerobatics, instrument usage, tactical flying, and night flying. The best-selling tandem-seat trainer's shape is known from CFB Moose Jaw, Saskatchewan, to Kalamata, Greece

After building aircraft since 1945, Swiss Pilatus Flugzeugwerke Ag. came to North American attention in the 1960s with its PC-6 Porter, still today the unbeaten STOL champion. The company brought out the first PC-7 Turbo Trainer in 1978, and since then, five hundred have been sold, the aircraft getting a spectacular shot in the arm when adopted by the American military for the Joint Primary Aircraft Training System, replacing the T-34C and T-37 basic trainers that both the navy and the air force used. In September 1990, Beech Aircraft offered the Beech Mark II, an advanced, high-performance version of the Pilatus PC-9, to be built by Raytheon. The competition winner, the Raytheon T-6A turboprop was then called the T-6 Texan II. It has a certified ceiling of 31,000 feet at mean sea level (MSL), structural limits of +7 to -3.5 G, and is capable of 270 knots indicated airspeed (KIAS) in level flight. With its Pratt &

Whitney Canada PT6A25A turboprop engine, Martin-Baker Zero-zero ejection seats, and state-of-the-art glass cockpit, the Texan has full aerobatic capability. The instructor's rear seat is slightly raised to improve visibility from the rear cockpit. The T-6A Texan II has a highly sophisticated cockpit, is qualified for visual flight rules (VFR) and instrument flight rules (IFR) flight, and has two coloured five-inch liquid crystal primary flight GPS displays and an onboard oxygen-generating system that reduces the time needed to service the aircraft between flights. Flight controls and avionics can be operated from both cockpits. The aircraft is fitted with hydraulically operated split flaps, used for takeoff and landing. The tricycle landing gear system is hydraulically retracted through electric controls.

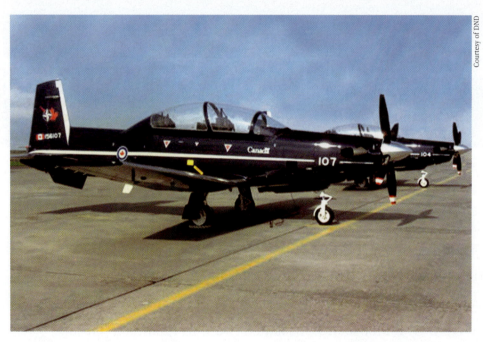

Raytheon CT-156 Harvard II.

On November 4, 1997, the Canadian Air Force entered a CDN$2.85-billion, twenty-year contract known as the NATO Flying Training in Canada (NFTC) program. A 1994 Bombardier Aerospace Defence Services initiative, the NFTC would train pilots primarily at 15 Wing Moose Jaw, not only for Canada but also for NATO allies and friendly, non-NATO countries as well. The Bombardier-led consortium of companies would provide and maintain two fleets of training aircraft and flight simulators — the CT-156 Harvard II and the BAE Hawk 115. During the Second World War the name Harvard was adopted for the Texan, and in homage to both training aircraft, the Canadian Forces called the new trainer Harvard II. By 2003, pilots from the air forces of Canada, Denmark, Great Britain, Singapore, Italy, and Hungary were participating in the scheme. The NFTC's Phase II used the CT-156 Harvard II, based at CFB Moose Jaw, prior to advanced jet, multi-engine, or helicopter training, and the first course, including students from Canada and Italy, began June 12, 2000.

The Harvard IIs wear the new blue training colour with a white stripe and carry military serials starting with 156101 to 156114. As they are not owned by the Canadian Forces, they lack "FIP" markings.

Bombardier Global Express

An Airborne Stand-Off Radar (ASTOR) platform for the Royal Air Force was not what Bombardier Aerospace had in mind when it launched the Global Express on December 20, 1993. With a cabin of 2,077 cubic feet it was to be a flying boardroom or a fully equipped office. That it could take 8 passengers at a speed of Mach 0.85 (561 miles per hour) a distance of over 7,500 miles — in effect, fly from New York to Tokyo non-stop — was a definite attraction. Its speed, range, and cabin size combined to make the aircraft attractive to government leaders who travelled with entourages and who did not want to refuel in potentially hostile countries along the way. But as the Global Express flew comfortably at an altitude of fifty thousand feet and had an endurance of over fourteen hours, the RAF chose it for ground radar surveillance. The first of five RAF Global Expresses left Downsview in August 2001, to be fitted with the ASTOR system. Equally at home keeping the peace or doing business, the Global Express was to be the flagship of the Bombardier family.

When Bombardier unveiled the first aircraft at Downsview in 1996, the ceremony was a combination of a Hollywood spectacle and a G-8 summit. It featured a forty-five-piece orchestra, a three-hundred-person

choir, seven hundred employees in white, floodlights, Prime Minister Jean Chrétien, Ontario Premier Mike Harris, a choreographed walk-on of all the partner country flags, and then the climax — the unveiling of an immense Canadian flag that revealed the Global Express. A culmination of five years of work by Bombardier, here was an aircraft entirely different from any that had ever been built. It had cost an estimated US$584 million to develop, and Bombardier was responsible for only half that. Rather than take all of the financial risks, the company had spread it out to nine partners in six countries. De Havilland Canada was responsible for the rear fuselage and final assembly, the nose section came from Canadair in Montreal, the forward fuselage and horizontal stabilizers were from Shorts in Belfast (all subsidiaries of Bombardier), the wings and mid-fuselage came from Mitsubishi in Japan, the flight control systems were from France, the avionics from the United States, the electrical system from Lucas in Britain, and the BMW-Rolls Royce engines from Germany. The ultra long range business jet was global not only in range but in risk sharing as well.

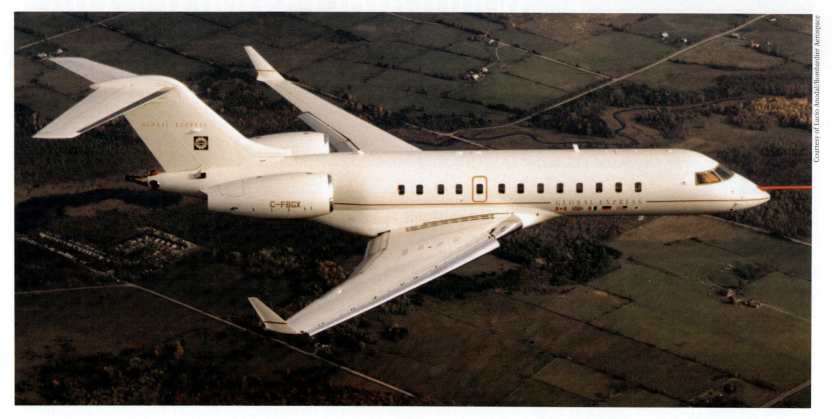

The first Bombardier Global Express flying on October 13, 1996.

The first Global Express flew on October 13, 1996, and entered service in July 1999, setting seven new world records in two weeks as part of its performance flight plan. Between May 1 and May 15, production

Bombardier Global Express

aircraft s/n 9014 made one U.S. transcontinental and six ocean crossings, including two Atlantic and four Pacific crossings. The most remarkable flight, one pilot commented, was from Hilton Head Island in South Carolina, which has a runway only forty-three hundred feet long, to Maui in Hawaii in nine hours and sixteen minutes. This shattered all previous notions of what could be accomplished from challenging airfields.

On October 26, 2001, the Global 5000 was unveiled at an event hosted at Bombardier's Montreal Interior Completion Center. A smaller, shorter-ranged derivative of the Global Express, its lower cost reflected the difficult times in the aviation industry. Capable of flying 8 passengers and 3 crew members a total of 5,523 miles at Mach 0.85 and accessing short airfields, it provides a step up for current large aircraft operators. Once more, Bombardier had teamed up with several international suppliers to design and produce critical components and aircraft systems. They selected Rolls-Royce Deutschland to supply the BR710A2-20 power plant, produced at the company's Dahlewitz facility near Berlin, Germany, and Mitsubishi Heavy Industries of Nagoya, Japan, for the detail design, manufacturing, and integration of the wing section and centre fuselage. Since the aircraft offered such features as the largest cabin in its class and an office connectivity suite (local area network, telephone, and high-speed data communication), it comes as no surprise that the launch price for a typically equipped Bombardier Global 5000 is US$33.50 million. To ease maintenance and for better dispatch capability, the Global 5000 will also include a central aircraft information and maintenance system.

As for the RAF ASTOR-equipped Global Express, it went into squadron service in the third quarter of 2004 as a Sentinel. Appropriately, Bombardier aircraft equip British No.5 Squadron, which worked so closely with the Canadian Corps on the Western Front in 1915 that they adopted the Maple Leaf as their emblem. This time that emblem would be on a Canadian-built aircraft.

Bombardier Global Express offered a 14-hour cabin and a cruise speed just below sonic level at Mach 0.85/0.88.

ON CANADIAN WINGS | A CENTURY OF FLIGHT

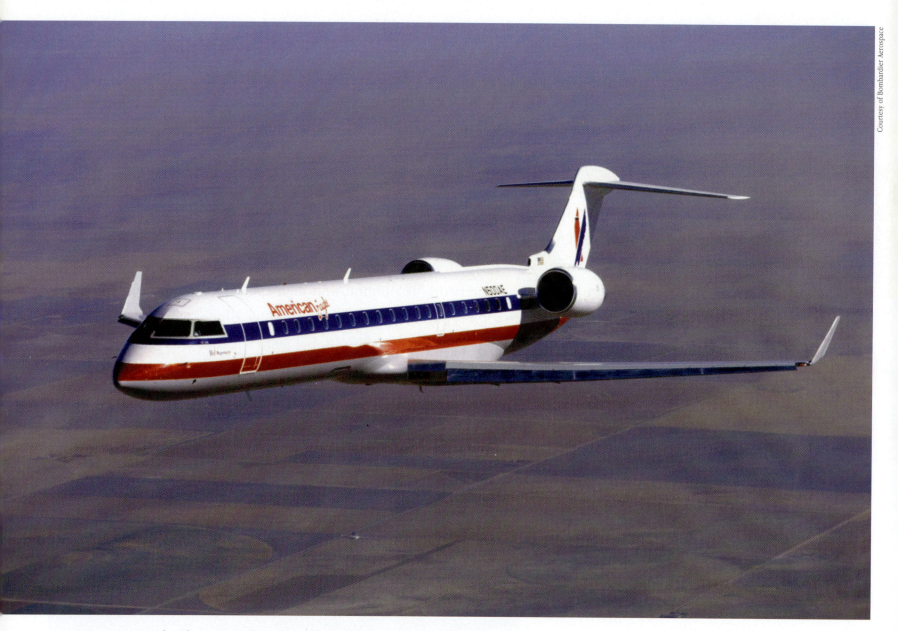

American Eagle, the regional airline of American Airlines, with one of its seventy-seat Canadair Regional Jet Series 700.

Canadair Regional Jet

Here is an aircraft that changed the world. Or at least the world of regional aviation, between airline hubs and their catchment areas. For years, commuter carriers were the poor relations of the parent airline. They flew hand-me-down puddle jumpers or loud, low-flying turboprops. All that changed with the introduction of the Canadair Regional Jet, or CRJ.

The forty-eight-passenger jet entered a notoriously unstable market, as Brazil's Empresa Brasileira de Aeronautica (Embraer), Germany's Fairchild/Dornier, and Britain's Shorts already knew. But when its birth was announced on March 31, 1989, few could have had any idea how far-reaching the consequences would be. When the concept of the CRJ 100 was first declared at the 1990 Farnborough Air Show, could anyone have guessed that this generation of small jet airliners would one day revitalize commercial aviation?

It was a different mindset then. Wall Street thought a jet for short-haul routes, particularly when there were so many old turboprops available, was lunatic. But passengers preferred jets to the "bone shakers," and the airlines soon discovered that those routes too extended for turboprops and too thin for their mainline aircraft were now within reach. With fifty-six firm orders, Bombardier unveiled the first CRJ in May 1991. Launch

customers were DLT (now Lufthansa City Line) on October 19, 1992, and Comair, a Delta Connection. The first North American carrier placed the first aircraft into service on June 1, 1993. Other airlines, from Lauda Air to Thai Airlines, soon followed. The cost-efficiency of running a CRJ fleet afforded dynamic growth to rural areas, giving them all-jet connections with big cities. Besides, offering seats on their bigger planes at deeply discounted prices was bankrupting the airline giants, and by deploying the smaller CRJs, they were reducing the supply side of the economic equation. The CRJs were cost-efficient to run — a 50 percent break-even load factor meant twenty-five passengers for a fifty-seat CRJ. Soon, it became a case of the tail wagging the dog, as the big airlines were turning over their traditional hub flying to regional partners. The poor relation was now feeding so much traffic into the hub that the profit margin of the parent airline depended on it.

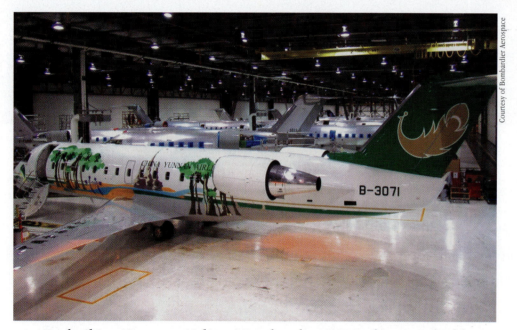

Each China Yunnan Airlines' Bonbardier CRJ is distinguished by its unique livery, depicting Yunnan province's special tourist destinations, exotic plants, and flowers.

Rather than be quiescent, Bombardier turned the CRJs out in all sizes. The regional jet market was fickle, and CRJ customers like American Eagle shopped equally at arch-rival Embraer. In a duopoly the key was flexibility, giving customers a family of appropriate, efficient aircraft for their routes before the rival did. In 1996, the Bombardier CRJ 200 was launched with higher performance engines. The seventy-seat Bombardier CRJ 700 made its maiden flight in May 1999 and was delivered to inaugural customer, Brit Air/Air France, in January 2001. On October 4, 2002, Bombardier delivered the first of twenty-seven Bombardier CRJ 700s to Comair. And in January 2003, the latest and largest member of the family, the eighty-six-seat Bombardier CRJ900, was delivered to Mesa Airlines of the United States. All three versions of the Bombardier CRJ have the same type rating, maximizing the benefits of common crew qualifications: one type, three sizes, no compromises. Soon, at the new Bombardier Plant 3 at Dorval Airport, beside the Air Canada base, CRJs were being fitted out in the livery of airlines from China, Africa,

Canadair Regional Jet

and Europe. The seven hundredth fifty-seat Bombardier CRJ (serial number 7700) was delivered to Air Nostrum of Valencia, Spain. Bombardier built other equally record-breaking aircraft, but none has revolutionized the airline industry and helped transform the company into one of the world's leaders in aerospace.

If the CRJs were the saviours of airlines and airports in rural areas, they were unpopular with pilots' unions and with the Brazilian government. Increased use of the CRJs by the major airlines led to labour trouble from pilots, who felt their opportunities were threatened. After some compromise on the part of management and unions, the famous Scope Clause was invoked, which permitted regional airlines to operate a limited number of CRJs. Trade disputes between Canada and Brazil over government financing for the CRJ were more difficult to settle, and it took the World Trade Organization to rule who was in compliance with its rules.

In October 2004, there were a total of 1,150 CRJs delivered, and the order book for the new 700 series was healthy. With the larger airlines continuing to turn to their regional partners for profitable service in many markets, the regional airline revolution that began with the pioneering Bombardier CRJs can only grow. As for the CRJ 700 series 701 and 705, as the first seventy-plus seat regional jetliners to enter service, the aircraft have a good head start on competing aircraft from

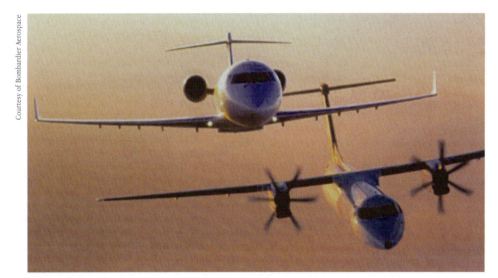

Sisters: Bombardier CRJ with Q400.

Embraer and Fairchild-Dornier. High performance, low operating costs, and the family commonality have always been the advantages of the Bombardier CRJs, and the CRJ 700s look to carry on the family tradition.

Almost single-handedly, the Bombardier CRJ has created a market where none existed before. Having captured 54 percent of regional jet sales worldwide in the forty- to ninety-seat market segment, today the Bombardier CRJ program is universally recognized as one of the most successful aircraft programs ever. The CRJ should stand for Canadian Revolutionary Jet, for that is what it is.

ON CANADIAN WINGS | A CENTURY OF FLIGHT

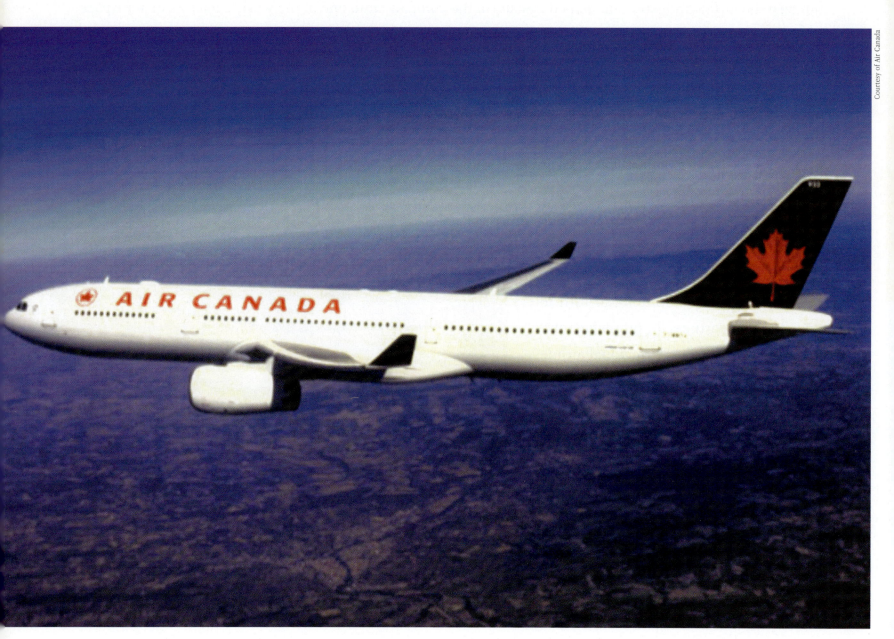

Air Canada Airbus 330.

Airbus 330

In October 1972, when Airbus Industries was barely two years old, the first A-300 first flew. The world's attention was then on the consortium's more glamorous product, the Concorde, and in an industry dominated by Boeing, the airliner was given little chance of survival. Its uninspiring shape and utilitarian name contrasted with the seductive speeding bullet of the Concorde, thought to be the future of air travel.

Five years later, with only thirty-eight A-300s sold, the company's desperation was symbolized by the sixteen planes sitting along a fence outside the Toulouse plant, their tails painted white, without airline insignia. Then it all changed. Just as American anti-noise regulations and the oil crisis in 1979 doomed the Concorde, the president of Eastern Airlines, Frank Borman, called Airbus. Unable to convince Boeing to build a wide-body twinjet, he asked to borrow four of those white-tailed A-300s for a six-month trial. Soon, he discovered that they used one-third less fuel than the L-1011s that Eastern was flying. In 1978, Borman purchased twenty-three A-300s. Airbus had broken through! Boeing would wake up and react by stating that it would build its own wide-body twinjet, the 767, but that was years in the future. The

European governments pumped subsidies totalling $13.5 billion into the Airbus consortium, allowing the company to turn out a family of airliners for every market and pocketbook. In 1986, the A-330/340 was launched — a single aircraft that could accommodate either two or four engines. The A-330, the twinjet version, was aimed squarely at the Boeing 767. Airbus now matched Boeing's new orders in its own backyard — North America. In 1994, it overtook the American manufacturer, winning 125 orders to Boeing's 120.

Airbus 330.

Airbus 330

The twin-engined A-330-300 entered service that year, typically seating 335 passengers in two classes or 295 passengers in three classes. It could fly up to fifty-six hundred nautical miles, combining the lowest operating costs with flexibility for a wide range of route structures. In 1998, Airbus brought out the A-330-200, which offered a longer range of up to 6,650 nautical miles with ETOPS capability and which could seat 253 passengers in three classes. Such was the A-300-200's reach that both Taiwan's EVA Air and Australia's QANTAS flew their aircraft home — non-stop from Toulouse. QANTAS made the longest flight ever by an A-330-200, flying non-stop between Toulouse and Melbourne, covering a distance of almost 10,500 miles in a flight time of 20 hours and 4 minutes. The A-330-200 captured the two hundred to three hundred seat medium- to long-range market with, in 2003, an 85 percent market share.

Both Air Canada and Air Transat bought the A-330, the latter gaining unexpected publicity with one of their aircraft. On August 25, 2001, an Air Transat A-330-243, C-GITS, with 293 passengers on board, was en route from Toronto to Lisbon when the crew became anxious about the fuel quantity indication. Reasoning that it could be a fuel leak, the captain decided to divert to Lajes Airport in the Azores. At 135 miles from Lajes, the right engine flamed, soon followed by the left. Engineless, the 330 was at 13,000 feet and was 8 miles from the threshold of runway 33. An "engines-out" visual approach was carried out, and although eight of the plane's ten tires burst during the landing, the captain brought the Airbus down safely. Investigation determined that a low-pressure fuel line on the right engine had failed, probably the result of its coming into contact with an adjacent hydraulic line. On August 29, 2001, Rolls-Royce issued a worldwide communication advising A-330 operators, among others, to check all engines to ensure that adequate clearance existed between the fuel and hydraulic lines.

The last Concorde flew on October 24, 2003. Its grace, speed, and beauty had not been enough to sell it commercially. On that day, there were 464 A-330s ordered with 277 in operation. Everyone, it seemed, wanted to fly economically — the Airbus was the future.

AGMV Marquis
MEMBER OF SCABRINI MEDIA
Quebec, Canada
2005